to STUART
FROM
ROB & JOSS.
XMAS 1993
xxxx .

W. Stuart Aitken.
25th December '93.

¡PAPARAZZO!

The Photographs of RICHARD YOUNG

Words by Sally Moulsdale

VIRGIN

Dedication
To Susan and my children

Acknowledgements

A Virgin Book
Published in 1989
by the Paperback Division of
W.H. Allen & Co Plc
Sekforde House
175/9 St John Street
London EC1V 4LL

Designed by PLANET 'X'

Printed and bound in Great Britain by
Cowells of Ipswich.

I would like to thank my wife Susan for her help and dedication. This book would not have been possible without her.

Enormous thanks to all the photographers for the loan of the pics of me and the stars. Thanks also to the *Daily Express* picture desk, the *Ross Benson Diary* and Rex Features.

My appreciation to Cat Ledger, Sally Moulsdale and Phil Healey for their patience, perseverance and great layouts.

Finally I would like to acknowledge the help of Brian Rolfe and all the PRs, doormen, chauffeurs, bodyguards, minders and 'deep throats'. You know who you are, and I couldn't have done it without you . . .

Foreword

When I was first asked to do this book, I thought it would take a lifetime to sort through the thousands of negatives that I have accumulated over the years. It hasn't taken quite that long, fortunately, but the process has certainly been drawn out by my pauses, every few pics, to relive old memories . . .

I can recall the circumstances surrounding almost every one of my pictures, and that includes how long I waited in the rain to get the shot! To catch some people it was necessary to formulate an elaborate plot, for other targets it was a case of a long siege, and for a magic few it was pure luck – a matter of being in the right place at the right time. For nearly all of them it has meant late, late nights, and far too many early mornings.

You have to sacrifice more than your sleep in this business; far harder than that is losing time with Susan and my children, Danny, Sammy and Hannah. But such sacrifices are necessary if you want to stay on top: if I'm not there to cover a big showbiz party, someone else will get the picture.

To me, the most important thing about my pictures is their entertainment value. They are not meant to harm or demean anyone in any way, but just to give ordinary newspaper readers an exciting or amusing glimpse into the lives of rich and famous people, the people whose music they buy and whose films they queue to see. Every day there are photographs of tragedy and horror in our newspapers. I hope my pictures counteract that a little by providing a touch of warmth, humour and fun.

I have enjoyed every minute (well almost) of the last 15 years, and I feel very lucky to have met so many fascinating, talented and beautiful people, travelled to so many interesting places – and eaten so much wonderful food! Roll on the next 15 years!

London, April 1989

Playing
the Game

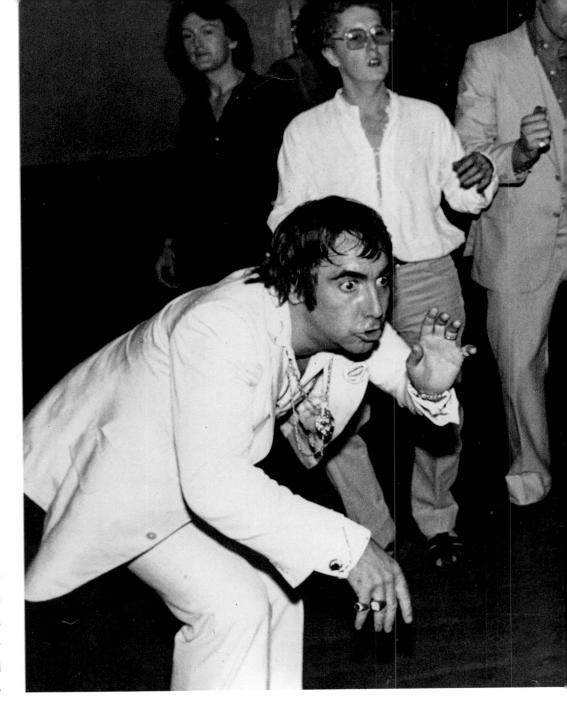

Keith Moon – getting on down to the end. The Embassy Club, 1978

No Jewish mother would choose a career as a paparazzo photographer for her boy. For a start, it's not good for the health. It combines the dangers of the quick knockout in a street fight with the more insidious risks to the constitution of long hours hanging about outside, interspersed with quick bursts of action when your quarry comes into sight.

Then there's the social kudos of the job. A guy who jumps out and photographs people when they're least expecting it doesn't seem to win the same respect from the public as, say, a bank manager or an accountant, which is what my mother would really have liked me to be. Of course, it's that same public who gawp and titter over the photographs at breakfast the next morning that pay my salary. And I shouldn't imagine that a bank manager gets much of a fascinated audience when he starts talking about his work.

It's certainly not a steady, substantial way of earning a living, and luck plays a large part together – of course – with skill, planning and determination. Events outside my control can influence the value of a picture. One morning a shot of Keith Moon at a party doesn't raise much interest among the news-papers' picture editors. The day after that he dies, and suddenly I'm holding the last pictures ever taken and I've got the world's press hammering on my door. That's the way it goes.

I can spend five nights on someone's doorstep, waiting for the big shot, and on the sixth night I'll get it and it'll all be worthwhile. Or maybe I won't, and I'll ask myself for the millionth time what a nice boy like me is doing, sitting in the dark outside a stranger's house with my camera tucked under my coat to keep it from getting wet. The answer is, of course, that I love it. It's like a very exciting boys' game. To win you've got to know who's hot and who's not, find out where they are and when and get to the right place at the right time for the best shot, ahead of the competition. The game's got glamour and excitement – and I'm good at it. It also brings its own rewards. I'm on first-name terms with stars other people only dream about, and some of them are my friends. I get invited to the top parties, drink wine and eat caviar with Joan Collins, exchange pleasantries with the Princess of Wales. It's a good life. It may not be a healthy, respectable or financially stable way of earning a living, but it sure as hell is fun . . .

Joan Collins – making a young

fan's day. Waldorf Hotel, 1987

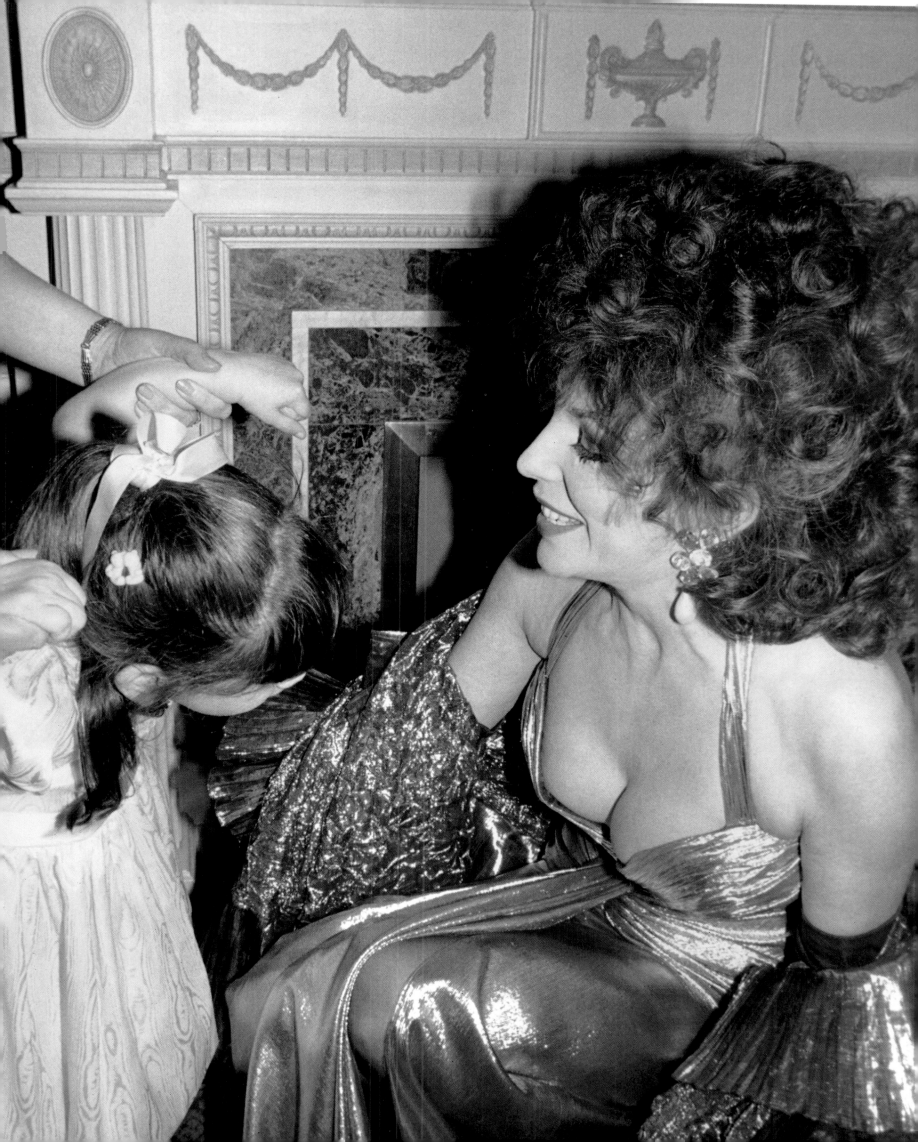

People often ask me how I became a paparazzo photographer, and I think the answer is it's in the blood. You certainly don't take a course in the subject, you simply have to have the combination of characteristics the job requires.

Many of these probably developed in my childhood. My family lived in Hackney, north London, and the idea of working hard for long hours was strongly engrained in my upbringing. There was no question of a cushy nine to five, Monday to Friday job. My father had a hosiery stall, and he worked seven days a week. During the week, he was at Berwick Street market in the West End, on Saturdays he set up stall at Epsom and on Sundays he could be found at Petticoat Lane in the East End. By the age of nine I had a Saturday job delivering groceries. From my dad I learnt that life was sometimes hard, sometimes tough, but you kept at it.

At school, I was one of only two Jewish boys there. The other was Marc Bolan, or Mark Feld as he was known then. We were picked on mercilessly, and it seemed to have the same effect on both of us. We were determined to succeed. I think being in a minority of two also taught us that we didn't need to go with the crowd, we could dare to be different, and that's a very important lesson to learn.

And I think I was different. Well, how many 11-year-old boys do you know who would cut out fashion pictures from *Vogue* and *Queen* and plaster them all over their bedroom wall? I was already in love with glamour and style, and when I left school at 15, I set my sights on a job that I thought had both – dressing the window of the local menswear store in Stoke Newington . . .

I did get a job with the store the day after I left school, as a trainee assistant – but, fortunately, I was distracted from my heady ambition by what was happening in London. It was the sixties and, for young people everywhere, London was the centre of the world. You'd have to be very thick-skinned not to feel the excitement and buzz and I was desperate to be part of what was going on. The instinct for action that keeps me in the thick of things today was already beginning to manifest itself.

I suppose the most vital characteristic of a paparazzo photographer is to have *chutzpah*, bottle, bare-faced cheek, or whatever you like to call it. The ability to present yourself where you are not wanted, or even where you are actively discouraged with anything ranging from massive bodyguards to heavy weaponry, is not a gift given to many. Most people, particularly in Britain, would cringe at the thought of turning up to a party uninvited, and even if they've been asked to come, will go into paroxysms of embarrassment if they turn up half an hour too early, or feel they've overstayed their welcome by five minutes. Personally, I find that if you arrive with a smile on your face, look as though you're having fun, make out you know quite a few of the guests (which, invariably, nowadays I do) and, above all, behave pleasantly and politely then, far from chucking you out, many hosts are quite pleased and flattered you're there.

Anyway, turning up uninvited is a skill I was obviously born with, and modesty or embarrassment have, fortunately, never stood in my way. So when, at the age of 15, I first felt the uncontrollable urge to place myself at the centre of things, it wasn't just any old boutique in Carnaby Street I chose, but the hub of the sixties scene. I wanted to work for John Michael, the man who dressed the stars. I had spotted that all the celebrities in my glossy mags were dressed in clothes from his shop, and I thought they looked fantastic. I was so naïve I didn't stop to think that it might seem a bit cheeky; I just went to his offices in Bond Street and asked John Michael for a job. His response was encouraging – he told me to stay where I was for another year, to get some experience, and then he'd give me a job. Exactly a year later I presented myself to him again, and he was as good as his word.

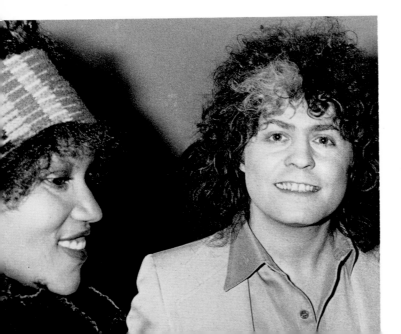

Marc Bolan – my old schoolmate,

with Gloria Jones, at a party for the

Ramones. Chelsea, 1976

I started work, at the age of 16, as an assistant at the trendiest shop in London, Sportique in Old Compton Street.

There were three of us there, the manager Bobby Harris, John Lawrence and me, and I still see them all today. I was there for three years and it was a wonderful time. Everyone who was anyone came in at some point or another. I remember Bob Dylan took over the small shop when he came in with The Band in tow. I sold him a striped orange matador shirt which appeared on the cover of his album, *Highway 61 Revisited*. The Beatles came in too, John Lennon would pop in for a browse, or Paul McCartney. I sold them those rollneck sweaters they wore under their suits. A friend of mine, Brian Aris, another East End boy who became a photographer, said at the time that he ought to stand outside the shop and take pics of everyone coming and going. Nobody did that sort of thing then, but I'd have certainly earned a lot more money with a camera outside the shop than with a tape-measure inside!

I was chatting to Mick Jagger about the shop a couple of years ago, and he said he still had the leather jacket I'd sold him. He didn't remember me, though – I suppose I had more hair then, and I was probably a little bit thinner as well.

I learnt a lot about life at Sportique – that the scent of success which hung about the stars' clothes was called marijuana; that the elegant young men with exquisite taste who haunted the shop were gay; what art galleries were . . .

When I was 19, I decided I'd better experience a bit more of life for myself, so I had a brief fling in Paris. When I returned to London, Sportique had closed. With three years' experience in the top people's shop behind me, it wasn't difficult to get a job with the boutique that succeeded to the title, The Squire, in the King's Road. It was owned by Jeffrey Kwintner, a man ahead of his time. Through him, I found out about Woody Allen, W.C. Fields and Eastern philosophy. He had an enormous influence on me. So, however, did the American scene, which was taking over London, American magazines, music, fashion. Again I felt this huge urge to be where the action was, so I borrowed some money from Jeffrey, sold my entire record collection – which I regret to this day – and bought a ticket to New York.

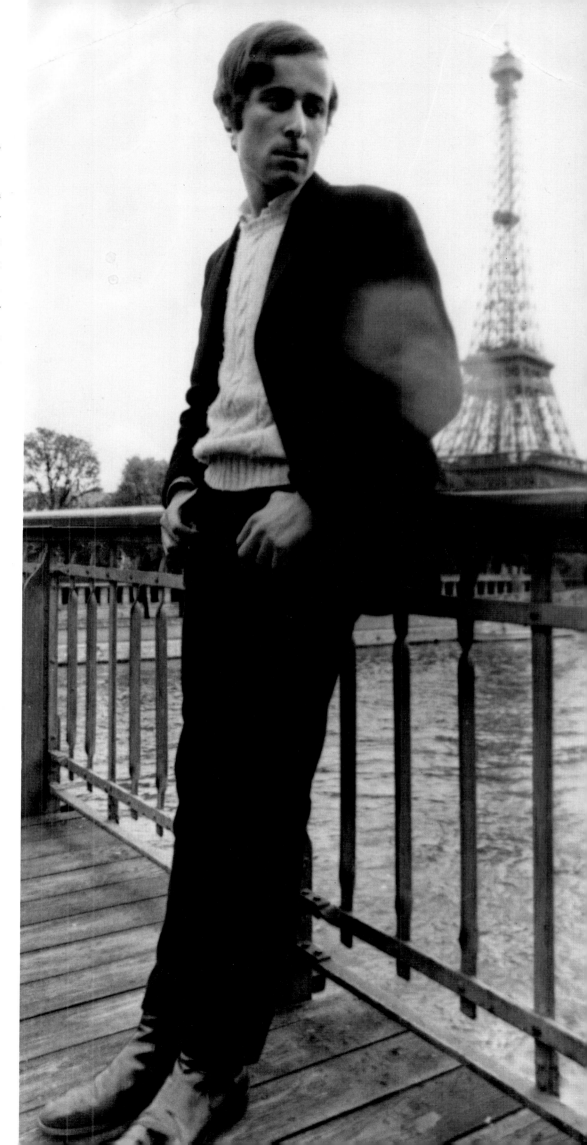

RY – younger, slimmer, hipper – but the

wrong side of the camera. Paris, 1964

(Picture by Brian Aris)

A good memory is another essential tool of the paparazzo photographer. I knew no one in New York, and I had very little money. Suddenly I remembered someone who used to be one of my customers at Sportique, Eddie Kramer. He'd told me he was going to work as a recording engineer for Jimi Hendrix in New York, and I knew from my own album sleeves that Hendrix's records were produced at a studio called the Electric Lady. I turned up at the studio, asked for Eddie Kramer and he offered me a job as a gopher, making coffee, filing, basically a dogsbody, but for $150 a week – and the chance to watch the world's biggest stars recording their latest music. I was fantastically lucky, but even then I stretched my luck a bit further and asked Eddie if he'd hold the job open while I went and saw a bit of America. He agreed, and after I'd done my Jack Kerouac number on a Greyhound bus, I turned up again, nine and a half months later . . .

I ended up staying two years at the Electric Lady, and I lived in a luxury duplex apartment they owned, which used to belong to Jimi Hendrix. A lot of his stuff was still there, photos and memorabilia. I had a wild time, I really fell on my feet. By this time I'd got a camera in my hand, solely to record the travelling adventures of yours truly; it didn't cross my mind to point the lens at Stevie Wonder, Stephen Stills, Jeff Beck, Richie Havens, Melanie or any of the other stars I watched at the Electric Lady.

Still, I was beginning to get interested in photography, and I'd wander around New York, taking shots of the city life with my Nikon F. One evening, I was asked to take Stevie Wonder down to Philadelphia to play in a Stones concert at the JFK stadium. I took my camera with me and photographed Stevie on- and off-stage. The shots weren't bad but, again, it didn't occur to me to sell them. That didn't happen until I was back in London, a year later. When I returned I went to see Jeffrey Kwintner, and he gave me a job as his personal assistant at the Village Bookshop in Regent Street, which specialised in books about Eastern philosophy. All these people used to drift about dreamily in a haze, and do T'ai-Chi in the back of the shop, next to the goldfish. I was very impressed by it at the time, and I read a lot of the books. I also met a lot of very intellectual young ladies with only one thing on their minds, and it wasn't books. However, photography was becoming my major hobby, and I used to go around London taking shots, and learning from my results.

I was living in a flat in Holland Park and a whole group of us used to meet in Julie's Wine Bar. One of the crowd was Craig Copeatas, *Rolling Stone* magazine's London correspondent. One evening he told me he had just come back from Rome, where he had interviewed Paul Getty Jnr. Getty was hot news; he'd just been released by his kidnappers, who had chopped off his ear and sent it to his family to encourage payment of the ransom money. Craig told me that Paul was coming to stay with him that weekend and, knowing that I could take photographs, he suggested I take a few of Getty walking around London.

It was easy. I spent the day with Craig, Getty and his girlfriend, Martine, and children. I took loads of pictures. When they'd gone, Craig suggested that I take the photos down to Fleet Street and try and sell them to a newspaper. I hadn't even thought of it. I took the bus down there, and walked into the first newspaper office I saw, which happened to be the *Evening Standard*. I went up to the picture desk, and said I'd got a few shots of Paul Getty Jnr walking around town. I've never seen people move so fast. Before I knew where I was, they had the film off me and the pictures in the paper. I walked out with a cheque for £30, and that was the beginning of my career.

Well, not quite the beginning. I spent another year working in the bookshop, but at the same time the *Evening Standard* would ring me up every so often and get me to do a job for them. They thought I was a real photographer. I would cover first nights for them, simple stuff, taking shots of stars arriving and leaving the theatre. Everyone expected photographers to be there, so it was no big deal. I was just one of the crowd, then.

Paul Getty Jnr – with girlfriend

Martine and their children. These were

the pictures that started my career.

London, 1975

9

It was November 1975 when the real break came. The *Standard* rang me up and told me Liz Taylor was throwing a 50th birthday party for Richard Burton at the Dorchester. They said there would be no chance of me getting in, but Liz and Richard might do a photo-call, so they asked me to cover it, in case. I went down there, and the place was crammed with press, photographers, TV; it was chaotic. Suddenly a press conference was called to say there would be no interviews, and no pictures, so could we all go away?

Now, no one knew me then, which was an advantage I don't have now. I was insignificant. I spotted one of the girls from the Dorchester's press office disappearing through a door, so I quickly slipped in after her. After a few corridors I lost her, but I found myself somewhere called the Gold Room. There were a dozen waiters sitting around, and one said, 'Are you with the band?', so I said yes, and he showed me the way to the ballroom where the party was being held. The room was empty except for the disc jockey, who was setting up in the corner. I went up to him and told him I was a photographer from the *Evening Standard*, and would he please, please not split on me? I think he thought it was quite funny, so he agreed to keep quiet and let me stand with him in the corner. After a while I started looking at the equipment and the records, and asked if I could have a go. He showed me how it all worked, and suggested that I spin some records so that it would look as though I were his assistant. Then he disappeared to the bar for three hours and left me to it! Suddenly I was the DJ at Liz Taylor's glamorous party. I quite enjoyed it, actually. People came up and asked me for requests, I played my favourite records, and I was just considering a change of career when the real DJ came back. And not before time. Just then, a huge birthday cake was wheeled in, and Richard and Liz went up hand in hand to blow out the candles. I sneaked round the circles of guests and then, using their shoulders as cover, I popped up and took a couple of shots. Liz looked up, but she didn't see me, and she must have thought it was one of the guests. Then she and Richard went into a passionate clinch, and I caught that on film too. At that point, I thought it was time to slip back to my spot by the DJ. After a while, Liz came onto the dance floor with one of her guests, so I took a couple more snaps. She came over to me, and without asking who I was or where I was from, she just said, 'I think you'd better leave . . . Now!' So I strolled out, escorted by two bodyguards.

I came down into the lobby, and I was immediately surrounded by photographers and press, desperate to know what was happening. 'Oh, they're having a great party up there,' I said, and I told them I'd got a few shots. Before I knew what was going on, this guy from the *Daily Mirror* grabbed me and hauled me into a taxi. I told him I worked for the *Evening Standard*, but he said, 'Never mind about that, the *Mirror* will see you right.' Well, they didn't. They ripped me off. They gave me £100 for a picture that was a world exclusive. It was worth at least £500 for the first use, and to this day I have a bad taste in my mouth about it.

I had to face the *Evening Standard* the next morning, and they weren't exactly pleased that a shot had already been used. Still, they said they would make so much money from the worldwide syndication of the pics that they gave me an advance of £500. It was then that it dawned on me what that scoop really meant. I realised that this game could be a really good business, and I decided it was for me. I had taken those pictures on the Monday night, on the Thursday I married my first wife, Riitta, on the Friday we moved into a new flat, using the £500 as a deposit. On the same day, I gave up my job in the bookshop and became a freelance, paparazzo photographer. In the course of one week in November 1975, my life changed for good.

Liz Taylor and Richard Burton –
a birthday kiss. My first paparazzo pics
taken at Burton's 50th birthday party.
The Dorchester, 1975

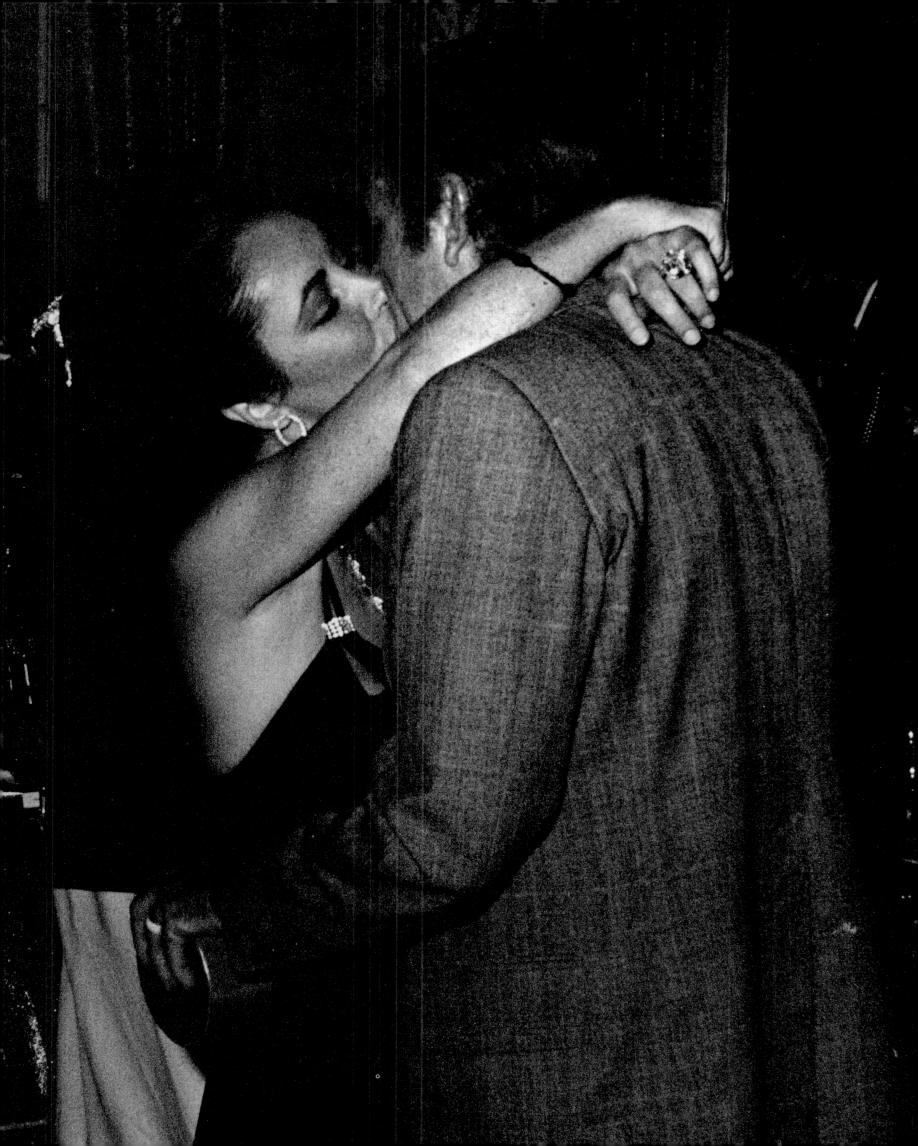

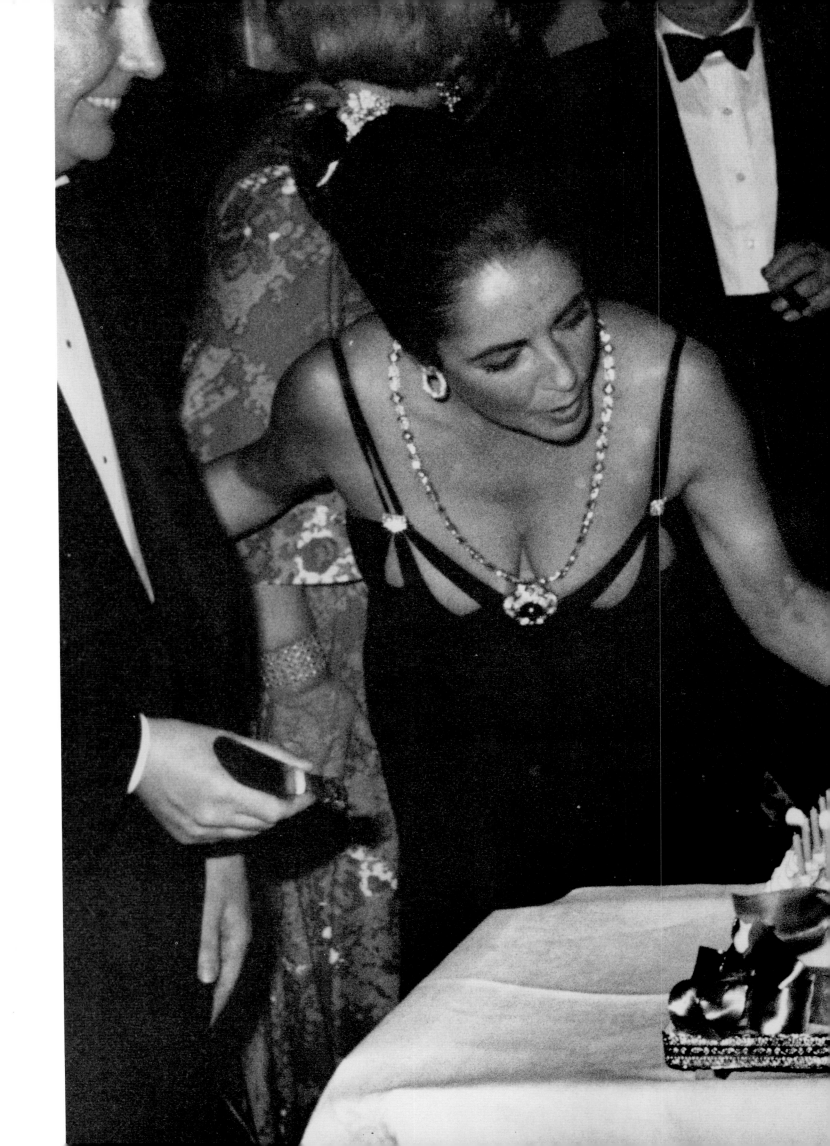

The shot that scooped Fleet Street

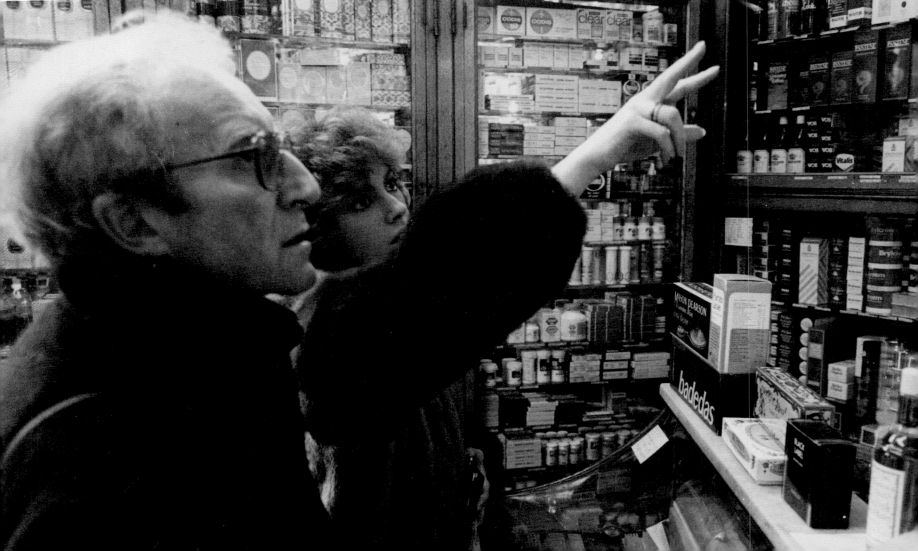

There were no rules in those days, because the game as we know it today was barely played. At that time the photographers were employed by the newspapers. The papers would tell them to get a shot of a star arriving at the airport, or leaving a cinema première, and once they'd got the picture, that would be it, they'd go home to bed.

I was different. I was a one-man business and I had to make it pay. At that time, public relations companies would tell me where the stars were staying, because it didn't enter their heads that someone would hang around a hotel all day in order to jump out in front of the star and start snapping. Nobody knew me then, so I could turn up at all sorts of places and I wouldn't set any alarm bells ringing. I would do my research carefully, read loads of newspapers and magazines, so I always knew when someone was in town and where they were staying. I would get to know the sort of places they were likely to go when they wanted to enjoy themselves, and I'd hang around restaurants and nightclubs until I'd got the shots I wanted.

At first, I think it was rather a shock for the stars. Wherever they went, there I was popping up from behind parked cars, or over someone's shoulder to take a shot of them. One day, I heard that Robert Redford was having lunch at the Connaught Hotel. When I went down there, sure enough there were limos parked outside the front door. It was just a matter of waiting until Redford came out. As soon as he came through the doors I started snapping. He was outraged, and instead of slipping quickly into a car he came straight for me and clipped me round the ear! Still, I got the shots . . .

I was very disciplined in those days; I had to be. I had to keep producing the goods all the time, so that I could build up a name for myself. I would get to bed by about 3am, after I'd delivered the roll of film to the newspaper. I'd be up again by 8am, and I would go into the newspaper, process the film if it hadn't been done and discuss the shots with the picture editor. He would then decide what he wanted to use, and I'd wander off into town. It's surprising whom you can see if you stroll around the West End at the right time – between noon and 3pm, I've always been able to

spot famous people, I think it's the way they carry themselves. Often my camera's up to my eye before I've consciously registered who it is. Once I came across Peter Sellers and his wife, Lynne Frederick, doing some shopping. The rule is to take a couple of shots first, then quickly take the camera away from your face and smile, say hello, be friendly. Then, hopefully, they relax and you can take some more snaps. But always get those first shots fast.

In the afternoon, I used to go back to the newspaper, to see if anything was happening in the early part of the evening. Often there would be a cocktail party, a book launch or an opening at an art gallery, and I would go along and check it out. If a fashionable artist is opening an exhibition, it's surprising how many celebrities will turn up.

Later on, I would go to all the 'happenings' in town, the premières, the club openings, to find out who was doing what where. Then I would start my long, lonely stake-outs outside the places where the stars went on to enjoy themselves, when they were off-duty, and off-guard.

There were days I didn't get anything, or nothing I could sell anyway, but I just had to accept that. It is a financially unpredictable profession, but even at the beginning I was earning £200 a week, which was more than I'd ever dreamed of – and certainly a lot more than I was paid in any of my other jobs!

Peter Sellers and Lynne Frederick –
shopping for the necessities of life in
Bond Street, London, 1980

Spike Milligan – warding off the
camera at his 70th birthday party.
Covent Garden, 1988

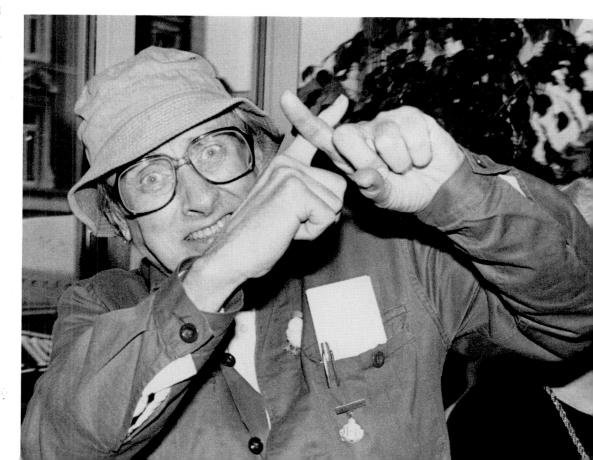

As I kept the pictures coming, my relationship with the newspapers changed. For the first two years in the job, I was freelance and I could sell to whoever I liked. However, I still worked mainly for the *Evening Standard*, because the picture editor there, Andrew Harvey, had helped me a lot early on. When Andrew moved to the *Daily Express* in 1977, he asked if I would like a contract with the paper. In return for the *Express* getting offered all my photos first, they pay me a monthly sum, known as a retainer. Once they've used the shots, or if they don't want them, then they go to one of the largest agencies in the world, Rex Features, who sell them for me in this country and abroad. That way, I only have to deal with one newspaper while Rex take care of the rest.

The reason the *Express* wanted me under contract was that I was getting the shots that other photographers weren't. At the beginning, I got a lot of them simply by walking through the door and starting to shoot. This got me into a lot of trouble, but I thought that was the only way it could be done. Then people began to recognise me – doormen, minders, restaurant owners – and I realised that if I kept on making trouble for them, my life was going to be made very difficult indeed. I had to say a lot of sorrys in those first few years, and I changed my approach.

The true paparazzo picture is not someone standing smiling into the camera; it's a shot with a bit of action, a bit of magic, a bit of spontaneity. A real paparazzo picture is worth a thousand words. It's not enough to photograph people walking in and out of theatres, I want to see them in action, being themselves, living their lives. That's why I like getting into parties, the restaurants and the clubs. I realised that in order to get *that* close to the stars, I'd have to use my brain and a lot of charm, and that's been my policy ever since.

Over the years, I've made a point of getting to know the restaurant owners and staff, of becoming a customer in those restaurants myself. Spending money in these places is one of the secrets. It makes it easier to infiltrate. I can walk in and leave the rest of the photographer pack outside. I'm building up contacts with two new restaurants right now. I know that sooner or later there'll be people going there that I'll want to photograph. I've been there a few times as a customer, got chatting to the staff. They know who I am; I haven't taken my camera in yet, but it's sitting in my car outside, just in case . . .

I've also got to know doormen, minders, chauffeurs. They all want a piece of the action, they want to be involved, they think it's glamorous. If they have any information, they ring me up. I look after them, and they look after me. When Madonna was in town, I got through barricades of minders and got the shot.

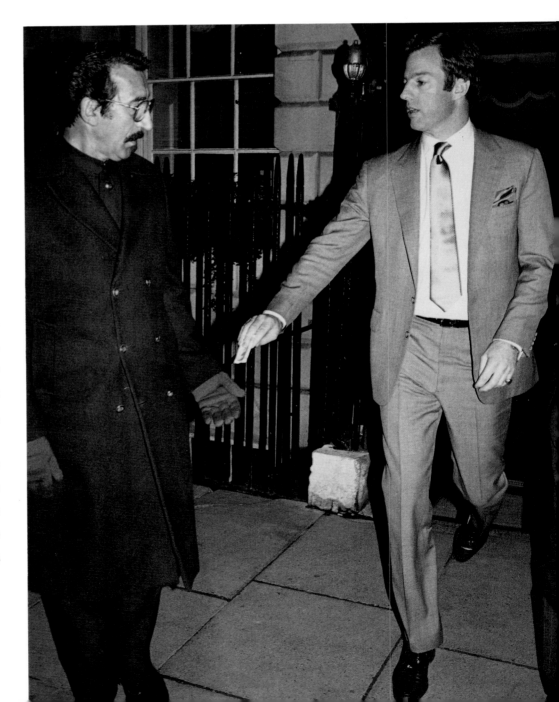

I don't like trouble. In the end it doesn't get you anywhere. There are only so many shots you can use of the photographer being beaten up – and only so many beatings-up a photographer can take! Of course, I'd rather get a shot of Barbra Streisand hitting me with her handbag all the way down the street, than her standing smiling at me, but it's her choice. I'm not there to provoke her, I'm there to catch the most exciting shot of her that she provides.

I find that charm works best, with a certain amount of persistence – like not taking no for an answer. Recently, I was covering an event in the Savoy Hotel, a fashion show, and there was a party straight afterwards. The PR people said that we could stay for the show, but they were very anxious that we should leave before the party started, although they wouldn't say why. I didn't want to cause a fuss – I have a good relationship with the management at the hotel – so I went away. At 11.30pm I returned, and discovered the reason for all the secrecy: Bros were there. I went up to the organiser and demanded a picture, and I got it. Bros were surrounded by bodyguards, but they stood in a group with some fans for a split second before breaking away. I took the shot and kept on snapping as they moved away. You must always keep them in frame as long as you can; you never know what you may get when they've dropped their camera face. That shot was used prominently in the *Express* the next day. It wasn't what I would call a paparazzo picture, but I got the shots and sold them, and that's what it's all about in the end.

Not that some so-called photographers seem to know any different. There are some, who shall be nameless, who think that getting someone smiling at the camera is a great paparazzo shot. In my view, you may as well call up the PR company and get them to send over a publicity pic. Most of the other paparazzi are my mates, we're all in the job together – but that doesn't mean you tell them when something's going on.

Some of the young kids only know one place to stake out, and that's a restaurant called Langan's Brasserie, in Mayfair. If they go anywhere else, it's because it has been advertised. They don't use their heads, make contacts – instead, they follow me! It makes me

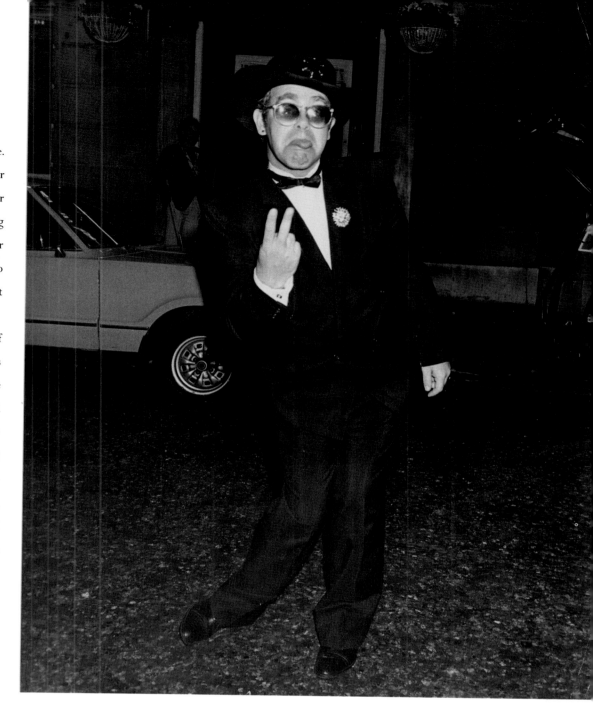

feel old, really, but because I was the first one in this line, they look at me differently. They've built me up much bigger than I am – it's crazy. Nowadays, they don't only look out for the stars, they look out for Richard Young! Doormen tell me that the pack has been in, asking if I've been around. If they see my motorbike or car parked anywhere, they all screech to a halt, because they figure something must be going on. It's ironic: I'm getting the same treatment I've been handing out to the stars for the last 15 years!

I'd rather not be known; I like to be the small guy, wandering around with a camera, snapping people. These boys have made me famous, and they've landed me with this ridiculous title – King of the Paparazzi . . .

Elton John – saying hello in his own quiet way outside Langan's, 1981

Mark Thatcher – out on the town.

Annabel's, 1987

Now You See Them, Now You Don't

People take this game much too seriously. Some of them want their photograph taken, others don't, and huge numbers of people are employed to make sure that one or the other happens according to plan, which, of course, it rarely does.

The public relations industry is huge and fairly unwieldy, but when I first started I made life even more difficult for myself by treating PRs badly. If they wouldn't give me a photopass for an event I wanted to go to, I would be very rude. It used to annoy me that some of them would get such a kick out of their power to refuse or admit people that they would forget the interests of the celebrities for whom they were working.

I remember, early on in my career, I gatecrashed a party given for Rod Stewart by his record company. I climbed through the kitchen window in the basement, and went upstairs. Of course, I was met by bodyguards, minders and the PR people, and they tried very hard to throw me out. I was outraged. 'Look,' I said, 'I'm from the *Evening Standard*. It's important that I should be here, to let the world know what's happening here tonight.' My argument didn't impress them a great deal, and they tried to throw me downstairs. I was very determined to stay, and there was a nasty scene, with a lot of shouting and swearing. Eventually, they decided I could stay for 20 minutes, and then I was turfed out.

That wouldn't happen now. I learnt the hard way that, as with most things, you get a lot further if you are nice to people. I realised I wasn't doing myself any good, and I started taking the PRs out to lunch and getting to know them. It paid off, and they began ringing me up when they were throwing a party for a celebrity, to ask me if I'd do the photos. Now a lot of them are personal friends, and some even come round to my house for dinner.

I have to say that they're not as vital to me as the chauffeurs, the doormen, the minders and the restaurant owners. They are the most important people to me in this business. I have a lot more respect for them than I have for many of the artists, and I don't like to see the way some of them get treated. I would hate to work for people who often don't even say please or thank you. I can sit at the bar of a restaurant, and some so-called big shot will come in and shout: 'Gin and tonic.' They've just become famous, they have no manners and no idea how to behave in public.

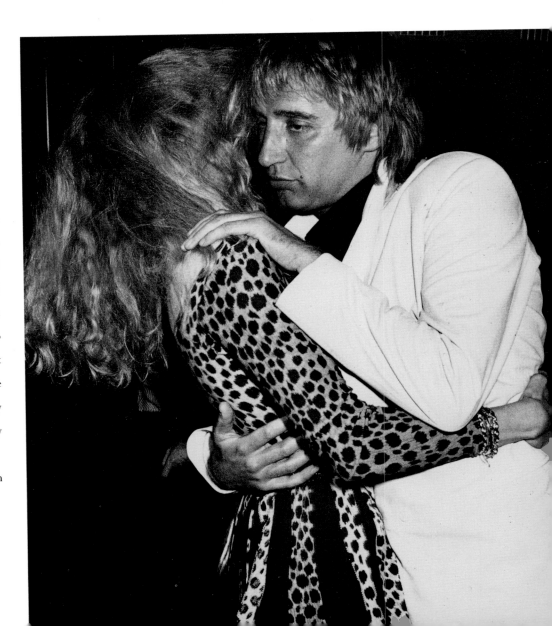

Rod Stewart and Alana — he's never let the camera cramp his style.
Embassy Club, 1982

Public Relations machinery is not always very good at getting the pictures they want in the papers. It's just not possible. They would like all the photographers to line up at a photo-call and take shots of grinning celebrities for 15 minutes, but this game isn't that easy to control. I personally never turn up to photo-calls. They are not the sort of pictures I want to take.

Recently, Duran Duran's PR people organised a photo-call for them, and over 150 journalists and photographers trooped down to the Docklands to take shots of the boys standing outside the new London Arena. The previous night, I – and a couple of other photographers – had taken lovely pictures of Simon Le Bon and his wife Yasmin. They were at Christie's for an auction of photographs. I was there because one of my shots was for sale. Simon looked serene and happy, Yasmin was newly pregnant and looking fabulous. The pictures told a story, and those were the shots that were in all the papers the next day, not the PR pics of the three boys standing around in the docklands.

I find I get the best results when I'm the one who decides whether or not to take pictures – although I'm sure many people wouldn't agree! I always get good shots of Simon Le Bon and the story behind that occurred years ago, when he first started going out with Yasmin. He took her to lunch at Langan's, and he obviously didn't want to frighten her off. He came up to me and said: 'I promise that if you don't take any shots today, I'll make it up to you some other time.' As there weren't any other photographers there, I knew I couldn't be scooped, so I walked away. And over the years, Simon has kept his word – he always gives me a good picture.

Although I get on with the PRs, nothing stops me from taking liberties, but if you do it with the right attitude and a bit of humour, things don't get nasty. I remember when Barbra Streisand was over here for a couple of months, making the film *Yentl*. I followed her all over the place, snapping her in restaurants, in shops, in nightclubs. Her PRs tried to stop me, her minders tried to stop me, even her driver tried to stop me, but I kept on snapping, and my pictures appeared in magazines and newspapers

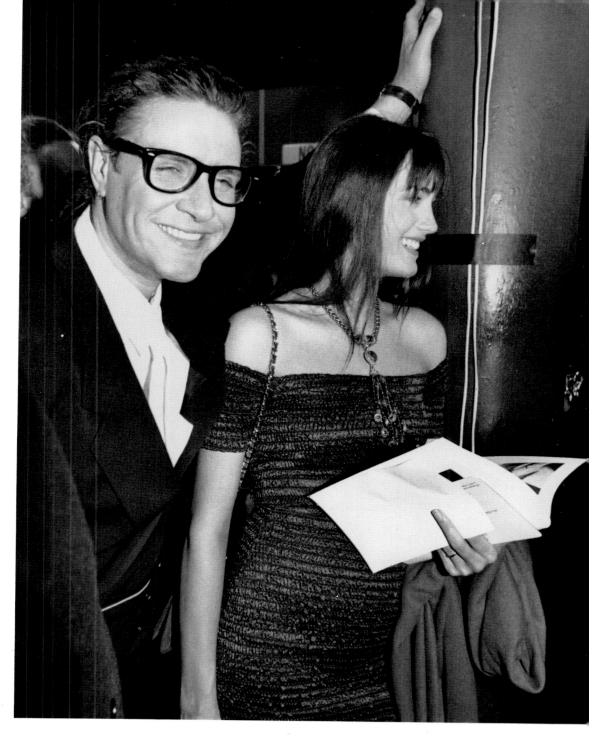

Simon and Yasmin Le Bon – two of the Beautiful People, at an auction of photographs at Christie's, 1989

everywhere. Some time later, her management in this country rang and told me that Barbra would like a copy of 'that sweet little picture' of her in a white hat coming out of a restaurant! I find that more often than not, whatever I've done and however naughty I've been, sooner or later the PR for that celebrity will ring up and ask for a copy of the picture. The whole thing is really just one big joke.

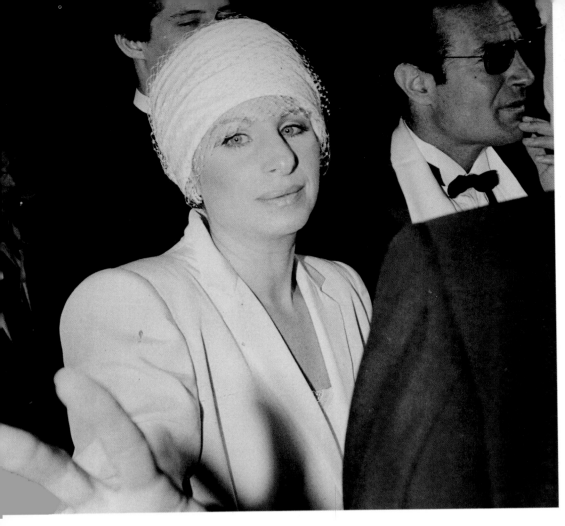

Barbra Streisand – the picture she did like. Langan's, 1982

Or it is until the celebrity decides to draw the line. And that is always a big mistake on their part. Not long ago, Streisand was here incognito on a private visit to London. I happened to be at a party at the St James Club. I was on the phone to the *Express*, giving them some details of the people there, when out of the corner of my eye I caught sight of this nose. There's only one woman in the world with a nose like that, and that woman is Streisand. I slammed down the phone and raced after her. She went out of the club and started walking down the road. I ran in front of her, snapping all the time, and she shouted: 'Get out of my way!' Then she started bashing me over the head with her handbag. She was furious that she'd been spotted.

The next time I saw Streisand, she was sneaking out of the Savoy Hotel. I was outside, waiting for Mick Jagger and Jerry Hall, when all of a sudden Barbra Streisand and her one-time boyfriend, Richard Baskin, ran out and jumped into a taxi. I found out they were going to Joe Allen's for dinner, so I walked over there and sat down a few tables away. When they were getting ready to leave, I nipped out in front of them and started taking pictures. They jumped into a cab, with me still snapping, and Baskin went berserk! Barbra had to restrain him . . .

Richard Baskin and Barbra Streisand – protecting her privacy and ruining her nails. Joe Allen's, 1984

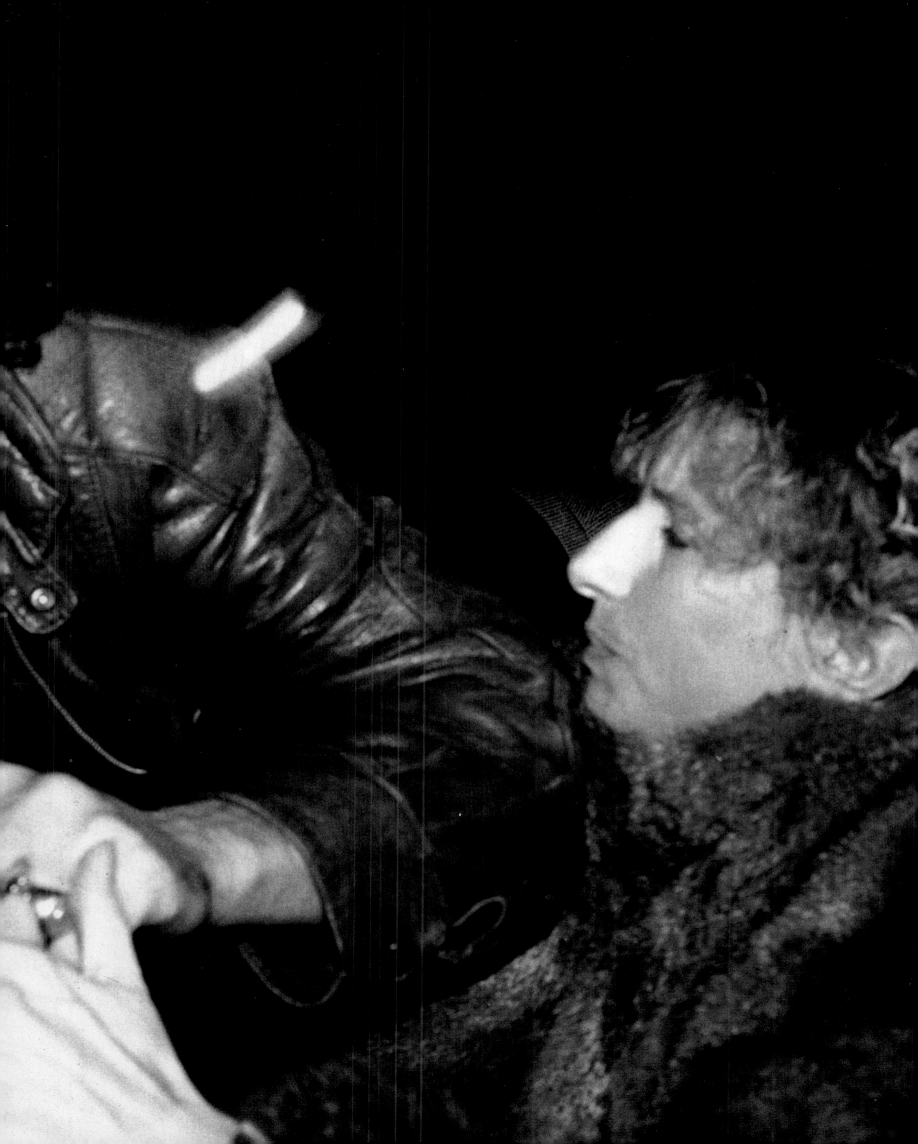

Dan Aykroyd – outraged on

the King's Road, 1987

When you're famous, you may be able to switch your publicity machine on and off, but you can't do the same to the paparazzi. Stars like to feel that they are in control, that no one can take their picture without permission. However, it doesn't work like that, and the harder they try to make the rules, the more determined I am to get their picture.

A while ago I was riding down the King's Road on my motorbike when I spotted Dan Aykroyd walking down the street. I turned round and drove back. I knew he was a bike freak so we got chatting, and then I asked very sweetly: 'Mr Aykroyd, would you mind if I took your photo of you next to my bike?' I pretended I was just a happy snapper, a fan. I only had my autofocus camera with me, so it could have been true. He was so rude. He just said: 'No, I don't have my picture taken' and walked off. I thought, 'Oh yes you do, mate' and I waited around. When he came out of a shop, I intercepted him and got a shot. He was furious, and raised a finger at me. I said: 'Thanks, Dan, that was a much better picture than I thought I'd get' and walked off, leaving him shouting and swearing. I ran into him again a week later outside the Hard Rock Café. He said; 'Oh, it's you again. You can take my picture tonight.' I didn't remind him that his permission wasn't necessary to get a shot. I took a few snaps anyway, but they were nothing to compare with my original picture.

At one time, Ryan O'Neal and Farrah Fawcett were in town. It was the beginning of their romance and they were desperate to avoid the camera. They would spend all their time sneaking in and out of back doors so, of course, they were the hottest shot in town. I knew they were staying at Claridge's, so one night I hung around outside. I knew they weren't there that evening, but I was waiting for that vital tip-off that would tell me where they had gone. Eventually the back doorman came over and told me that they'd gone to San Lorenzo in Knightsbridge. I followed them there, and walked into the restaurant. This is where having a long customer-relationship with a restaurant comes in useful. I went up to Mara, the proprietress, and asked if Ryan and Farrah were there. She pointed round the corner, I took a quick look and there they were! I then had to decide whether it was worth taking a shot and risk

causing a nasty scene and upsetting everyone, or whether I should wait. I decided to wait, so I went outside. As time went on, five or six other paps arrived, one by one. We hid behind the parked cars. Finally an American woman came out and screeched, 'It's okay darlings, there are no photographers here!' Ryan and Farrah emerged, and we all stood up and shouted: 'Oh yes, there are!' and started shooting.

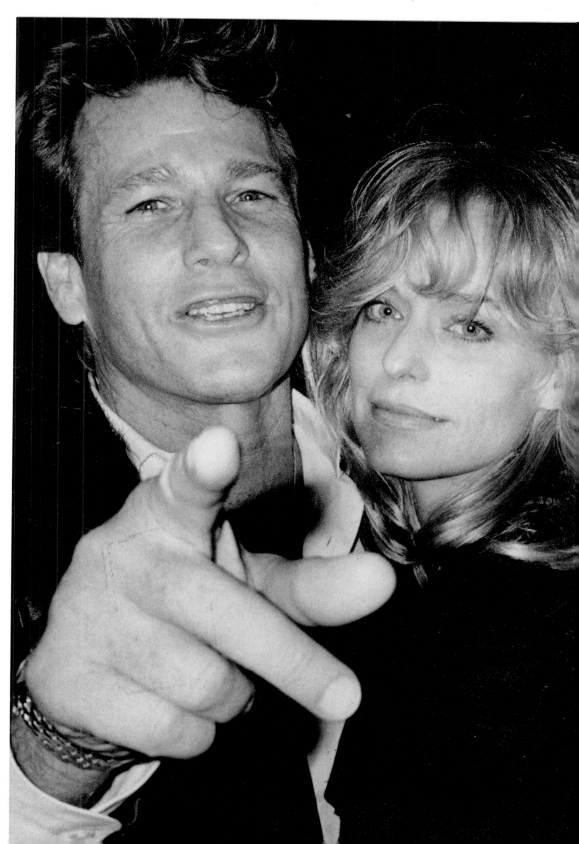

Ryan O'Neal and Farrah Fawcett –
surprised outside San Lorenzo, 1987

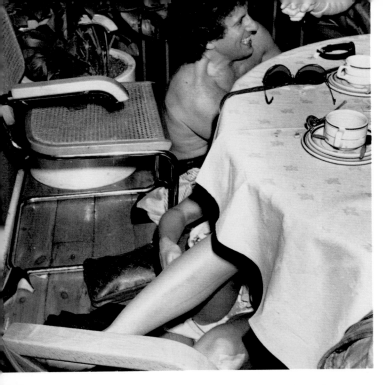

Pamela Stephenson — shy and retiring.

Legends, 1979

Not long ago, Ryan and Farrah were in London again, as Farrah was making a film here. I heard from a contact that they were going to Yuki's fashion show at the Dorchester. I found out where they were sitting, and positioned myself on the other side of the catwalk, directly opposite. They came in and sat down. Ryan looked up, saw me and said; 'Oh no.' He knew I'd got them cornered where they couldn't escape, so I imagine he thought he might as well make the best of it. He started kissing and hugging Farrah, and I got some fabulous shots. After the show I went up to them and said: 'It was worth waiting all this time to get a decent shot of you at last.' We sat down and had a glass of wine together. I met up with them again four or five times while they were here, and Ryan was always ready to pose for me.

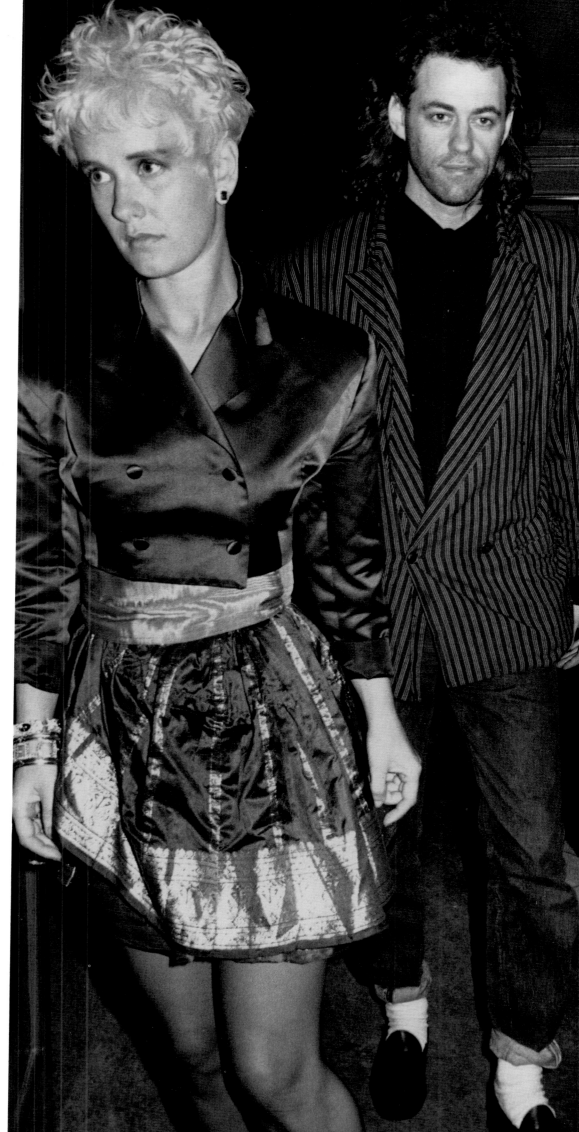

Being friends with the stars can, however, work against you. Sooner or later they are going to come up to you and say: 'Please don't take my picture today.' Then you *are* in a tricky situation. Either you sacrifice the relationship, and they feel betrayed, or you sacrifice the picture. If the shot isn't much good, I might not take one, but I'm in this business to get pictures. Taking a photograph isn't going to harm anyone and I can be singularly determined in pursuit of a good shot.

Most people in the business accept that attitude – eventually – but it has lost me a few friends. One was Pamela Stephenson. In the early days we got on very well; once she even took her clothes off under a restaurant table – and I got the shots! But when she started going out with Billy Connolly, she didn't want any pictures taken. One night I went to their house in Fulham with a couple of colleagues, and waited for them to get back. As Billy and Pam got out of the car and started walking up the steps to their front door, we started blasting away with our cameras. I think it frightened the life out of them, it was a dark street and they weren't expecting us. Pamela took it very seriously, and that was the end of my friendship with them.

Of course, I can understand why she was cross. I would be upset if I was photographed going home with a lady who wasn't my wife. But it's not the photographer who has created the situation. Whatever is going on is happening whether we are there or not; we are not responsible for it. Everyone is going to find out sooner or later. I just make sure they know that much sooner. That's the name of the game. If they really don't want to be snapped, then perhaps they should stay at home.

Paula Yates and Bob Geldof – giving it
all they've got: in their different ways.
Langan's, 1986

Pamela Stephenson and Billy Connolly
– older and calmer?
Live Aid, 1985

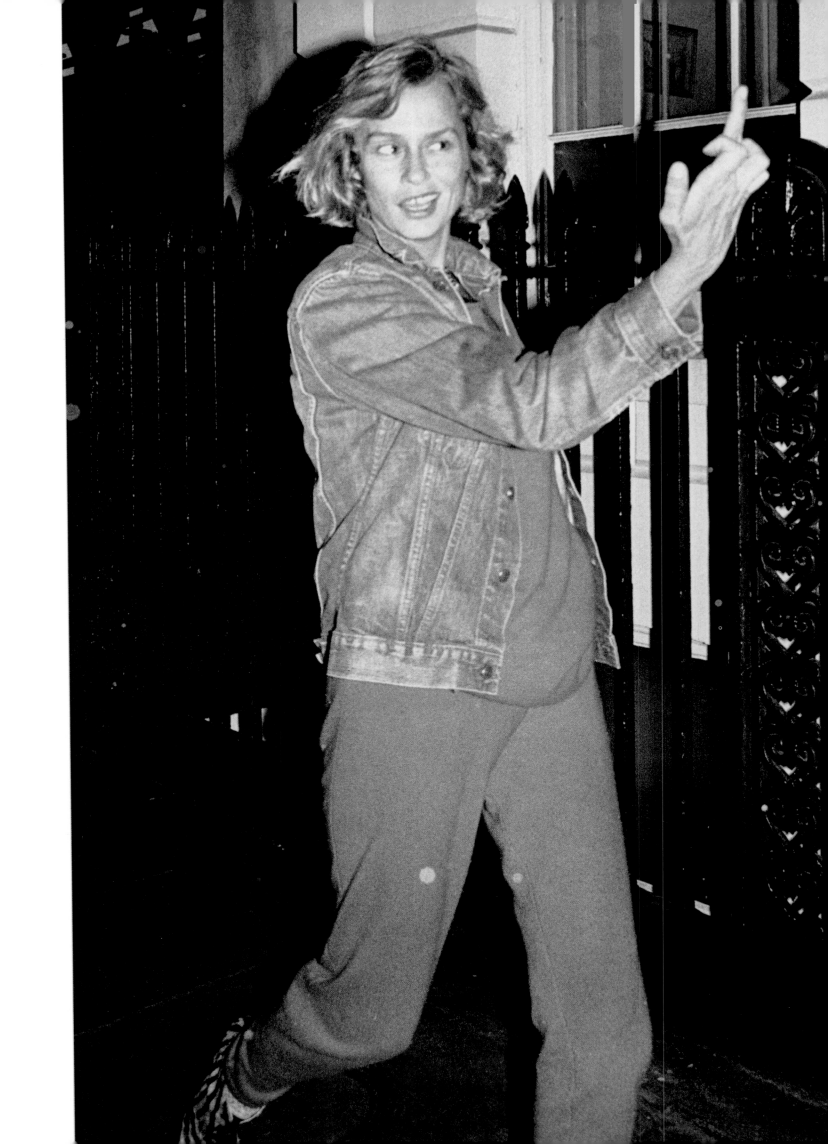

What I can't understand are people who go to the most public of public places, such as Langan's Brasserie, where there's always a posse of photographers hanging around, and then get upset when someone tries to take a snap. One night, it was pretty quiet, everyone must have been at home watching telly, and the only celebrity at Langan's was Lauren Hutton, the model. She'd been sitting there having dinner with this bloke for about five hours. I wasn't very interested in her, but I thought I'd take a shot as they came out. Instead, the man came up, pushed me and shouted at me to go away! I couldn't believe it. It wasn't as if there were hundreds of photographers jumping on her. Now, I don't like being pushed around for no reason, so I hit him. Then Lauren Hutton went mad! She started doing all this kung-fu, jujutsu stuff on me, and she roped in two passers-by to help. We were all on the pavement, so I crawled out from underneath, and they just walked off. Alan Davidson, a colleague of

mine, got wonderful pics of me being bundled over by this furious woman!

Peter Langan would have appreciated the scene. He wasn't there that night but he used to get into quite a few brawls himself. He was a fantastic, completely outrageous character. However, not all the stories about him are true. I'm sure he didn't get through 12 bottles of vintage Krug in a day, I think it was more like four or five . . .

He always liked to see how far he could push things. I remember one night a foursome came into the restaurant. They weren't stars, just some couples from the East End on a night out. Peter draped himself around them and said: 'If you two girls strip off, then I'll give you all a champagne supper on the house'. And they did! The two women took off their clothes and pranced about naked in the bar area. Peter was delighted and gave them all a slap-up dinner and a night to remember.

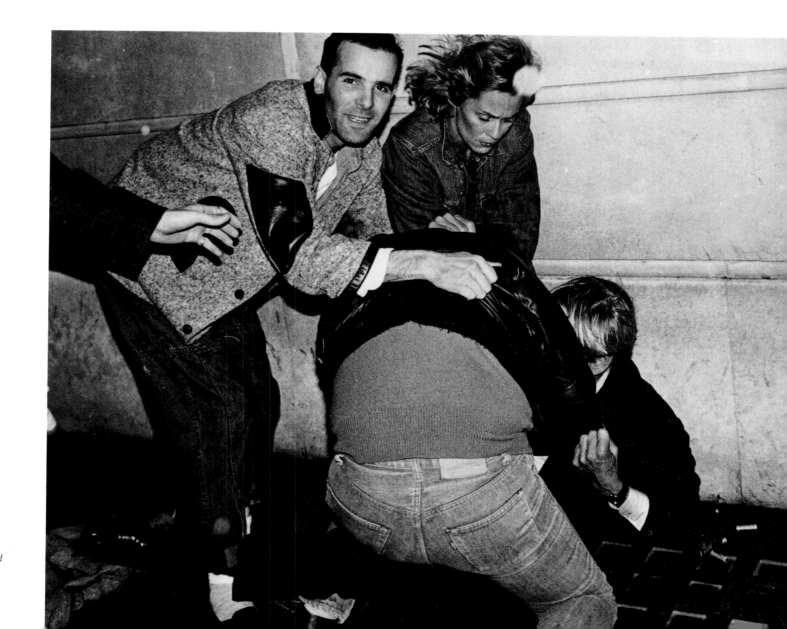

Lauren Hutton – giving me a hard

time. Outside Langan's, 1984

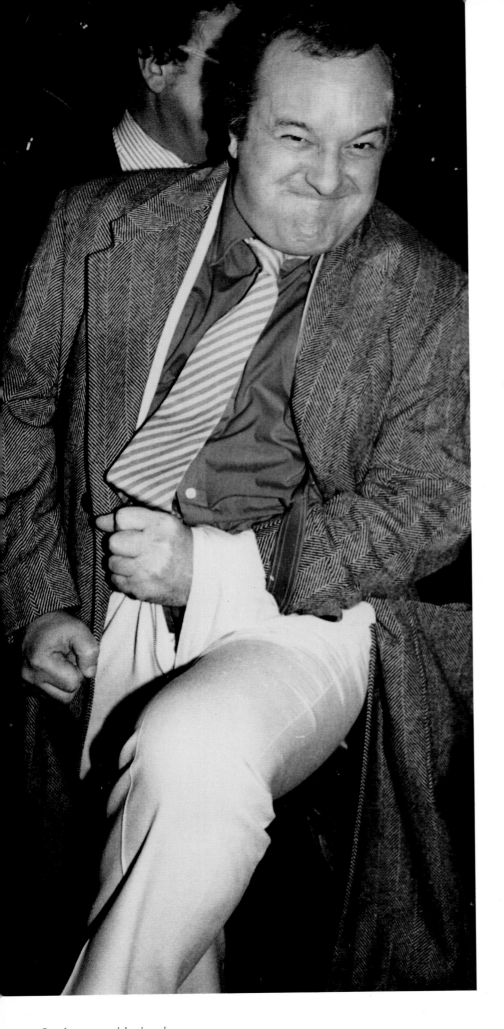

*Peter Langan — much loved, much
missed restaurateur. Langan's, 1982*

Sometimes, though, he just didn't know where to stop. One night, he simply slid off his chair and fell, comatose, onto the floor. A woman in the restaurant started screaming, she obviously thought he'd had a heart attack, or a stroke. I had to reassure her that he was only drunk.

Not everyone saw the funny side of his behaviour. On one occasion, one of his co-owners, Richard Shepherd, had had enough of his antics. He got a table and chair placed on the pavement outside, and banished Peter from the restaurant! As a photographer, I always had my camera ready when Peter was about, because you simply never knew what would happen next.

The same was true with Richard Burton. You had to be ready for anything. One minute he would be hidden in dark limos, surrounded by security people, and out of the camera's reach; the next I'd be sitting having breakfast with him in his hotel suite! On the night of Liz Taylor's 50th birthday party, the photographers were following Liz and Richard everywhere. The party, at a club in Mayfair, ended in the small hours, and I followed Liz and Richard back to her house in Cheyne Gardens. They went in, and most of the photographers left, leaving just me and a couple of other diehards.

A few hours later, we were well-rewarded for our wait. A dishevelled Richard Burton came out at about 6am and announced that he and Liz had just made passionate love on the floor! 'I've left her to sleep,' he said cheerfully. 'Why don't we go and have some breakfast?' I don't know how true *his* story was, but I think the shot I took of him tells a story of its own! Anyway, we all piled into his limo and swanned off to his suite at the Dorchester. We tucked into bacon and eggs and he tucked into some more vodka, and we chatted away about the party until about 7.30am. His PA came in at that point and said: 'Who are all these people, Richard?' Burton looked round and said: 'I don't know; get out, the lot of you!' So we left.

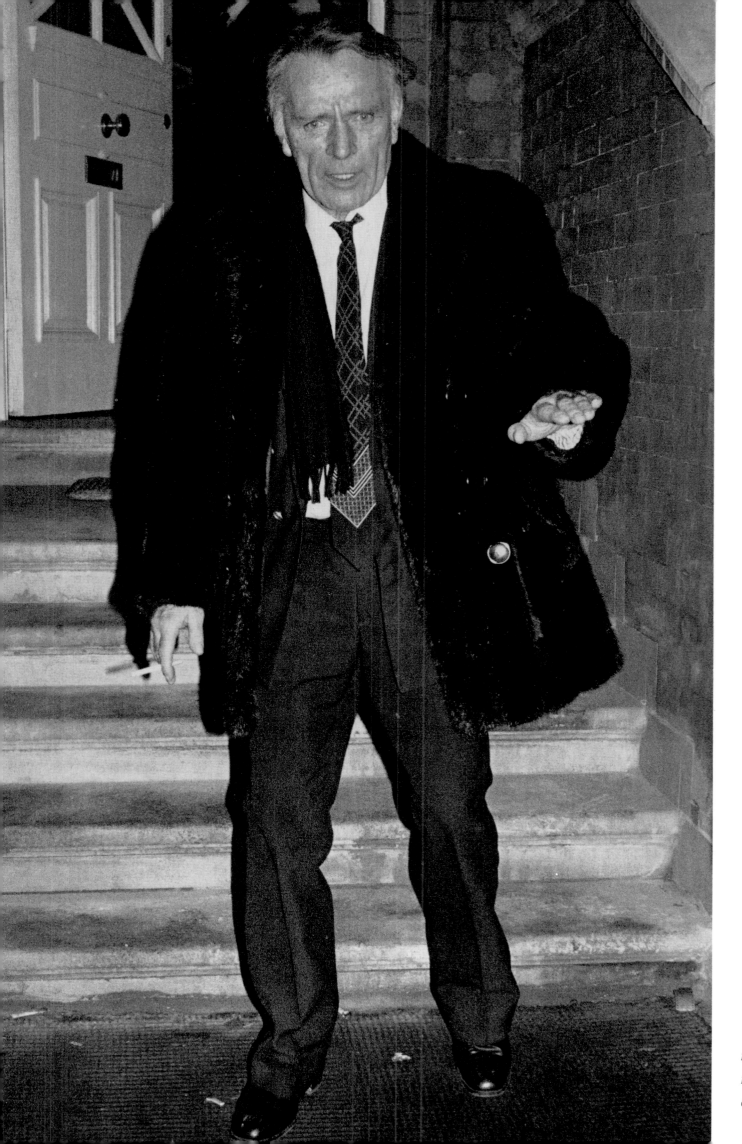

Richard Burton – offering a lift to the

Dorchester, with breakfast thrown in.

Chelsea, 1982

Obviously, photographers aren't always the innocent party when there's a scene. They can do their fair share of winding people up, although it's not generally a policy of mine. However, I miscalculated badly on one occasion some years ago. I was at the Cannes Film Festival where, obviously, everyone is desperate for some publicity for their film. It was the year *McVicar* came out, a movie starring Roger Daltrey as prisoner John McVicar. The publicity people had hit on a stunt of handing out handcuffs everywhere.

Now it happened that I spotted director Roman Polanski having lunch with film producer Richard Donner. Polanski is still wanted by Los Angeles police, on a charge of having sex with an under-age girl. I must admit I didn't think about it terribly hard, but I thought it would be fun to get a shot of Roman Polanski with a pair of handcuffs. So I wandered up and asked him to hold up the handcuffs, while I took a picture. Nothing prepared me for what happened next. Polanski threw the handcuffs back at me. They shot past my ear and landed in the distance, with a tinkle of glass. Then he got up and pushed the table over, jumped over it and got me by the throat. I staggered back, and we smashed into a table of champagne glasses, set up for a reception.

He then grabbed my camera and ripped the film out, which was unnecessary because I hadn't had time to take anything. One of my colleagues was now getting the same treatment from Richard Donner, and the whole hotel restaurant had turned out to watch us in our starring roles. Later, I was hauled up in front of the Festival committee and told to behave myself. I was only too happy to oblige. I prefer being on the sidelines, photographing the action, rather than providing it.

Roman Polanski – he's obviously charming company but, unfortunately, when we met in Cannes we didn't hit it off. Mr Chow, 1980

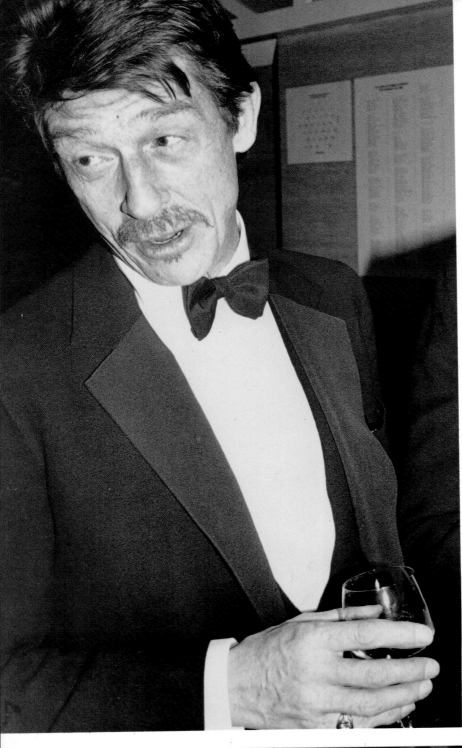

Recently, it was John Hurt who was centre-stage when he was the object of a photographer's wind-up. I think the blame for the eventual situation can be divided fairly equally. John was enjoying himself at the BAFTA awards dinner, when it was drawn to my attention that he was standing up at his table, swaying about and shouting, so I went over and took a few shots. He flung his arm around me, and shouted: 'I know why you're taking pictures of me!' Then he told me to go away, or words to that effect, so I took a few more shots and left him alone. Ten minutes later, I heard that John was up in the bar, with his arm round some girl. By now the other photographers were aware that there was a situation, and they were all up there, circling around. Suddenly it was too much for John, and he turned round and lashed out at the nearest photographer. All hell broke loose and the flash-guns went crazy. The shots were in all the newspapers the next day. John Hurt didn't do badly for an actor who didn't get an award. He certainly put BAFTA on the map, and he walked away with all the publicity!

John Hurt – actions speak louder than words, and certainly get more publicity. BAFTA awards dinner, Grosvenor House, 1989

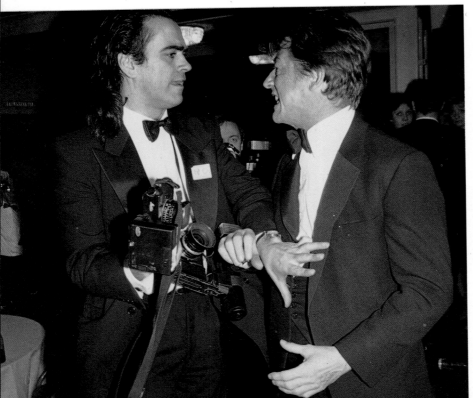

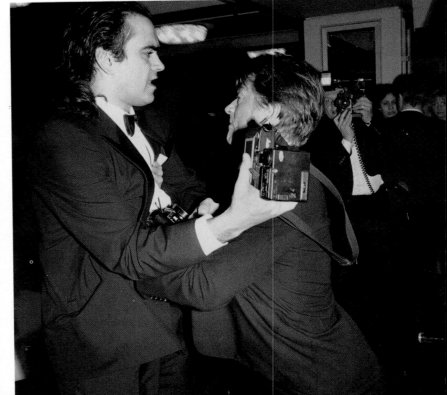

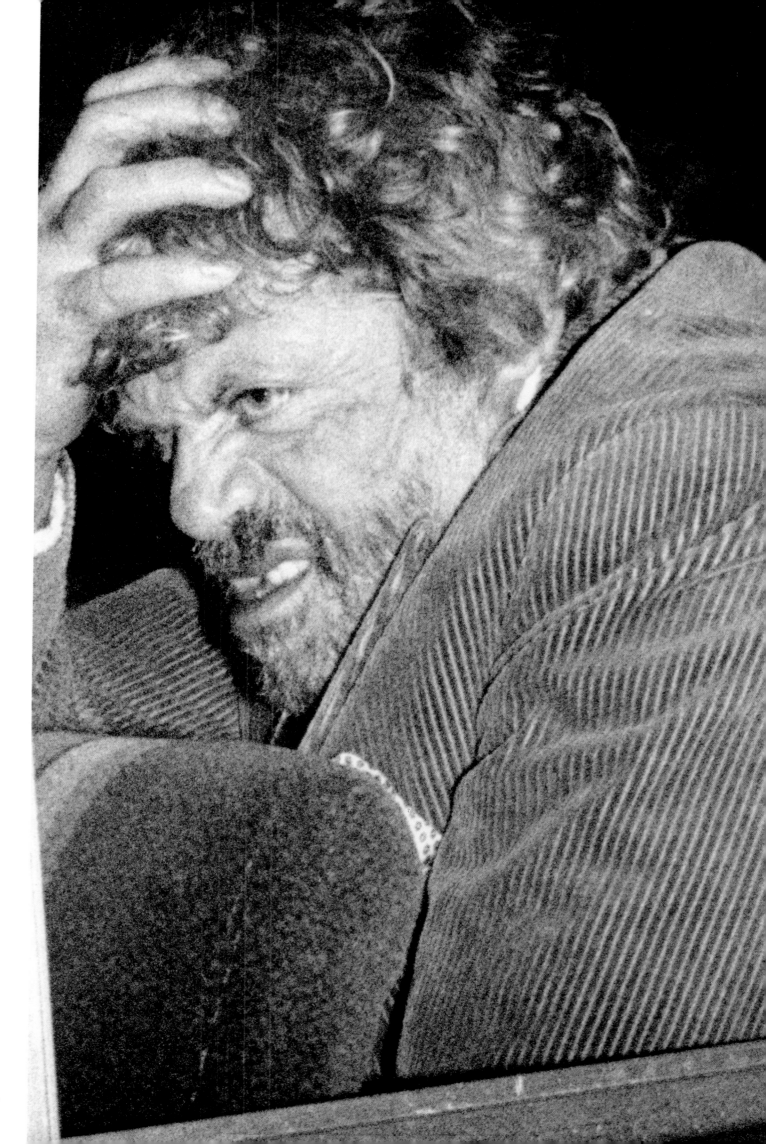

Oliver Reed – a hell-raiser with a

headache. Outside Stringfellows, 1986

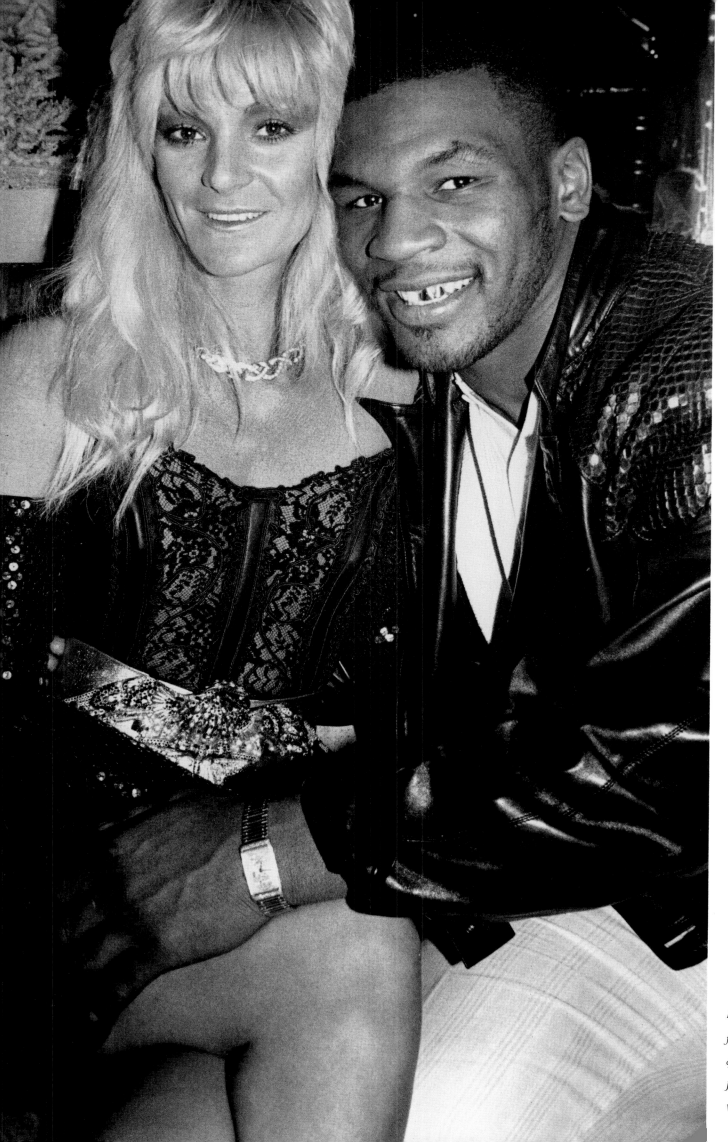

Frank Bruno and Mike Tyson —

fortunately, they're not ones to fight shy

of the camera ... Claridge's, 1987;

Jacqueline's nightclub,

Wardour Street, 1986

Prime Minister. Chelsea, 1979

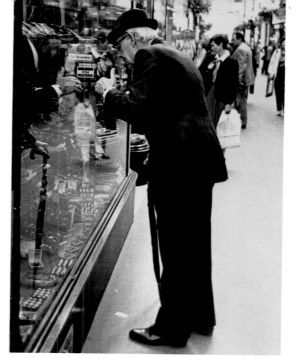
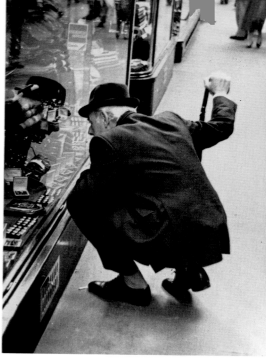

There are people whose careers depend on getting only good publicity – and they are called politicians. They will do anything for a shot that shows them in a good light – kiss babies, help old ladies across the road, cuddle their constituents – but they are not foolish enough to do anything outrageous in front of a camera.

Margaret Thatcher has perfected the art of personal publicity. She's completely aware of the camera and what it can do, and she makes sure it works *for* and not *against* her. I did a session with her in Downing Street once, and she knew exactly which poses and angles would make her look her best.

She's also very quick to take advantage of any situation that would make a good shot. The morning after she first became Prime Minister, in 1979, I went round to her home in Flood Street, Chelsea. There was a crowd of people outside the door, and when she came out, they started cheering. She smiled, and then caught sight of a baby in the crowd. She went over and gave him a big kiss – perhaps the only politician to kiss a baby *after* winning an election!

Politicians are professionals. I've never seen a politician run away from the camera, or get upset when there's a photographer around. If they are caught in a restaurant or in the street, they just slip the political mask on and smile. No one's going to pay me for a photograph of a grinning MP!

In general, politicians are too boring to make it worth my while to follow them around. If they turn up at parties though, I'll take a picture. That is how I happened to get a shot of Sports Minister Colin Moynihan with Pamella Bordes, a few weeks before the scandal broke. They were arriving at the Tory Blue Ball and, at that time, he was quite happy for a photograph to be taken of him with a beautiful woman. Some weeks later, she went into hiding, and I was left holding some of the few shots of her with a politician.

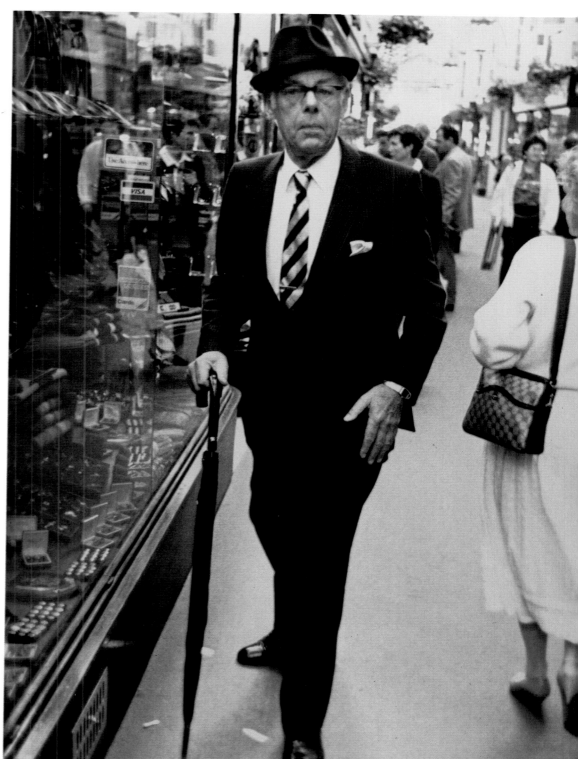

Denis Thatcher – shopping for

that perfect little something.

Burlington Arcade, 1985

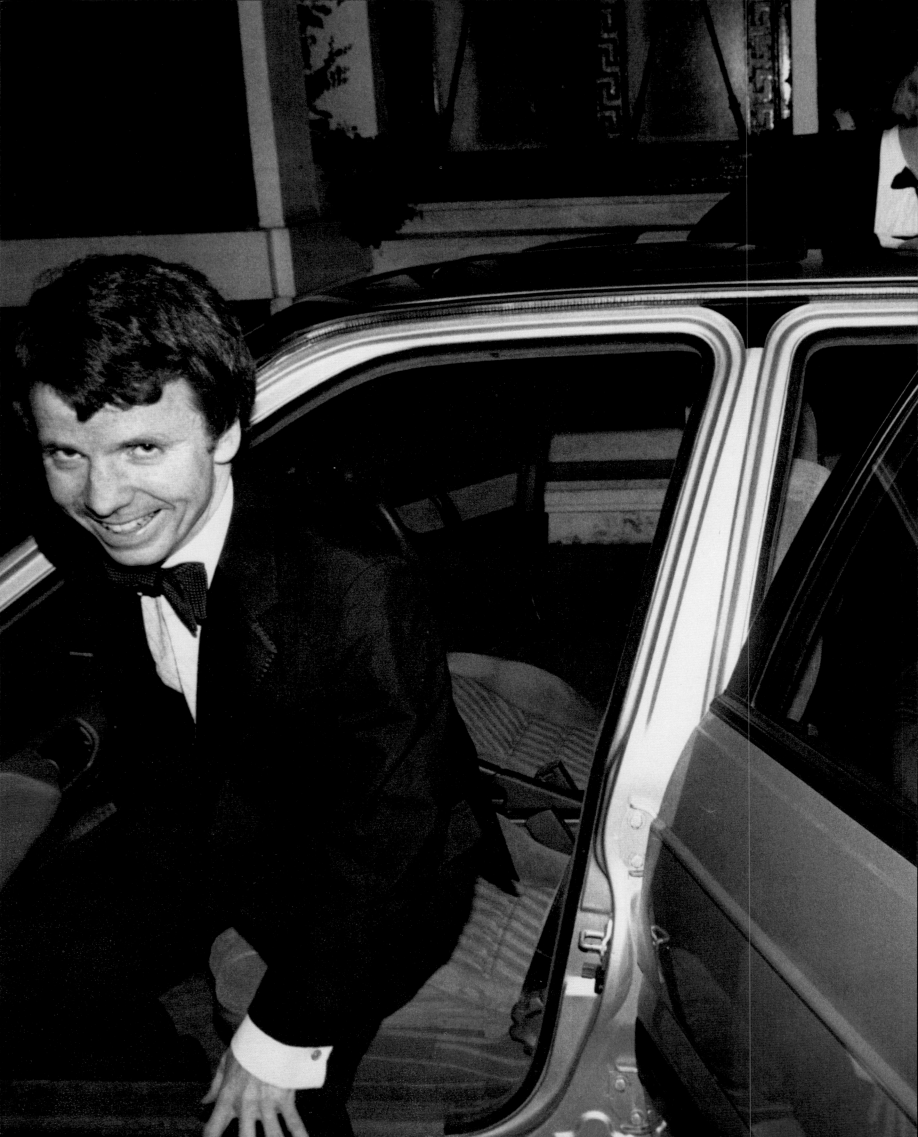

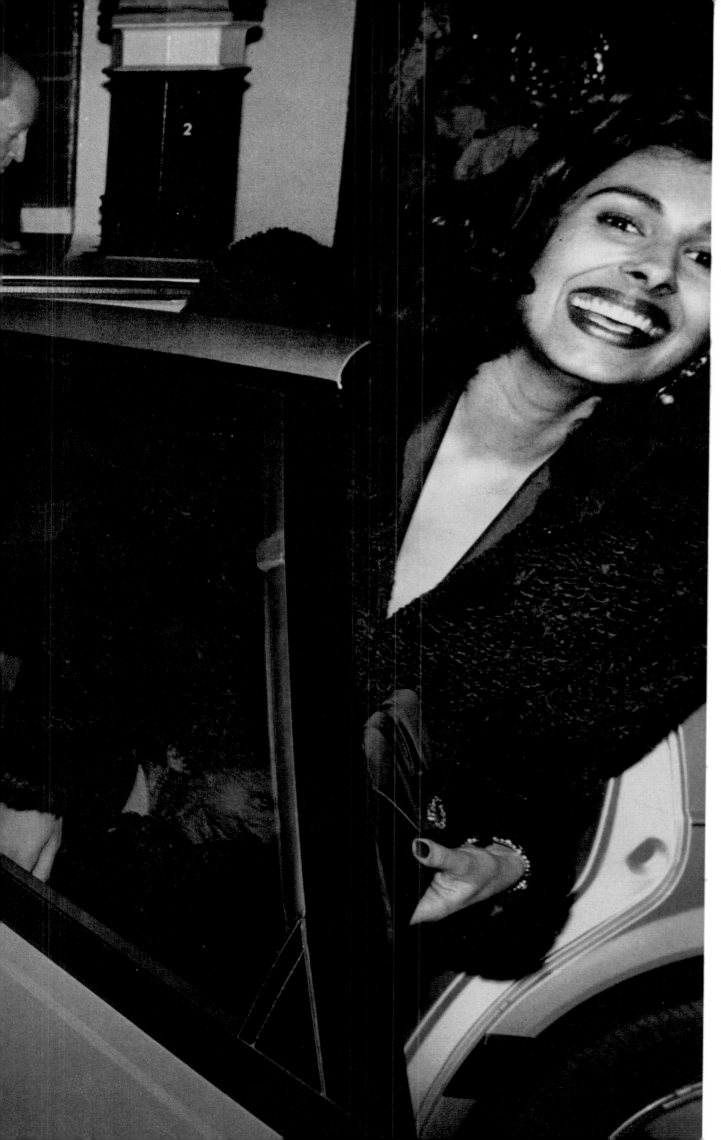

Colin Moynihan and Pamella Bordes —

leaving the Tory Blue Ball.

All was revealed a few weeks later.

Grosvenor House, 1989

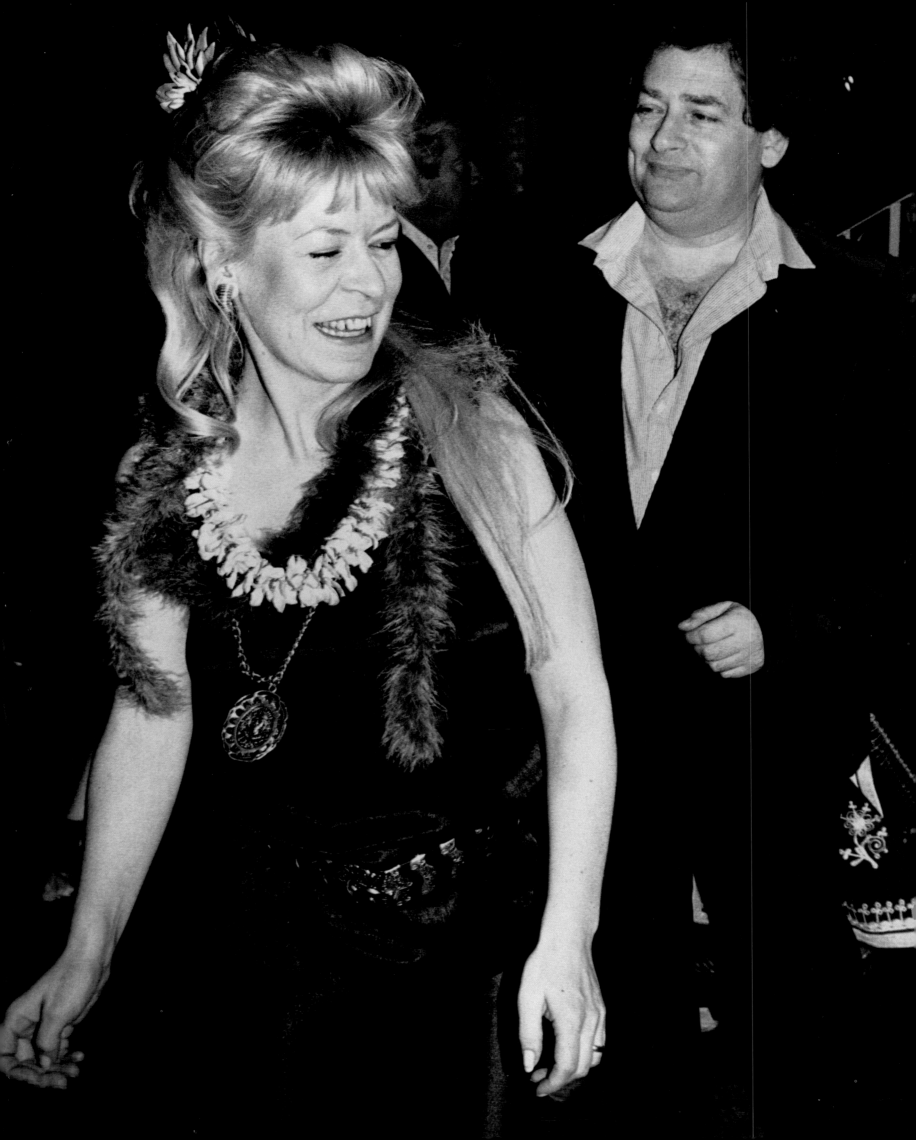

Nigel and Thérèse Lawson – at the

Sixties Ball. The Chancellor shows he

knows how to shift a few pounds.

Camden Palace, 1988

Last year, some other wonderful pictures of prominent political figures just fell into my lap. I was at a Sixties Ball at Camden Palace when Nigel Lawson walked in with his wife, Thérèse. She was wearing tight jeans tucked into boots, a silk shirt and beads, and he looked hilarious in an open shirt, bell-bottoms and a velvet jacket, with his hair all over the place. They took to the dance floor with wild abandon, providing me with brilliant material for my camera.

Unfortunately, you don't see politicians letting their hair down very often. I was at a book launch with some of my colleagues, and nothing was happening at all. David Steel was there, chatting away, so we asked Cleo Rocas, a very sexy lady, to go and pick him up. She did, literally, and they both fell over in a tangled heap! David Steel still managed to keep smiling, which was more than I did, because I was changing my film and missed the action!

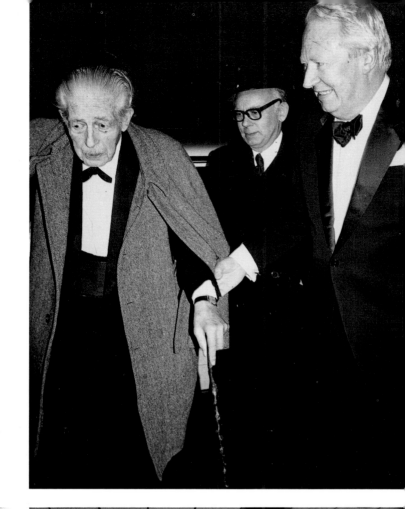

Ted Heath and Harold Macmillan –
outside Ted Heath's house, 1984

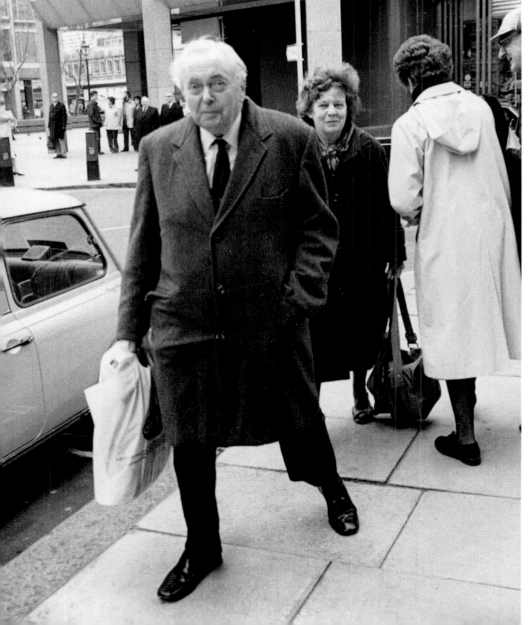

Harold and Mary Wilson – the ex-
Premier achieves a fine balance in the
domestic economy. Westminster, 1980

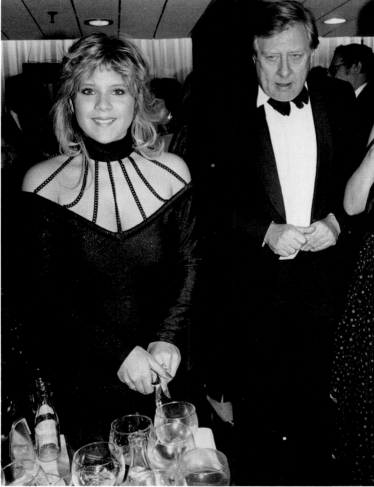

Samantha Fox and Roy Hattersley –
a politician upstaged, at the
Royal Lancaster Hotel, 1984

41

Politicians may want only flattering publicity, but people who yearn for fame are desperate for any publicity, and it's amazing what some of them will do to get it. Robert Redford only has to stand still for a second, and some bimbo will attach herself to him in the hope of getting into the papers. I'm always getting phone calls from girls who want me to take some shots of them to launch their 'modelling' career. At every party, you can be sure that 'rentacrowd' will be there, the group of minor celebrities who will stand and pose in front of you all evening.

They'll try anything to attract attention. One aspiring pop star recently turned up at a party with two Page Three girls on his arm. The photographers from the *Sun* and the *Mirror* snapped away, and this nobody walked off with all the publicity.

Take someone like Mandy Smith. She and Bill Wyman seem to be everywhere – openings, closings, you name it. He has his own chair at Tramp, and he must be there almost every night. I've got more pictures of him than anyone else!

I've got very little interest in mediocre people. Sometimes I'm forced to take shots simply because the other photographers are. Then the pic editors want to know where my picture is of some insignificant little thing who's been photographed by the *Sun* and *Mirror* boys because she's got hardly any clothes on. I'm not going to photograph all these ridiculous people, they're not stars. I'm there to photograph people who mean something.

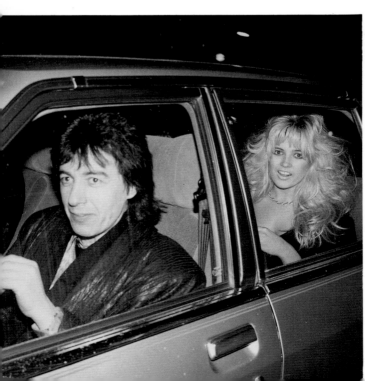

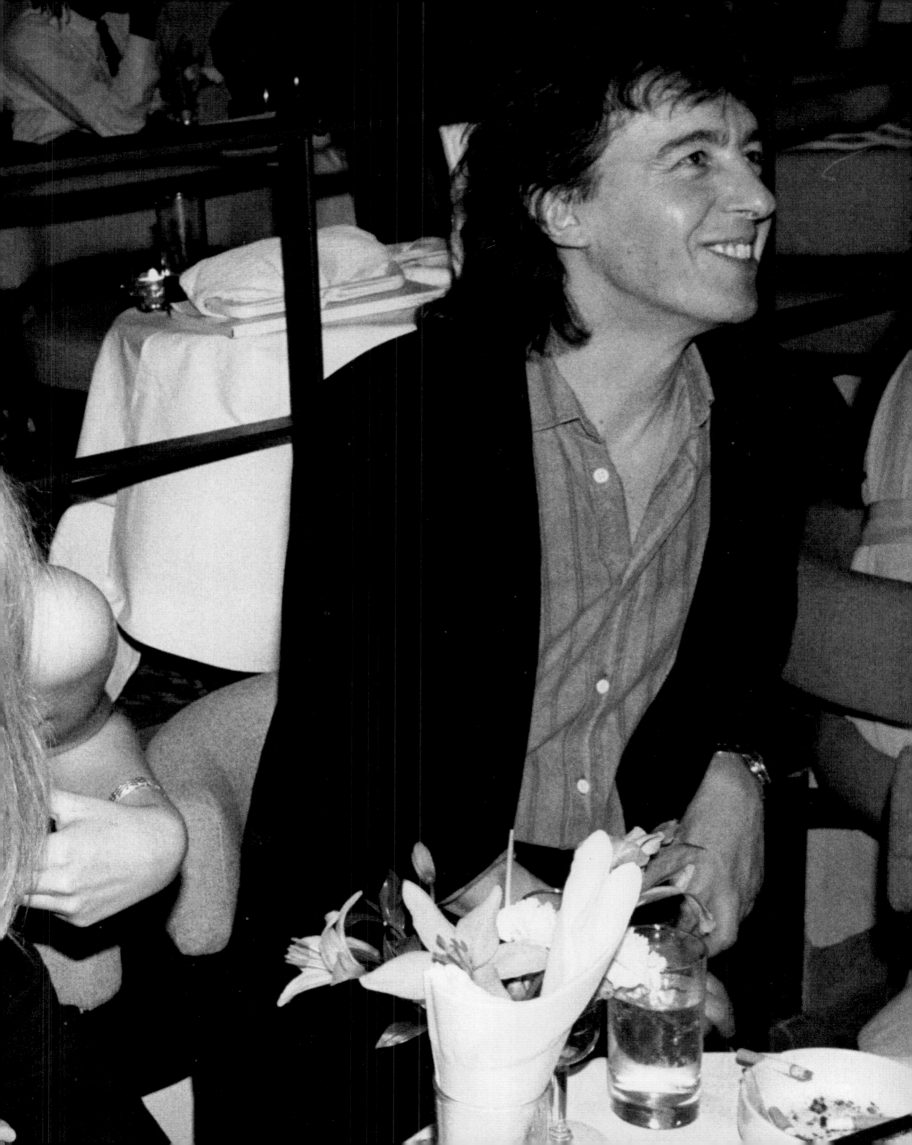

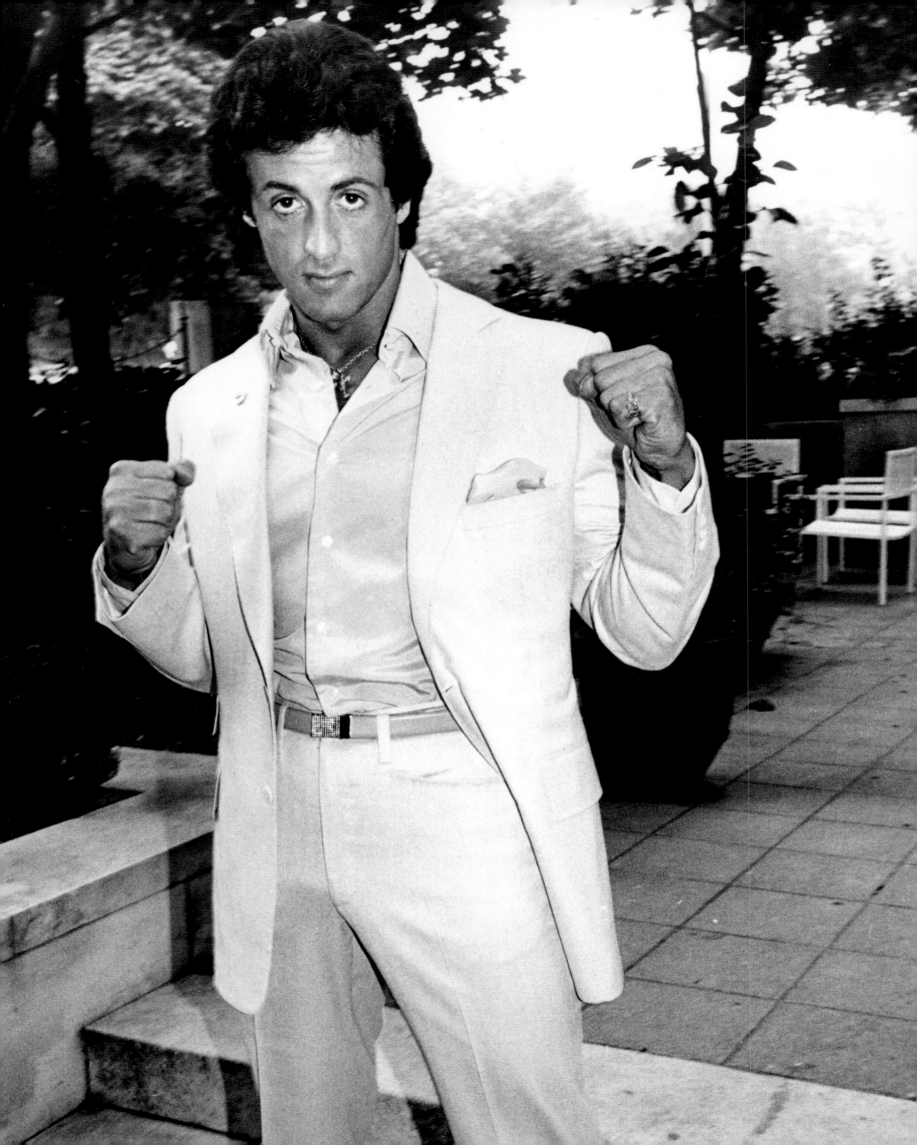

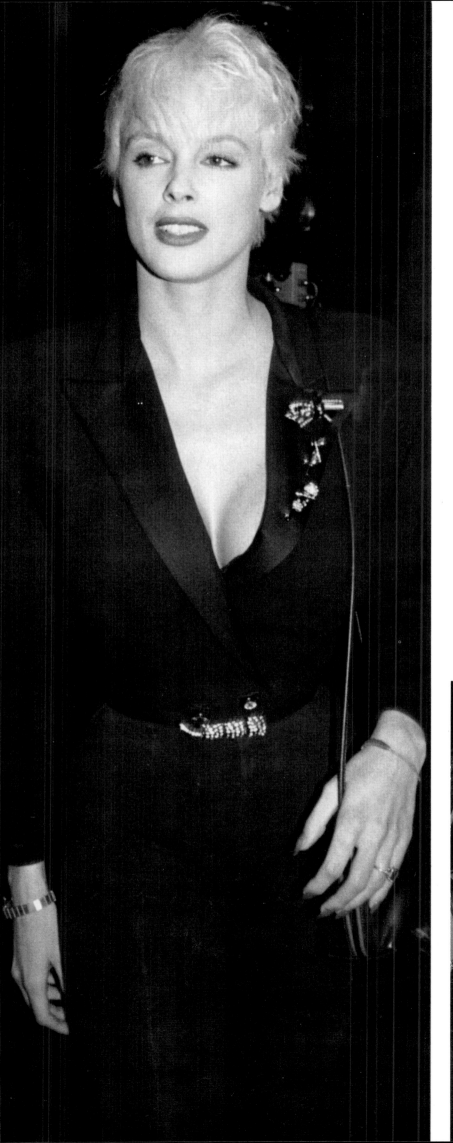

It's funny that some of the most difficult people are the ones who only mean something because of the person they married. Sylvester Stallone enjoys his fame, he likes being photographed and is always happy to pose for the camera. His ex-wife, Brigitte Nielson, by way of contrast, had no intention of giving us a photograph when she was last in London. She went off to a party in a limo, followed by a car full of minders. Unfortunately, the limo had to brake sharply, and the minders' car went straight into the back of it. I've got some wonderful pictures of Brigitte sitting sulkily in her broken-down car, waiting to be rescued!

Sylvester Stallone and Brigitte Nielson:
Sly will pose anywhere – Inn on the
Park, 1982 – his ex-wife draws the line
at broken-down cars – Camden, 1987

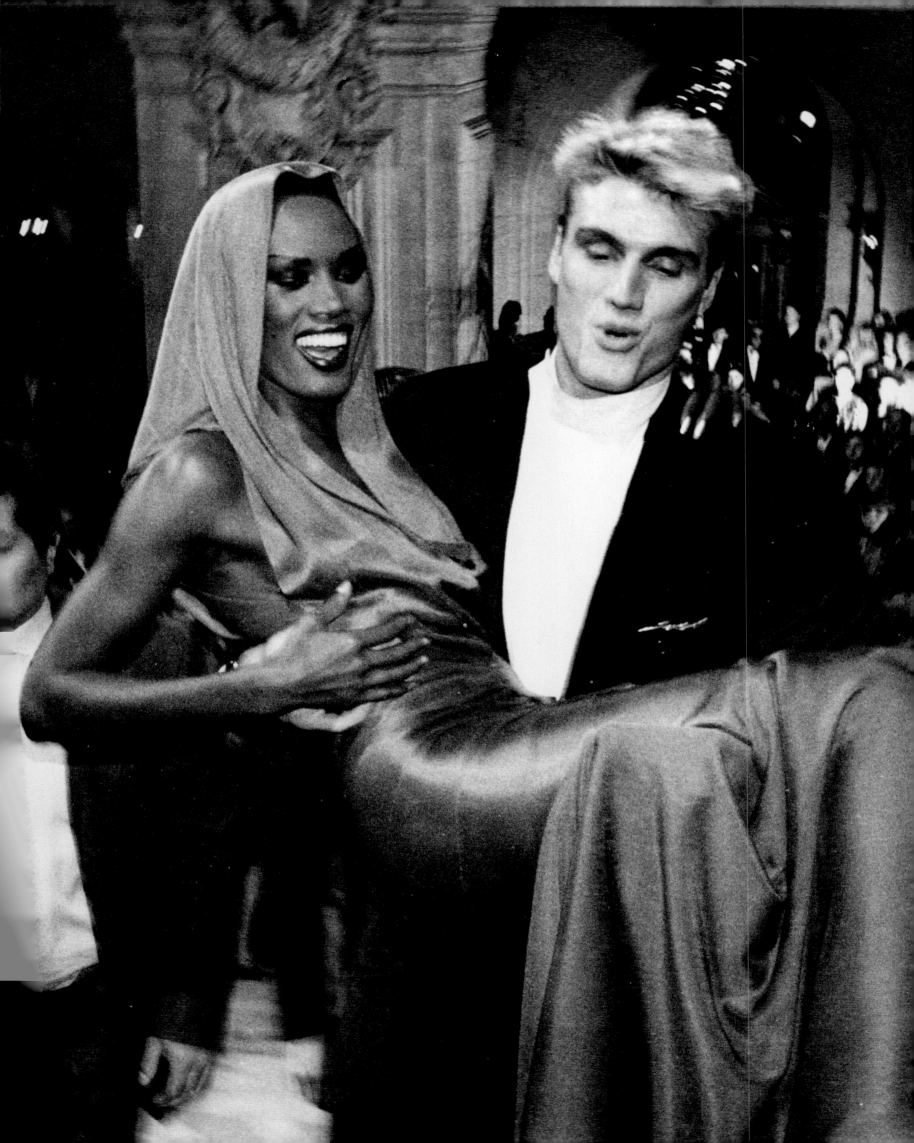

*Grace Jones and Dolph Lundgren –
making a spectacular entrance at the
Paris Fashion Oscars, 1986*

*Grace Jones – how to make an event out
of arriving at Heathrow Airport, 1987*

In this game, there are people
who want publicity, people who don't and people who only want it
when they say so. But there's a small group of stars who always
make fabulous shots because they're naturals. They've got beauty,
style and they attract attention by sheer charisma.

Women like Marie Helvin, Grace Jones, Bianca Jagger and Jerry
Hall have a glamour that the camera loves. They enjoy their fame,
they are usually the centre of attention, and that's where they feel
at home! Last year Grace Jones stopped the show when she arrived
at a Paris fashion awards ceremony. She made her entrance up the
stairs in the arms of Dolph Lundgren and everyone just stood and
gawped. That woman can make even an arrival shot at Heathrow
look stylish.

*Grace Jones – lashing out at
Maunkberry's nightclub, 1978*

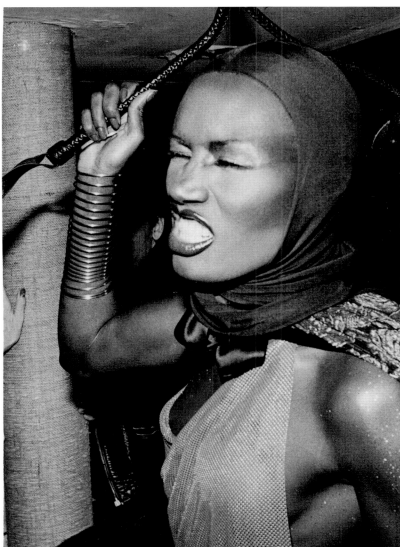

Marie Helvin – tired but still beautiful.

Outside Langan's after Michael Caine's

party, 1983

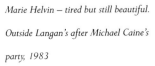

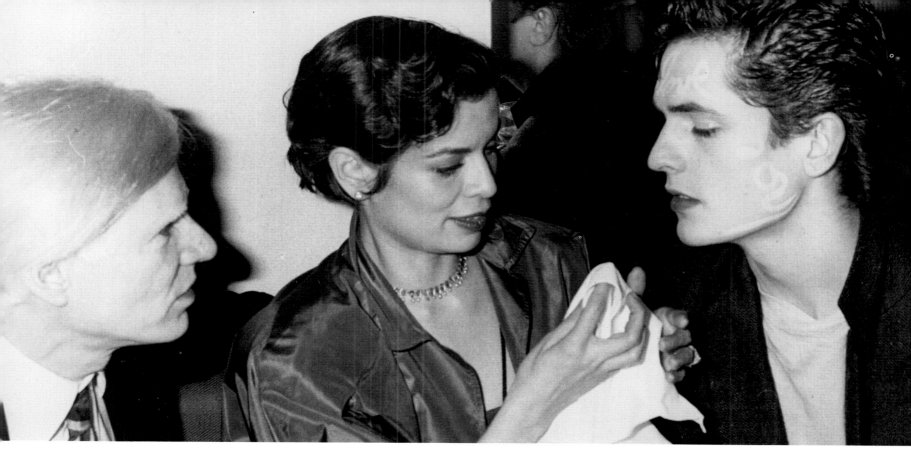

Andy Warhol, Bianca Jagger and
Rupert Everett – the writing was
on his face at Warhol's party in
the King's Road, 1980

Bianca Jagger is always where the action is, and she seems to create a good deal of it herself. Once, when at an Andy Warhol party in the King's Road, she found herself between Andy himself and the young actor, Rupert Everett. However, Bianca had eyes only for Rupert and, at one point, she got out her lipstick and wrote 'I love you' on his face. Pretty soon after, they left together . . . Jerry Hall really likes you to get a good shot. I wish that more famous people thought the same way, more for their own sakes than mine. As Jerry says, she's wanted to be famous all her life, why should she mind the camera? Why indeed?

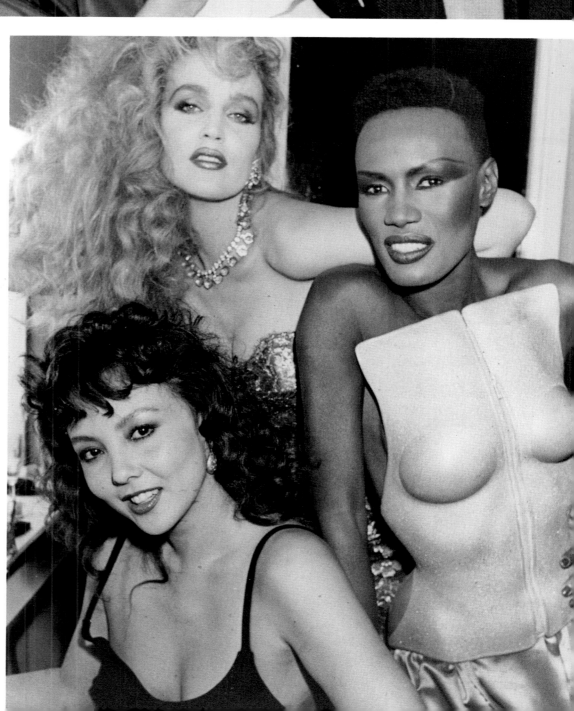

The professionals – Marie Helvin, Grace
Jones and Jerry Hall posed together for
a second in their dressing-room and this
was the result. Fashion Aid, 1985

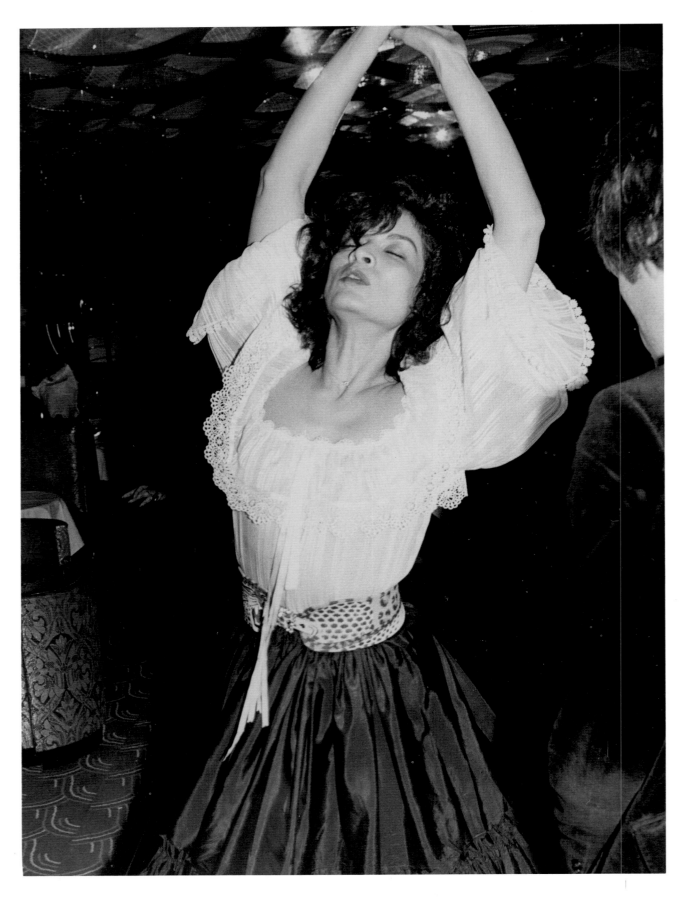

Bianca Jagger — wild thing.

At Regine's, 1981

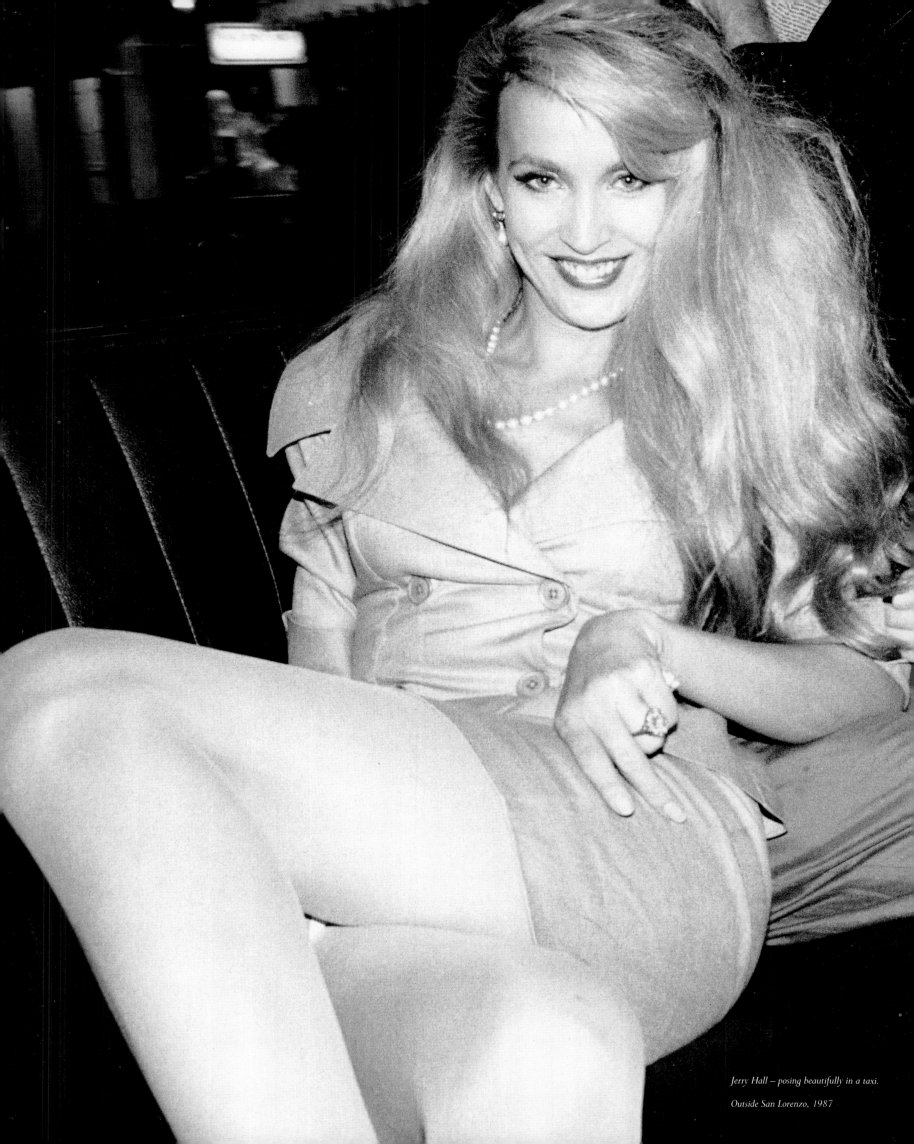

Jerry Hall – posing beautifully in a taxi.

Outside San Lorenzo, 1987

Dance to
Their Music

Rock stars are the most difficult people to photograph; the whole rock scene is a world apart, with its own particular priorities. This is partly because of the massive security that is thrown around artists as soon as they become bankable commodities. The record companies want to protect their investment, not so much from the photographers, as from the fans. There are a lot of strange people out there, wanting to get near the star. You only need one crazy kid with a gun or a knife. . .

That's why rock stars employ the beefiest minders in the world. I'm on pretty friendly terms with them – they know I'm not going to jump on their charges brandishing a knife, so they give me a certain amount of leeway.

That was how I got a shot of Madonna, when she arrived over here to film *Shanghai Surprise*. Outside the airport there were fans and security people all over the place. I managed to get through, together with more security men and a few other photographers, to the area where she would be arriving. Our only chance to shoot her would be when she walked towards the exit to get to her limo, but we had no idea which door she would be using. I looked around and suddenly I saw movements through the glass of a side door. I ran through it like a bolt of lightning and came face to face with Madonna! I took some pictures quickly and then backed away as the other photographers went after her like the clappers. I thought I'd get some shots of them battling it out! Her driver and bodyguards

were pushing the photographers away, and one guy got so frustrated he hadn't got a pic that he hit the driver. The bodyguards pushed him over, jumped into the car and sped off. The photographer's leg got caught in the front wheel, but they didn't stop the car. Fortunately, he wasn't seriously hurt, although he wasn't too pleased that I ended up with a scoop picture of Madonna – and a shot of him being run over that sold around the world!

The rock scene also has more rules than any other area of the paparazzo business. One of these is that photographers who are covering pop concerts are only allowed to shoot the first three numbers, and then they have to leave. The fact that the best shots are far more likely to come at the end of the concert, when everyone's letting themselves go and having a great time, is ignored. So is the rule, if I can get away with it.

I hadn't even got a photo-pass when I photographed Madonna in concert. I went in on a ticket like an ordinary fan, but with my monopod down my trouser leg and my camera under my jacket. I said to a row of girls behind me that I might have to stand up for 10 minutes or so, but then I'd get out of their way. The gig was so good that I was snapping for half an hour. They got extremely annoyed and started throwing Coke cans at me!

I was also forced to bend the rules at Michael Jackson's Victory! concert in Kansas City in 1984. The PRs had promised me a good position in the pit, the area in front of the stage where the photographers stand. When I arrived, I found that the American photographers were at the front, but the European photographers had been placed almost halfway down this huge arena. On the first night I tried to get some shots but, when I wired them back to the *Express* in London, the pic editor said they were appalling! So, on the second night I broke away from the other photographers and sneaked right down to the front. I pushed in amongst all the kids, with my camera hidden inside my jacket. When the concert started, they all stood on their seats, so I got up there too, boogied away and photographed the whole concert!

Prince – when stars get big, their minders get bigger. BPI Awards, Grosvenor House, 1985

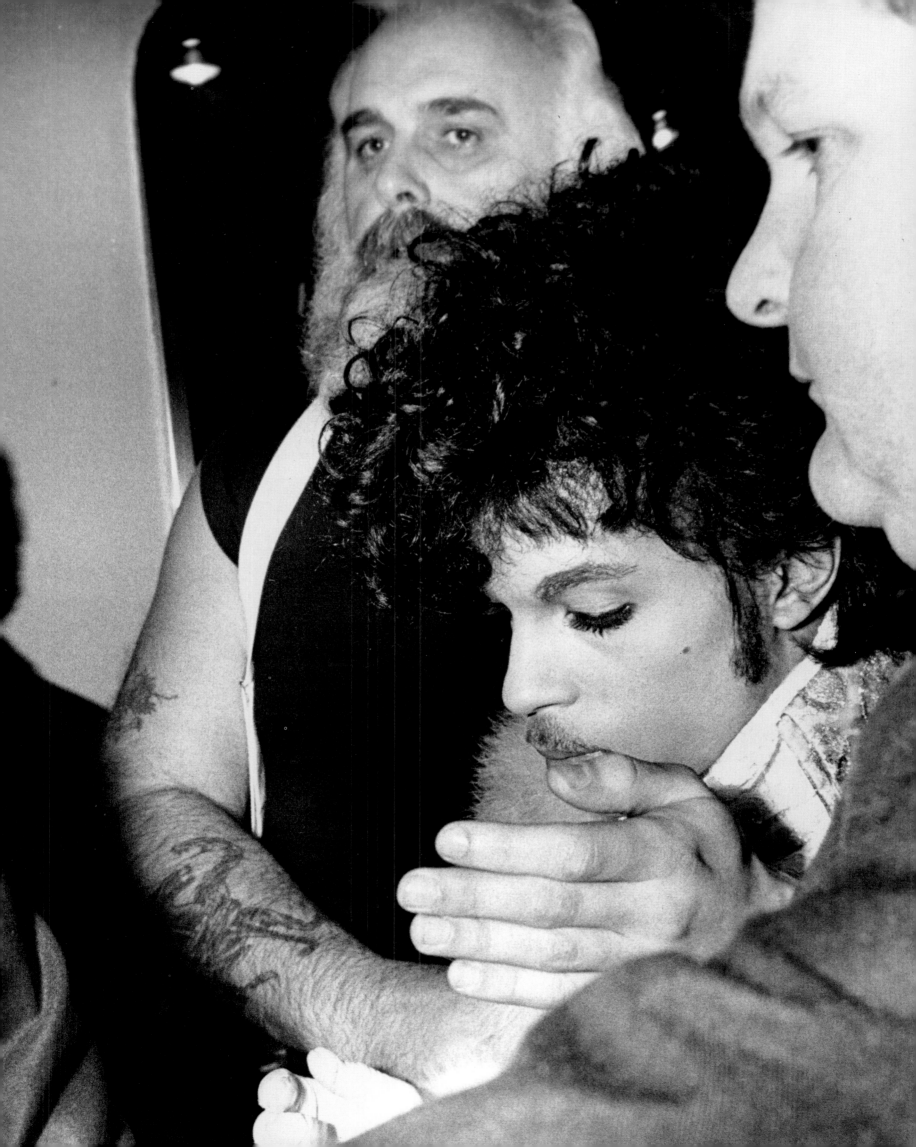

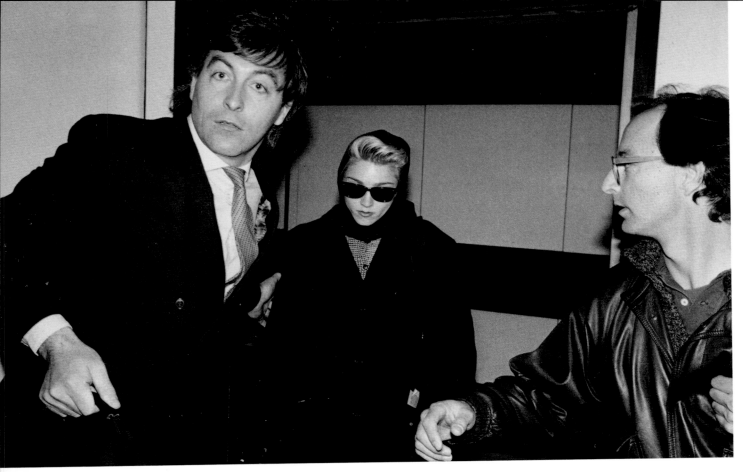

Madonna – taking pictures of Madonna
can be risky, tiring, or both.
London, 1987

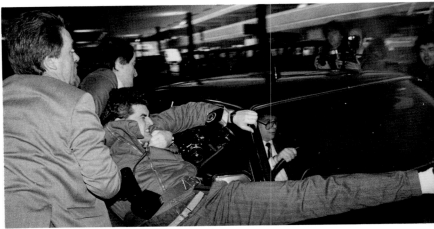

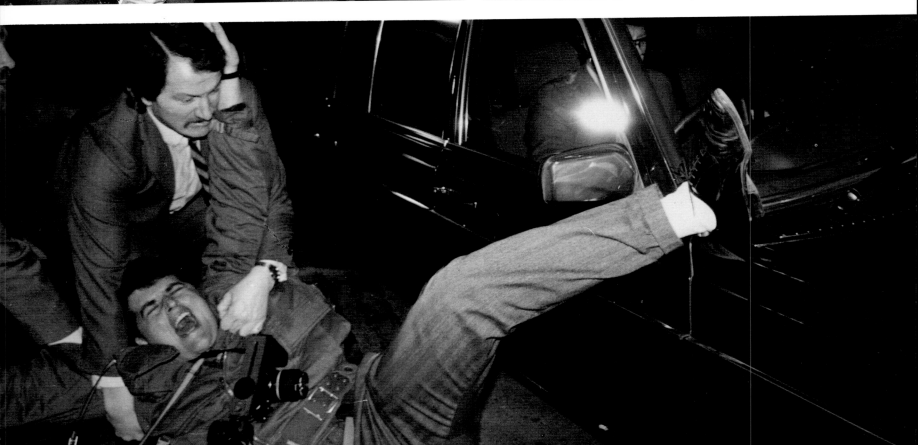

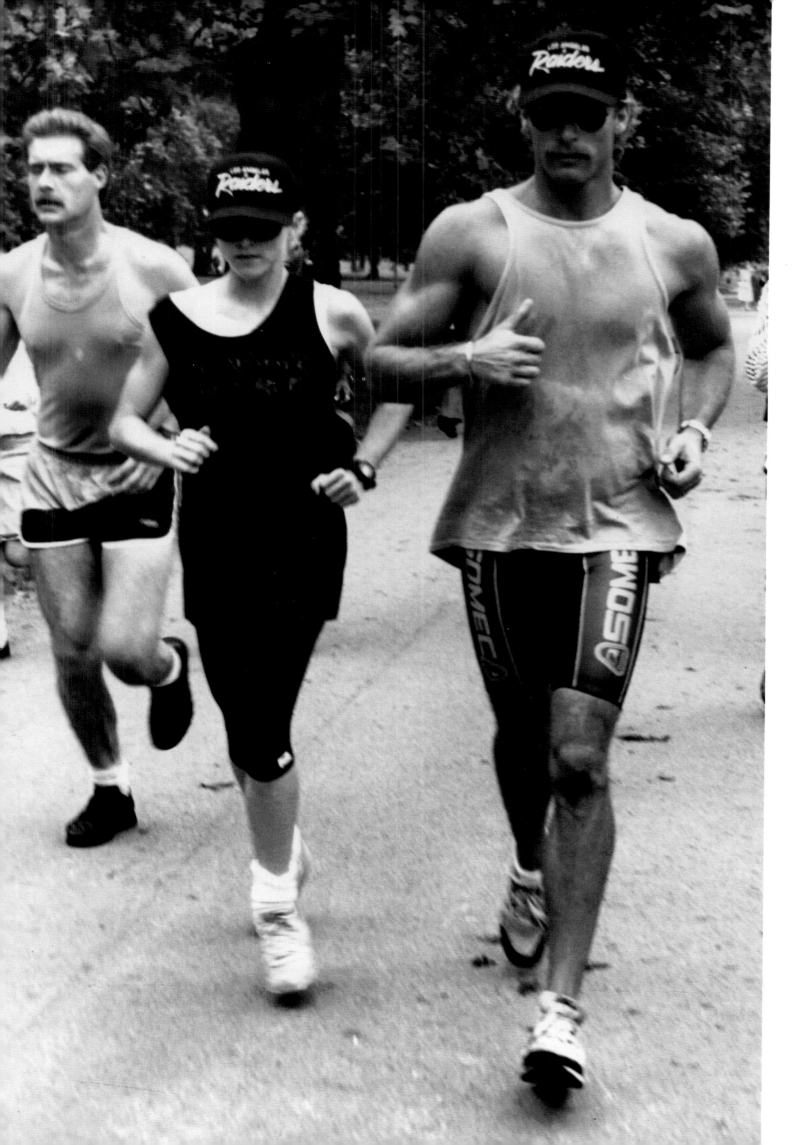

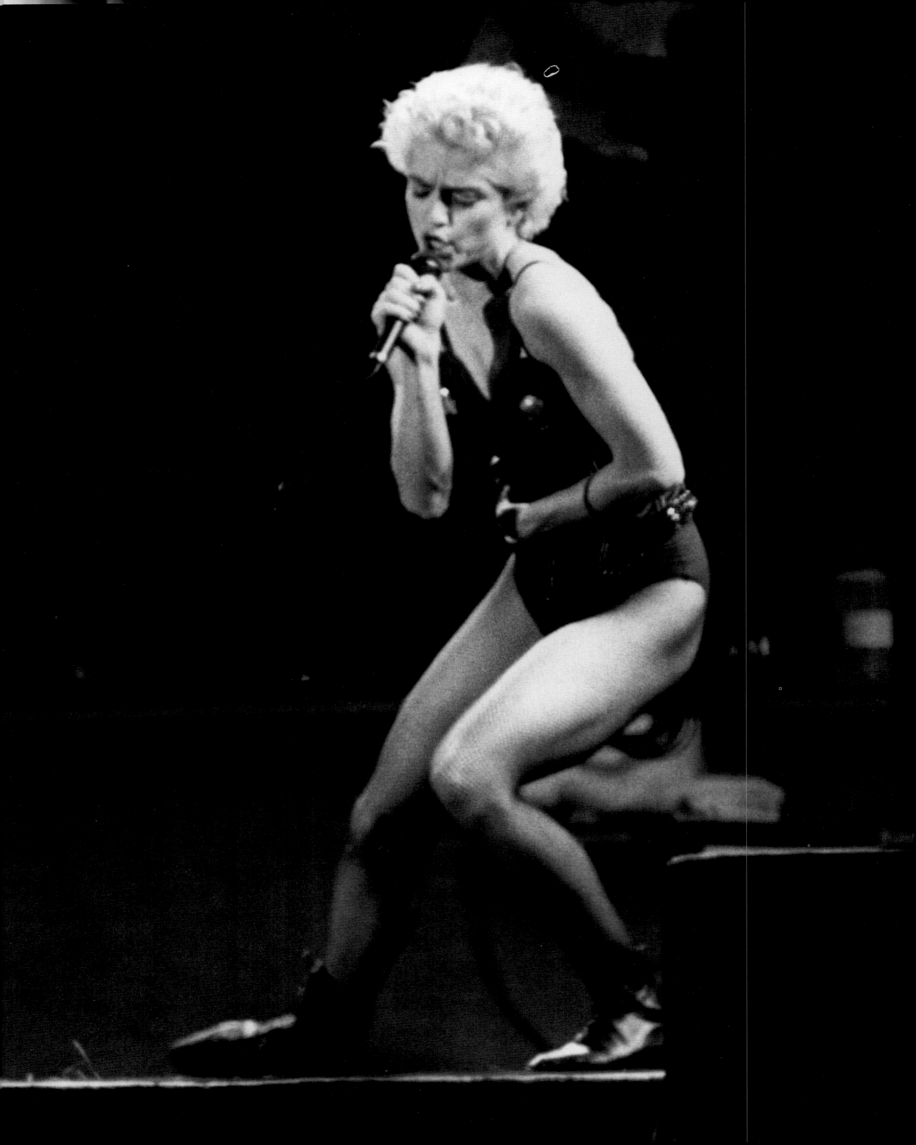

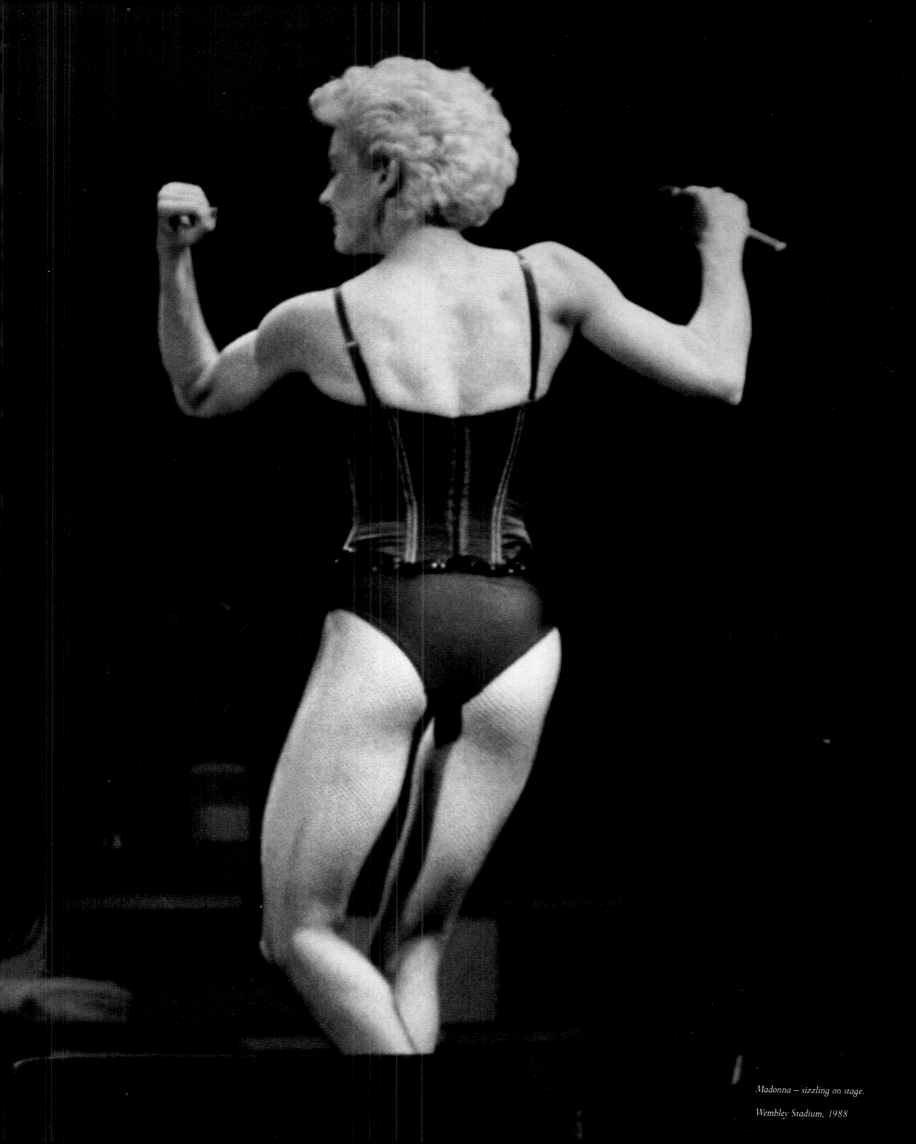

Madonna – sizzling on stage.

Wembley Stadium, 1988

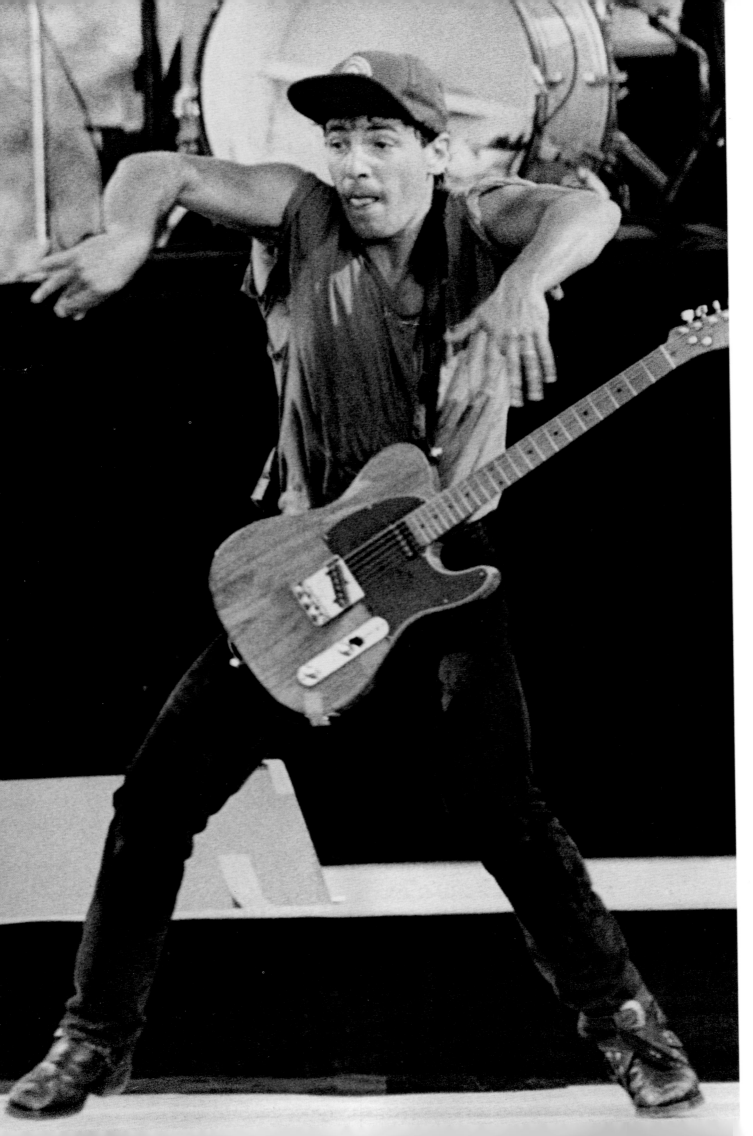

Bruce and Julianne Springsteen –
holding on tight, but not for long.
On the King's Road, 1986

Bruce – playing to the audience.
Slane Castle, Dublin, 1985

Sometimes, though, even I give up. In 1985, when Springsteen was on tour, I thought it would be nice to photograph him backstage before his concert at Slane Castle, in Ireland. I found out that I would need no fewer than 17 passes to get to see Brucie backstage. I collected 8, then I threw in the towel.

In 1988 I was actually invited backstage to take a publicity shot of Michael Jackson for his promoter. I thought I was on to a good thing, but no such luck. The promoter was also organising a 'Disney on Ice' show, and I had to photograph Michael with two Disney characters! I was led into the inner sanctum by the manager and the promoter, given three minutes to take the shots and then led out again.

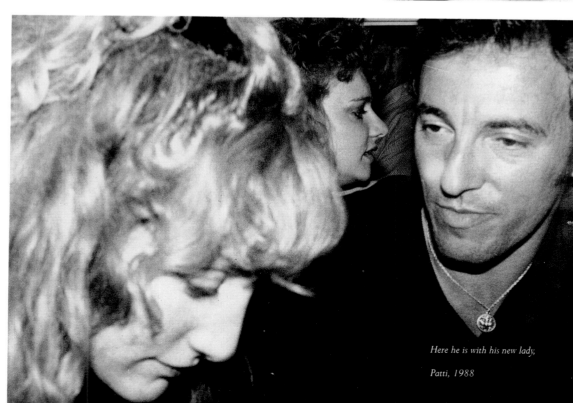

Here he is with his new lady,

Patti, 1988

I find I have better luck with these people when they are on my own territory – the street – and I can see them face to face. When Michael first arrived for that tour, everyone was going wild, trying to get a good shot of him. He drove in a convoy of three black limos on his way from the airport to the Mayfair Hotel. No one knew which car he was in or which entrance he would use when he arrived, except me. I'd been tipped off, and I was standing by the right entrance and the right car when he got out. All the other photographers were 100 yards down the road, behind barriers. Some were even on ladders. As I said at the time, I'm a photographer, not a window-cleaner. . . The shot I took of Michael on that day was recently sold in a charity auction at Christie's.

Although I couldn't get pictures of Springsteen backstage, it wasn't difficult to snap him in the street. On the 1985 tour he was staying with his wife, Julianne, at the Mayfair Hotel. One afternoon, when I was the only photographer outside, their huge minder came out. 'Are you Richard Young?' he asked. I said yes, and he asked me what I wanted. 'I just want some nice shots of Bruce and Julianne, preferably standing still for a second,' I said. He disappeared and, five minutes later, there were Springsteen and his wife in front of me. I did some shots there, and followed them around taking pictures of them shopping. Then I thanked them and left them alone. I caught Brucie a few days later, out with Nils Lofgren; they were on their own, with no minders, no security, nothing.

That was easy enough, but circumstances sometimes conspire against you to make even street photography almost impossible. A couple of years later, Springsteen was back for another tour, but this time he brought a protective army with him. It was around the time of his divorce, and he didn't want to be photographed with his new lady, Patti. Although I managed to get a good pic of Bruce and Patti arriving at the airport, I kept on following them in the hope of getting something more. One night, after a party, they got into their car and were driven round the sights of London. Bruce and Patti were in the back seat, cuddling, and I followed them on my motorbike. Every time they slowed down or stopped at the lights, I was there, taking shots of them through the window. They weren't too happy, but there wasn't much they could do about it.

Michael Jackson – arriving

at the Mayfair Hotel, 1988.

The other photographers were waiting

at the wrong entrance

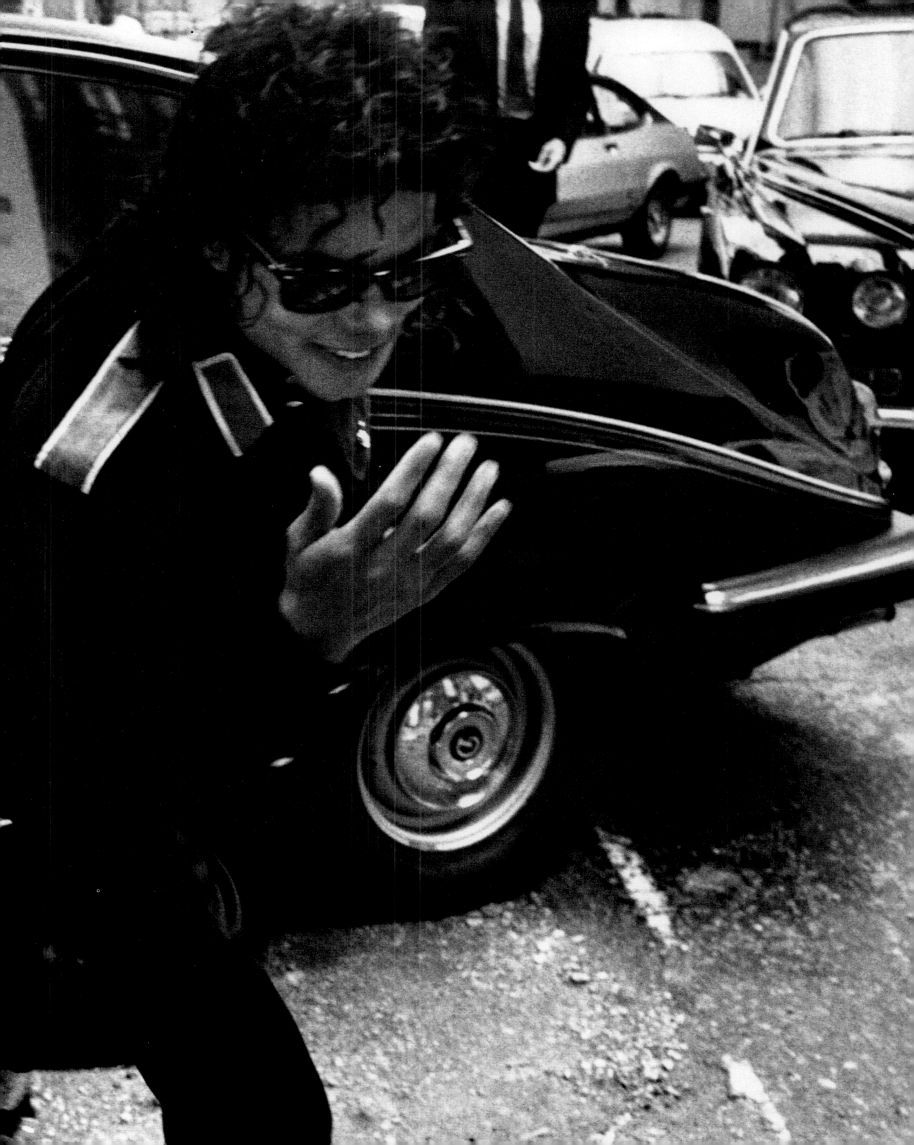

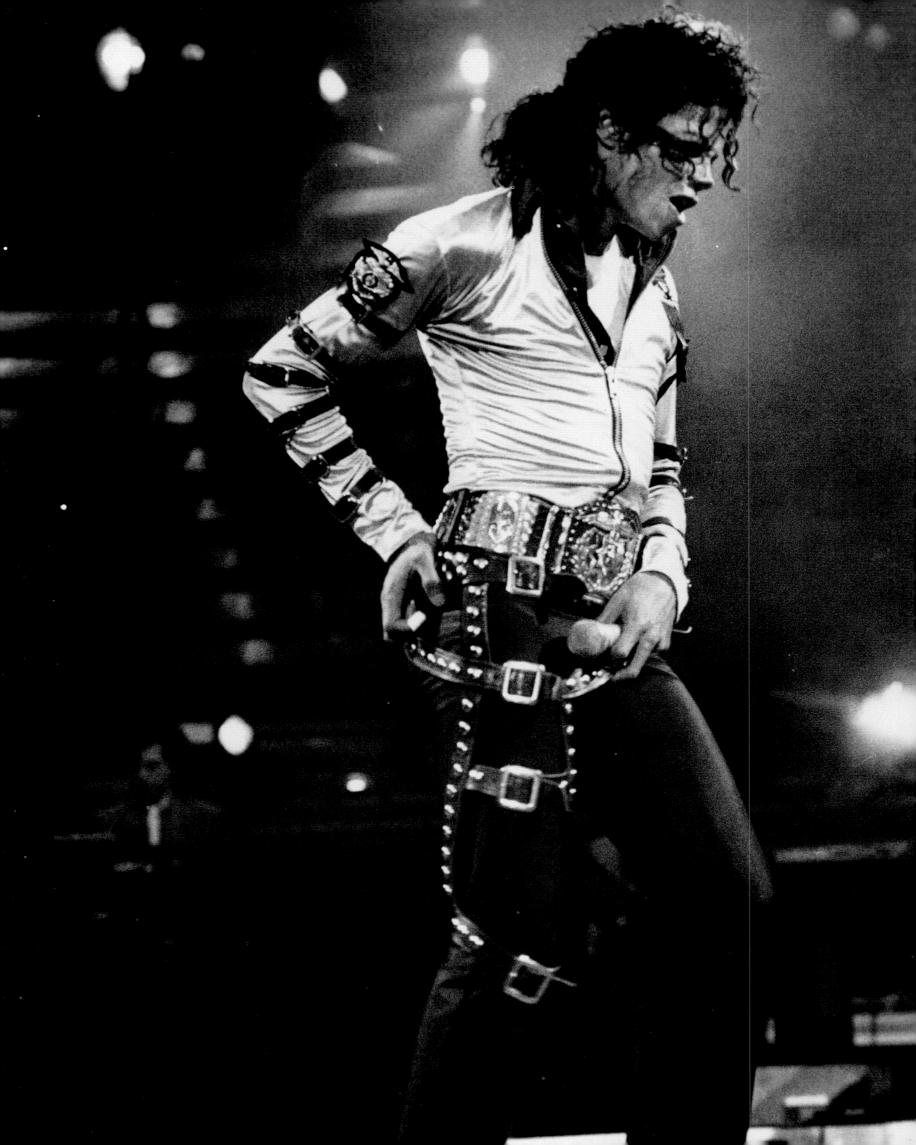

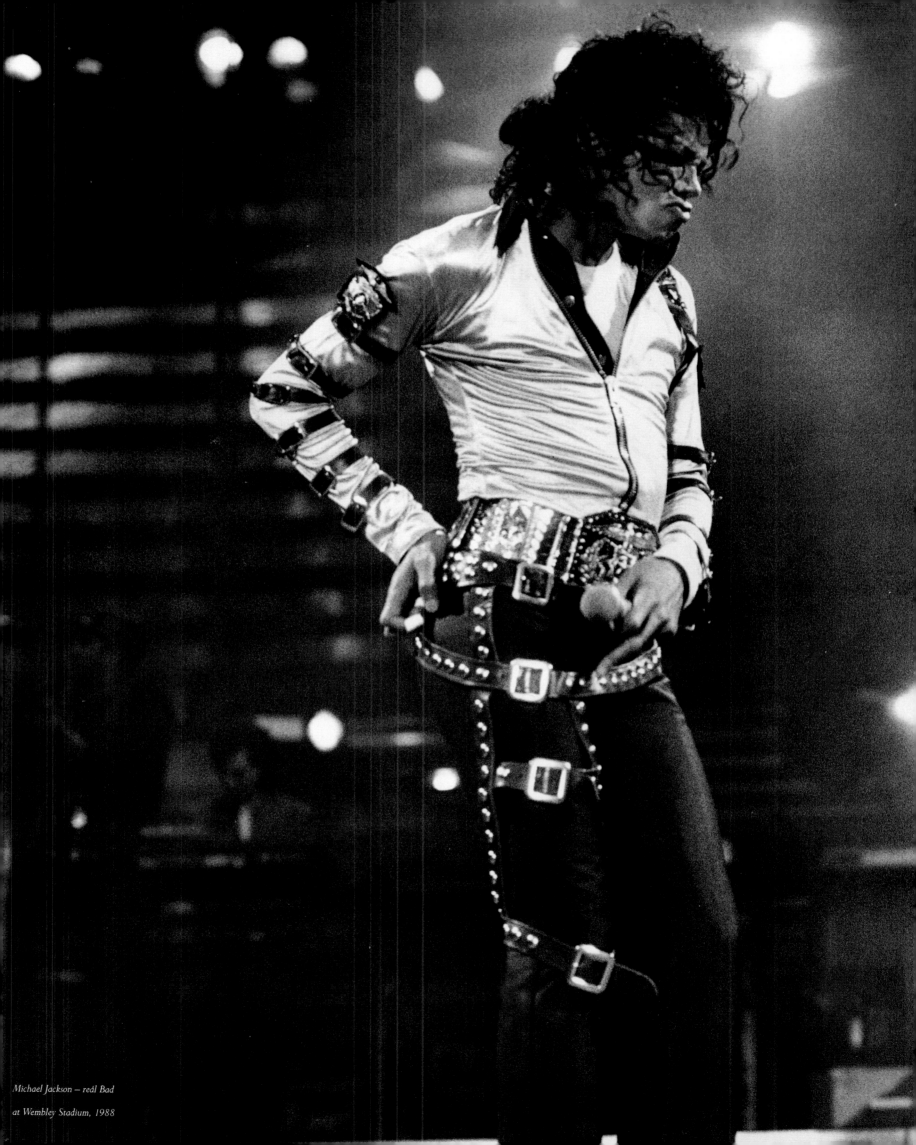

Michael Jackson – real Bad

at Wembley Stadium, 1988

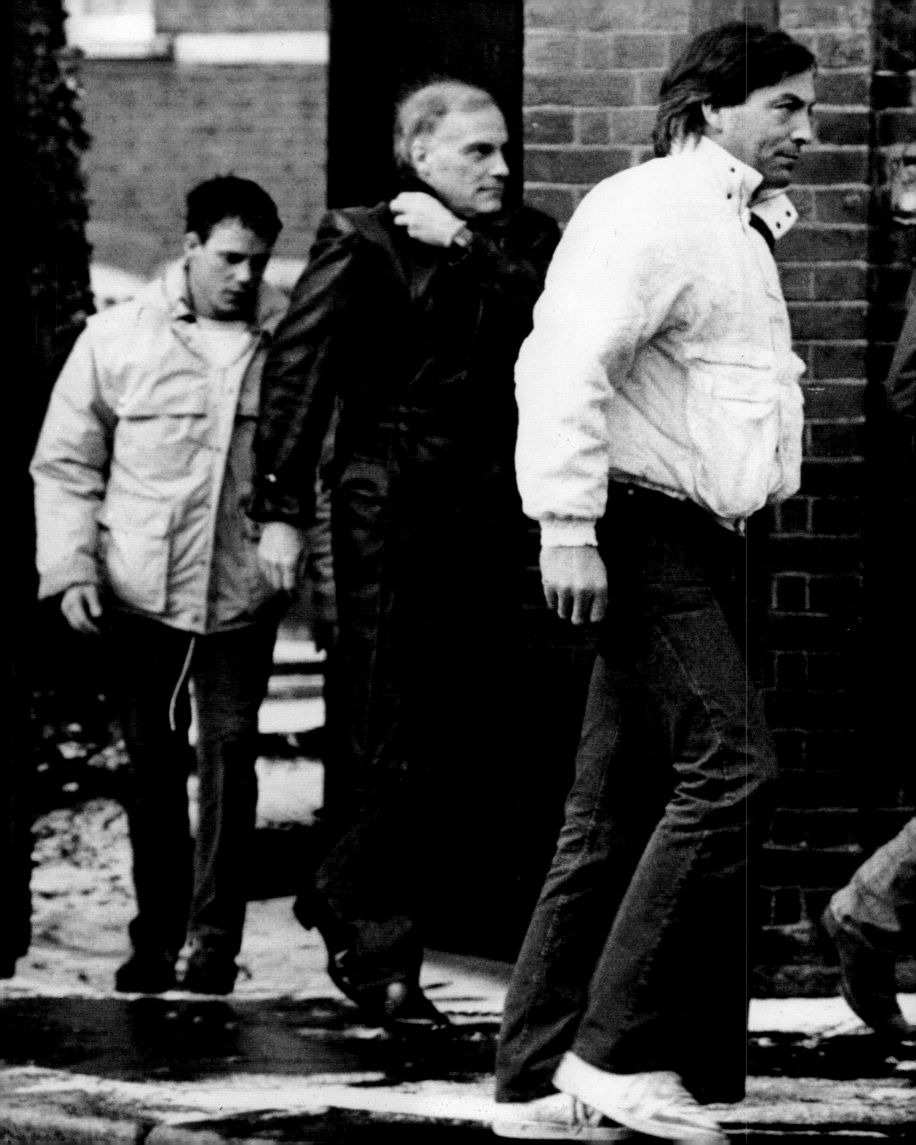

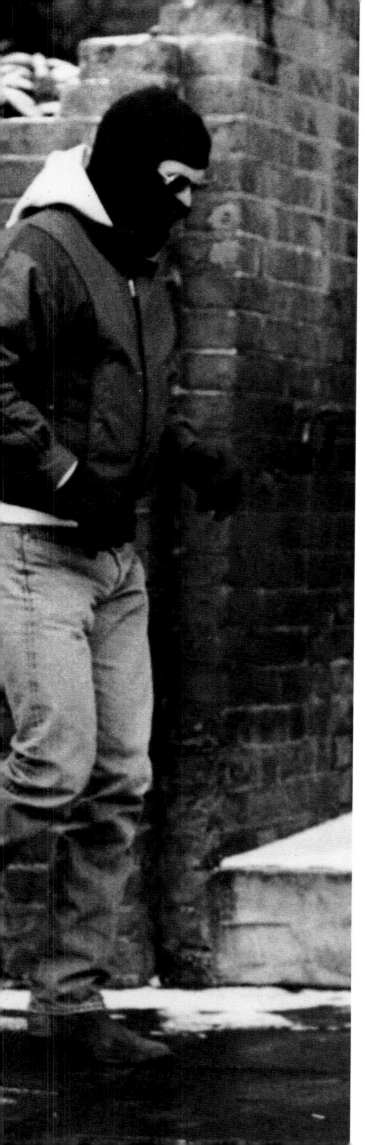

Madonna and her husband, Sean Penn, soon found that, as far as paparazzi are concerned, circumstances could get beyond their control, particularly when they moved from the pop world onto a film set. Through my contacts, I found out that they were filming *Shanghai Surprise* in a disused mental home outside London. It backed on to a railway embankment. From there I had a great view of the set and the stars' trailers. I had a colleague with me, and we started taking pictures. Within minutes these bodyguards leapt over the wall to try and stop us. I just said: 'This is British Transport Authority property. We have the permission of their press office to be here as long as we don't go near the rails!' They fell for it and left us alone. But because we were there, Madonna and Sean Penn refused to come out of their trailers, and filming was held up for three days! We got the pictures in the end, but they were furious. I shouldn't imagine the film producers were too pleased either!

In general, the pop scene's too volatile for my liking. You have a mixture of heavy security, crowds of hysterical fans and some kid in the middle of it all who has just become a star, and believes all his own publicity hype.

Sean Penn isn't even a pop star, yet his wife's fame seemed to go right to his head. He cuts a ridiculous figure. I remember taking a shot of him going out jogging. He was surrounded by grim-faced minders, and he was wearing a balaclava so no one could see his face. I must say, the balaclava did him a favour... As well as being ridiculous, Penn's behaviour can be deeply unpleasant. One time I knew he and Madonna were in an Italian restaurant, so I was waiting outside in my car for them to emerge. Sean came out first, and he strolled over to the car and bent down, as if he wanted to ask me something. I wound down the window and the idiot spat in my face! Nobody needs to behave like that.

The photographers following Bros have a hard time too. If they do manage to catch a shot of the group, and the boys don't like it, the Bros fans will spring to their defence and start pushing the paps out of the way, pulling their cameras and spitting on them. Not a nice way to earn a living.

Sean Penn – off for a jog, disguised in a

balaclava. Holland Park, 1986

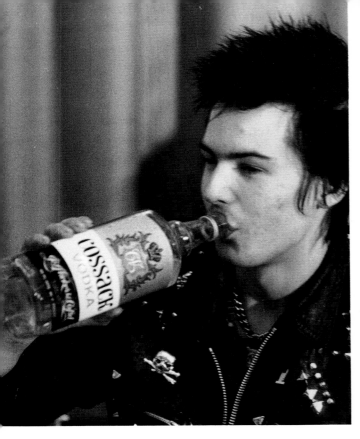

*Sid Vicious – celebrating the signing
of the Sex Pistols' A&M record
contract, 1977*

I simply won't photograph people in those circumstances any more. I'm not following the pop scene, getting shoved around and spat on by people who will be a joke by next year.

I remember right at the beginning of my career, I covered a Bay City Rollers concert at the Victoria Apollo in London. I was in the photographers' pit and it was bedlam. The group only managed to play three numbers because their fans rioted. All these girls were screaming and climbing all over the place – if they weren't fainting! The St. John Ambulance people had to take over. I can't say I enjoyed being trapped in a small pit, surrounded by hysterical kids.

Things could aways get quite ugly when the Sex Pistols were around. It wasn't so much their behaviour, as people's reactions to them. I covered them on a tour of Britain, and they were only allowed to play in two cities! Some of the British public found their rendition of 'God Save the Queen' extremely offensive. Their contract with A&M records was signed outside Buckingham Palace, and I took a shot of Sid Vicious swigging from his vodka bottle. A Sex Pistols party was definitely a pop event to avoid. You'd probably get people spitting, and Sid Vicious throwing up in front of you.

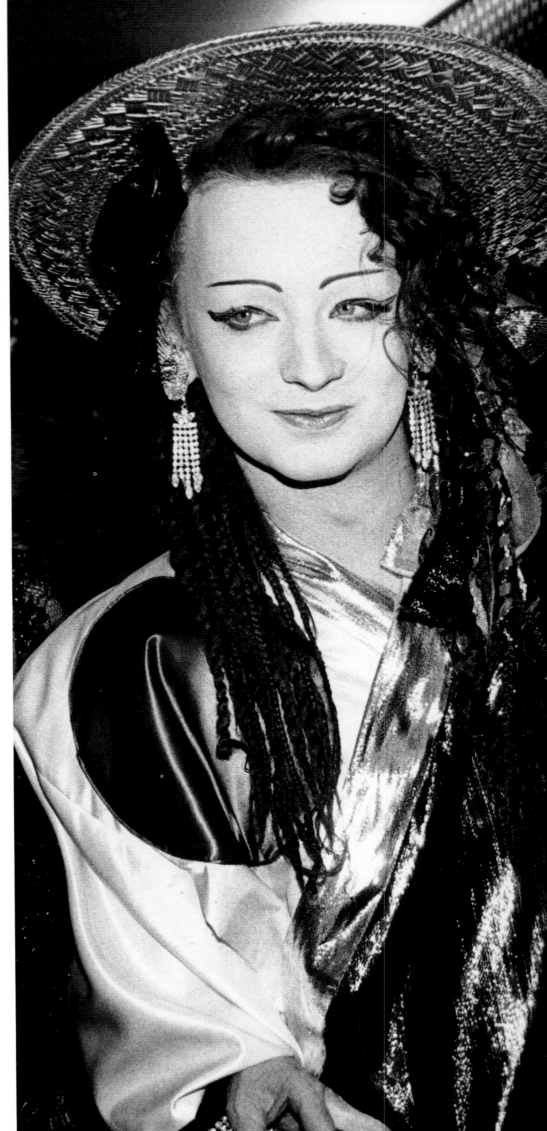

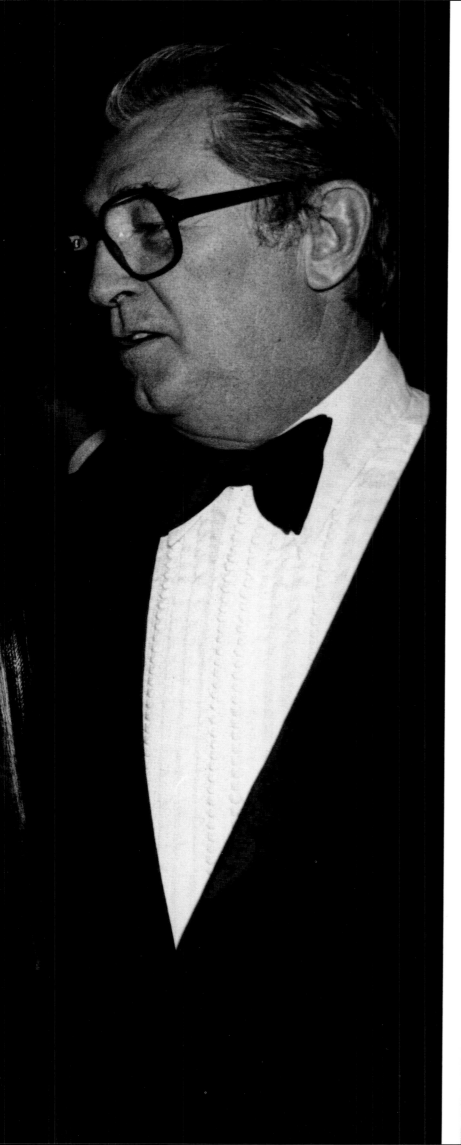

You have to remember that the pop scene moves fast. There's no guarantee that you'll be big tomorrow because you're big today. Boy George became fantastically successful because he had a new style, as well as talent and charisma. At one point it seemed that whatever he did, everyone loved him. But then he got into trouble with drugs and people couldn't get away fast enough.

Shots of fading stars make sad pictures. The Beach Boys always conjured up the good life, but when I was asked to photo Brian Wilson's birthday party one year, that wasn't quite how it came across. . .

Boy George with Robert Mitchum.
TV Times Awards, 1984. George had
more than enough adulation and
hangers-on while he was on top, but not
everyone can win at the fame game

Brian Wilson — the Beach Boy eating
cake at the Hyatt Carlton Tower, 1981

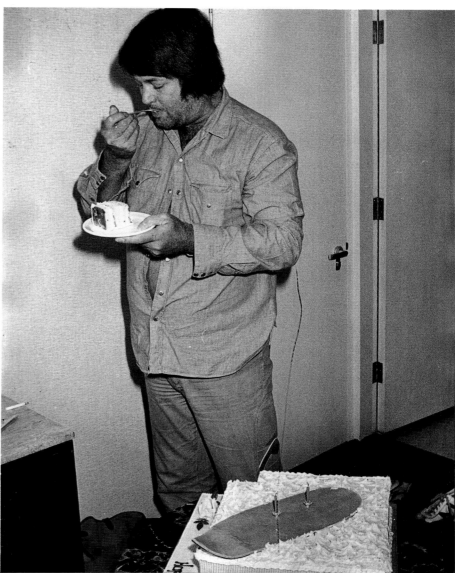

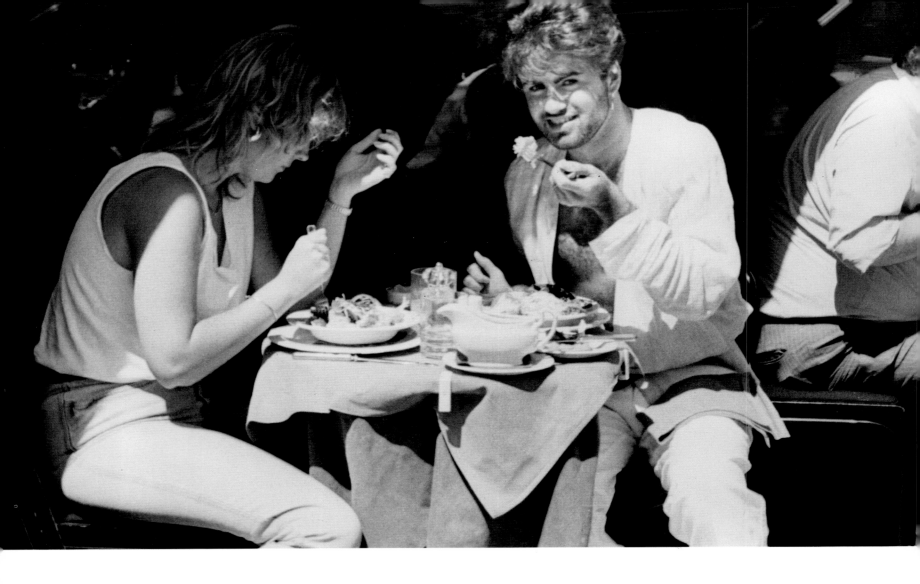

I think if these pop stars realised that their time in the spotlight is likely to be short, maybe they wouldn't make such a fuss about a few photographs. At the beginning of their career, Andrew Ridgeley and George Michael were only too pleased to pose for the camera. I have loads of pictures of them together, grinning away. I once caught George Michael having lunch with a girlfriend at a pavement café in Chelsea – not the sort of place you go if you're desperate for privacy – and he was perfectly happy to have his photo taken.

Once they became successful, things changed dramatically. Suddenly, the photographers who had helped make Wham! famous became the enemy. They would do anything to stop us from taking photographs. We got a bit fed up with it so, one night, when Andrew came out of Langan's with his usual posse of friends, we all put our cameras down and said: 'Oh, it's only Andrew, we thought it was George!' He was a bit shaken. At the time it was only a joke but now, of course, that's exactly what would happen: Andrew is no longer a star.

George Michael seems to have developed a hatred for photographers. Whenever he might be caught by a snapper, he will surround himself with friends and walk along with his head down so no one gets a good shot. It seems strange to me, but that's the sort of thing some people do in the music business. They become huge stars, and then they start worrying that someone will take a good picture of them and it will end up on an 'unofficial' T-shirt or poster. That's no way to enjoy fame. . .

George Michael and companion – lunching publicly in the King's Road, 1987

Andrew Ridgeley with Donya Fiorentino – an ex-star out at night. Soho, 1987

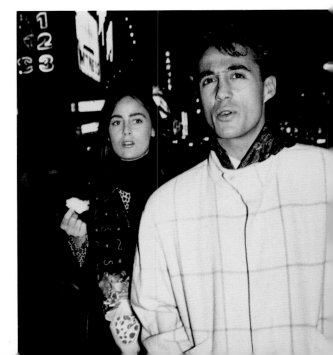

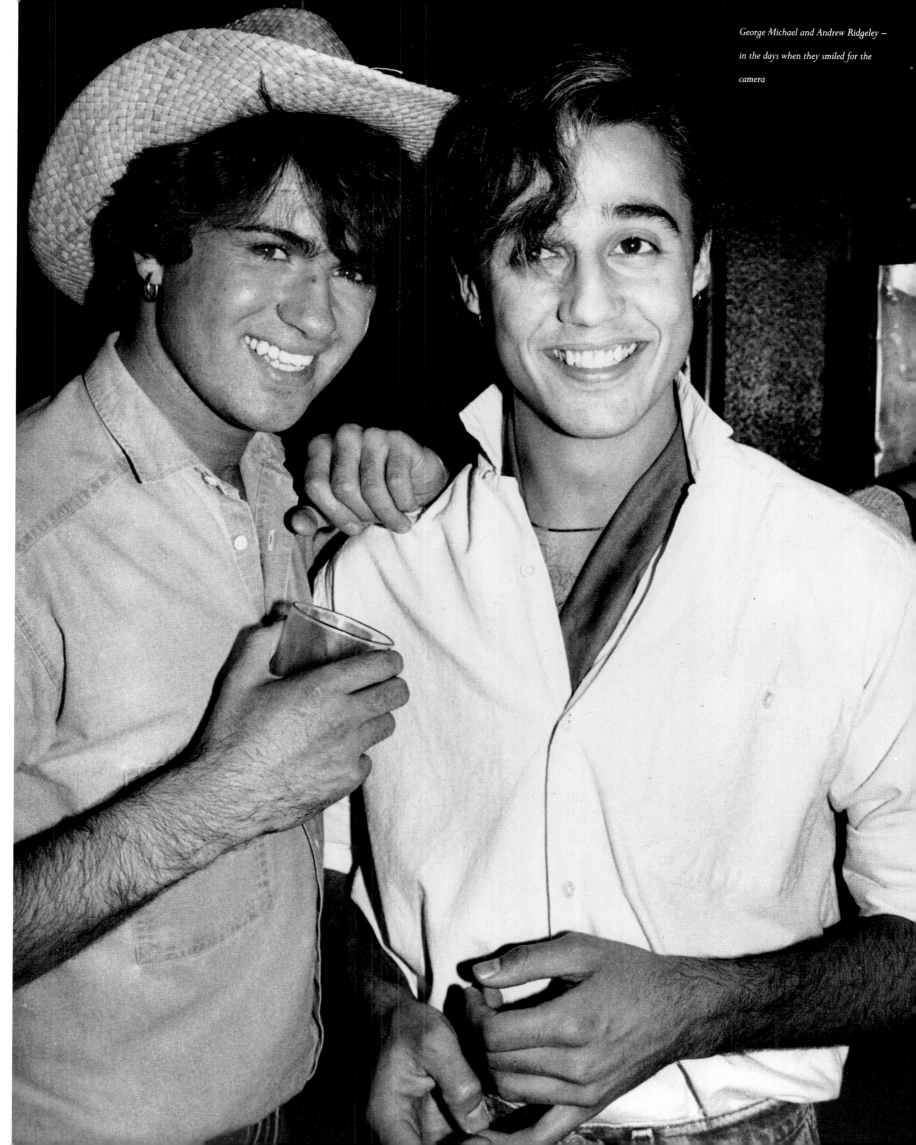

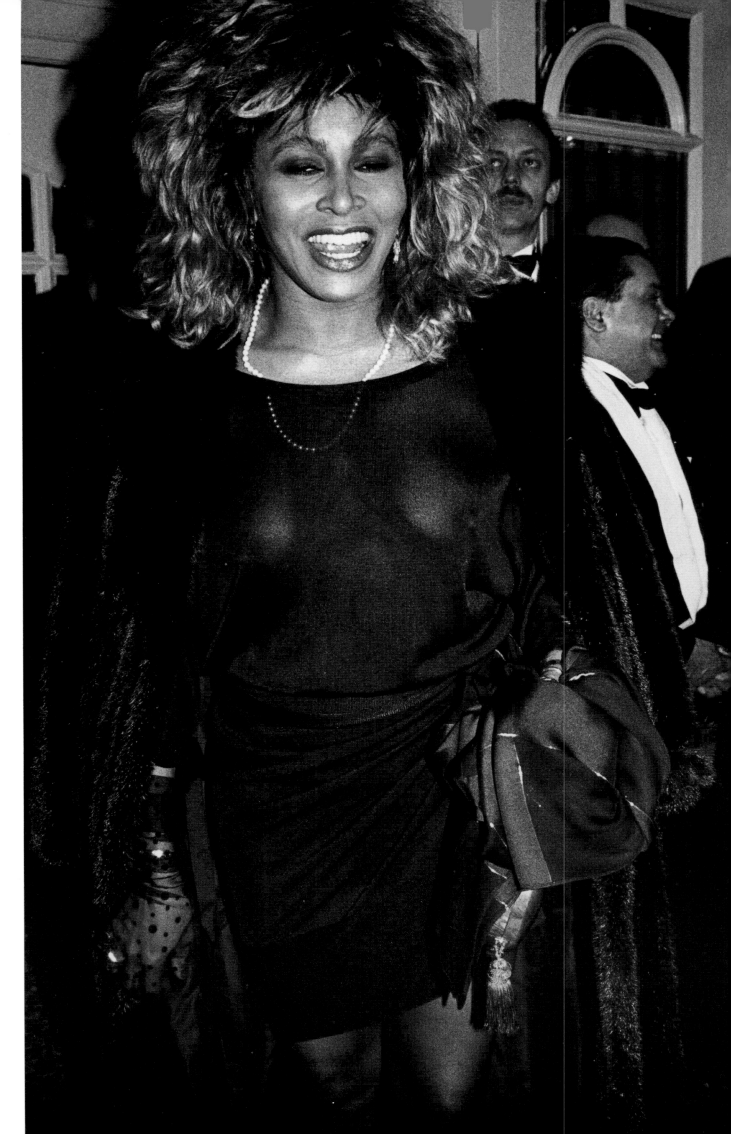

Tina Turner – showing she's still got what it takes. London Palladium, 1986

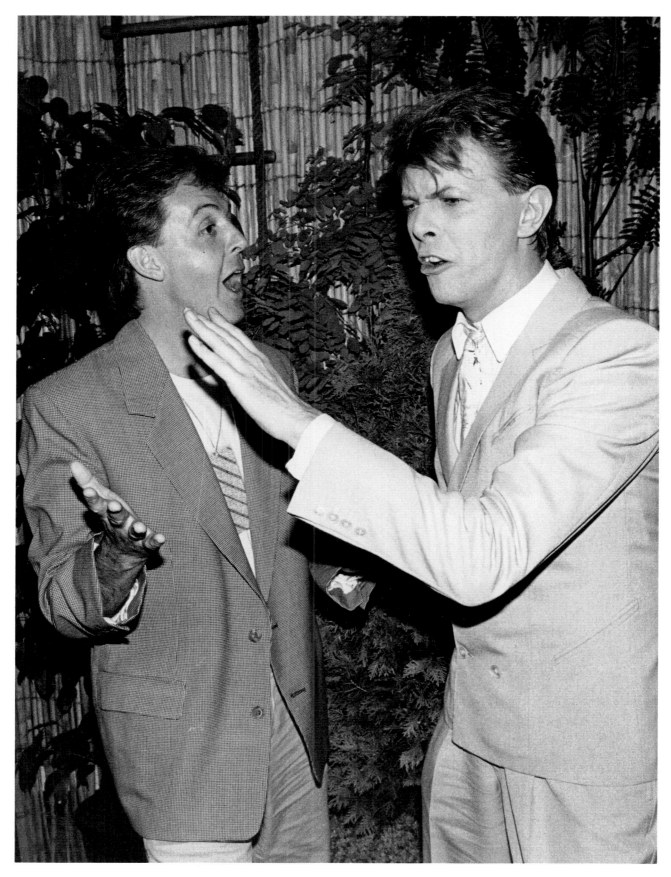

Paul McCartney and David Bowie –

singing for Live Aid, 1985

It seems that if you can last longer than five years in the music business, you become a legend and hang around for ever! People like Mick Jagger, Tina Turner, Paul McCartney and David Bowie have musical talent, personal charisma and whatever else it takes to keep the fans coming back for over two decades. During that time they have learnt exactly how to play the publicity game so that, most of the time, only the sort of shots that they like appear in the newspapers.

These stars control the system, not by banning photographers completely (*the* way to ensure the unwelcome attention – and attendance – of the paparazzi), but by appointing one photographer to take shots of their party on the condition that they have the right to approve all the pictures. It's a clever ploy. The other paps don't bother too much because the official guy is going to get all the good stuff, and the appointed photographer behaves himself because he can make a lot of money out of pics of a rock party, and he wants to be invited again.

Sometimes, although you've been invited to the party to take photographs, you can't take shots of the star because they're in an even more exclusive area, and you're not allowed in – until they say so. Last year I did Whitney Houston's party at a hotel in Park Lane. Most of the guests were downstairs, and she was upstairs with a select few. Eventually she was ready to be photographed and I was called up. They weren't what I could call party shots exactly!

Of course, I try to make sure I'm always the photographer they choose for these parties. I've been around a lot longer than the others and I think I deserve to be there! Over the years I've built up relationships with these people and their managements, and they trust me – to a certain extent. They know that I know how to behave at parties. I'm not about to go around moaning at them to pose for pictures. Some photographers, who shall be nameless, try to use the occasion to arrange photo-sessions with the stars, which I think is very naff. After all, it's a party and the celebrities are there to enjoy themselves, not to have their ear bent by a boring old photographer trying to set up an earner for himself. There's a time and a place for everything.

Whitney Houston and Stevie Wonder –

elated by the fabulous Nelson Mandela

concert, 1988

You have to make yourself pleasant to have around, and you must join in the party – even to the extent of dressing in drag! One year, I got a phone call from Freddie Mercury's people. They asked me if I'd like to cover his 40th birthday party in Munich. No problem, I said. They told me it was a drag party and I said that was fine – I'd been to lots of drag events. Yes, but you'd have to be in drag as well, they said. That threw me a bit, but a job's a job, so I borrowed a very loose dress from my wife, and some tights, and sent her out to buy me a wig. The lady at Selfridges told her not to worry, they get a lot of women buying wigs for their husbands!

I flew out to Munich with the showbiz editor of the *Express* and a few others. When we arrived at the hotel, there was a fashion shoot going on. We booked the make-up artist to come up to our rooms, and when he had finished we looked wonderful. I felt truly glamorous!

We all went downstairs for a drink and had great fun flirting with some Arabs in the bar! The party was mainly for Freddie's management and his friends in Munich, and we had a great time. At about 3am this woman came up to me and whispered: 'You look wonderful darling, but your shoes give you away.' I said: 'Thanks very much, but what about my beard?'

I've photographed nearly all Freddie's parties over the last eight years, and some of his tours. He's a fantastic showman, as anyone who has seen him in concert will know. So is Elton John, as he revealed when I was covering a Cartier party in Tunisia.

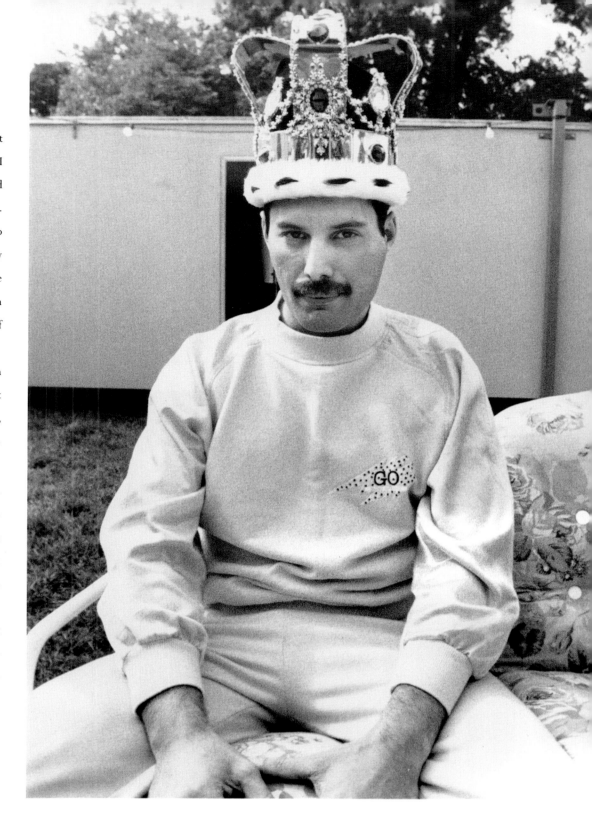

Freddie Mercury – playing at being Queen for a day. Slane Castle, Dublin, 1986

Cartier really know how to throw a party. They jet in all their rich, famous customers and make it an event to remember. And I get invited to take the photographs. On this occasion they were launching their range of sunglasses, and some bright spark obviously thought Tunis, with its sun, sea, sand and palm trees, was the ideal spot. Unfortunately, no one realised that particular time of the year was the hurricane season. The marquee had been set up outside, and all the tables were laid out, beautifully decorated. There was a stage, a piano, a dance floor and everything was ready for dinner. Then the wind got up. It blew more and more strongly until, suddenly, the marquee simply took off and was blown out to sea! The dining area was a shambles. Everything had to be moved into the hotel ballroom, and the guests didn't sit down to dinner until midnight.

Obviously, some of the party mood had disappeared by then. Elton suddenly got up and went to the piano. For the next hour he played some of his greatest hits, and the party came alive again. Everyone was cheering and calling for more. Later, I followed him outside to where the marquee had been. The disco was blaring, and Elton got up on stage and started dancing with Hazel O'Connor. The directors of Cartier were sitting at a table in front of the stage and, grinning cheekily, Elton started to do an impromptu striptease. . .

He doesn't always go quite so far for a good picture, but he enjoys fooling around for the camera. So when he asked me to take the cover picture for his album, *Breaking Hearts*, I booked a studio for a day and organised enough food and drink to keep everyone happy for several hours, while we tried out different poses. Elton arrived and was made up. He stood in front of the camera for the Polaroid test shots. He came over to look at the results, picked one up and said: 'That's it, that's the cover,' handed it to his art director, and was gone! I ate sandwiches for the rest of the week. . .

Unfortunately, I fell out with Elton's people a couple of years ago. It was around the time that his relationship with his wife, Renata, was going through a sticky patch. He was in Australia, and Renata came home with a friend of hers called Sylvia. The *Daily Express* knew that I was friendly with Elton so they asked me to go and see her with a reporter. An article appeared in the paper the next day which was extremely offensive to Renata. When I next saw her, I apologised and, not surprisingly, she really let rip at me. Elton is certainly not as friendly towards me as he used to be, and I haven't been invited to any of his parties since. . .

When Elton gets in a party mood

Tunisia, 1983 . . .

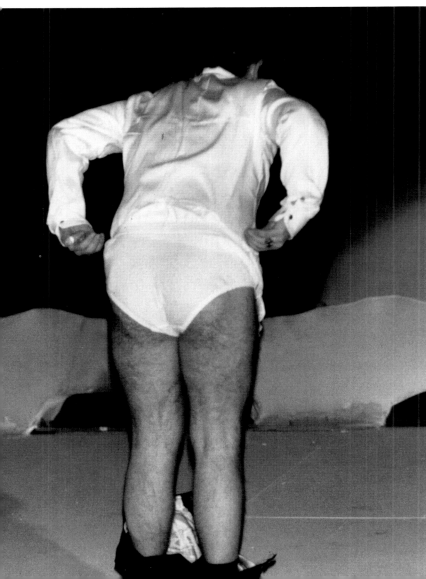
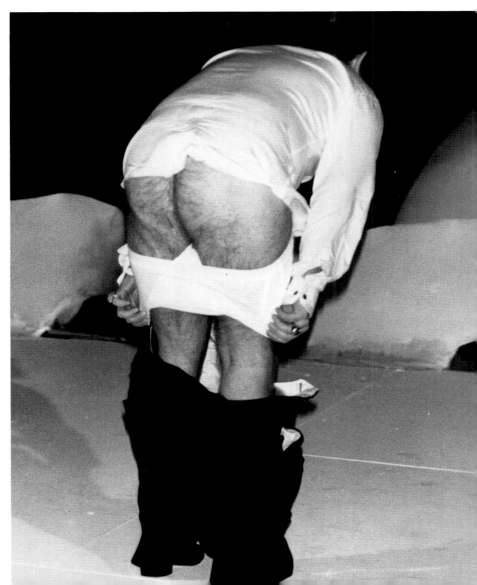

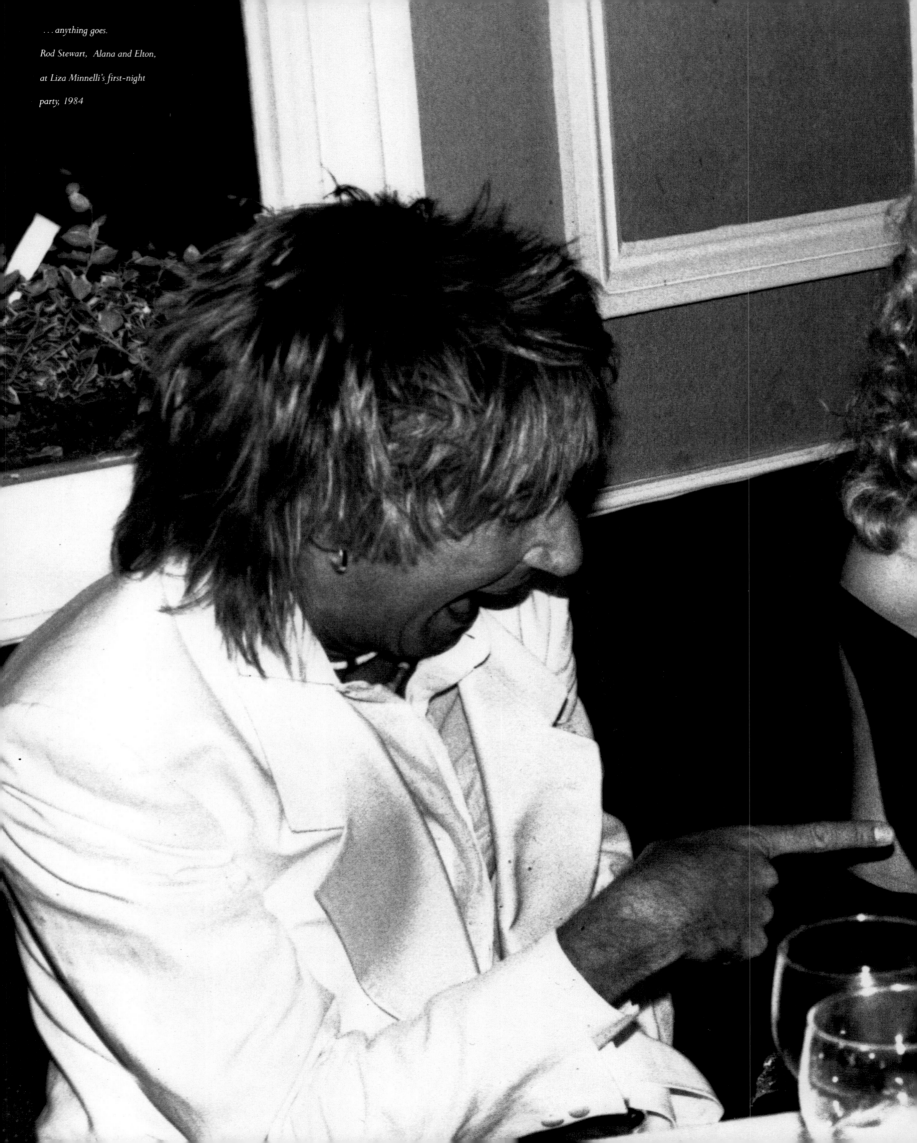

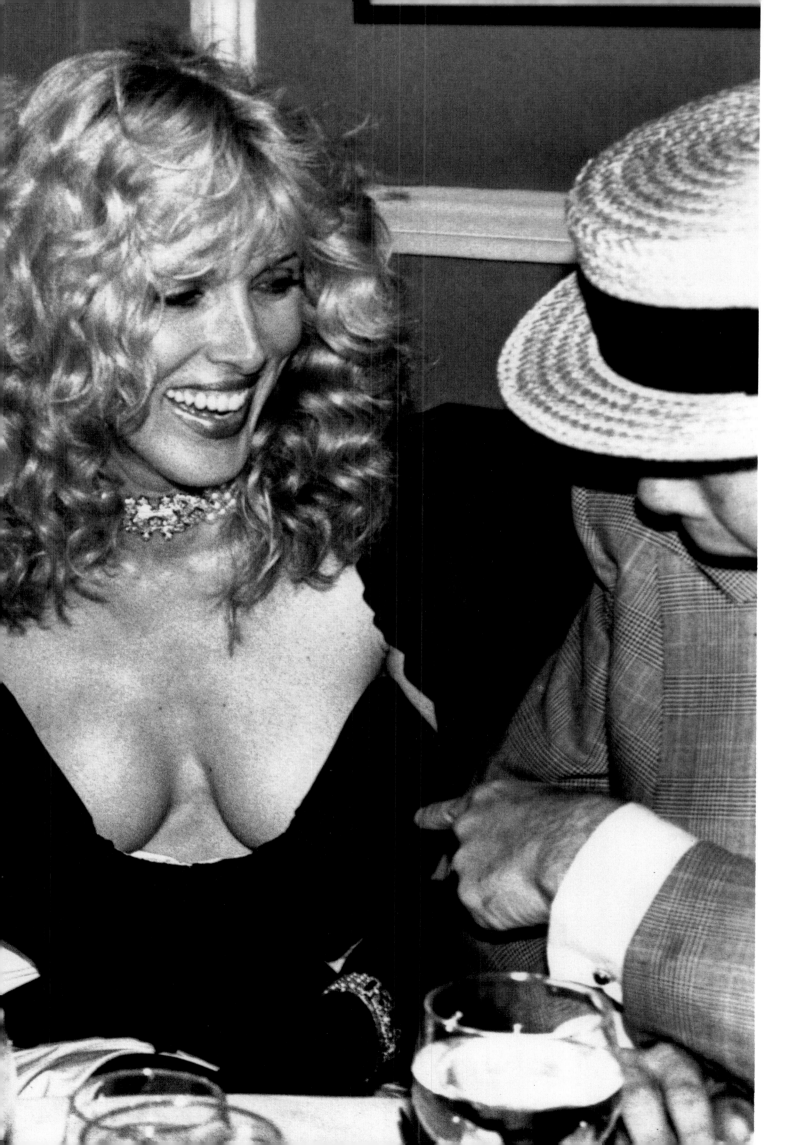

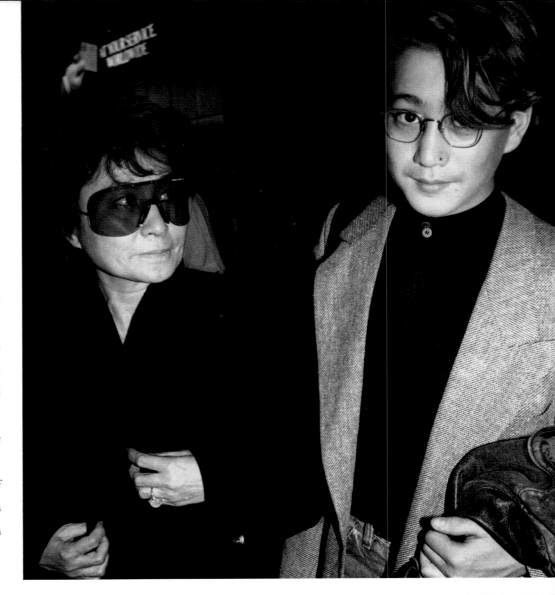

Staying friendly with the stars is like walking a tightrope. But if you're going to get hassle, it might as well be with the best of them! Paul McCartney also used to invite me to photograph his parties. He owns the copyright to Buddy Holly's songs, so every year he throws a Buddy Holly party. One year his eldest daughter, Heather, came along. It was during the punk era, and she was looking fairly punky. I went around, snapping away as usual, and then I got the pics approved by McCartney. Unfortunately, the newspaper used a shot from the contact sheet which hadn't been approved. It was only a picture of Paul with Heather, it wasn't as if I'd caught him with a secret woman – but Heather did look like a punk and that didn't fit in with the McCartney image. Great offence was taken, and that ruled me out for any more exclusive parties!

Another year, I took a shot of Paul and Linda coming out of one of these Buddy Holly parties. Linda is giving her impression of a fifties teenybopper. Somehow I don't think that picture will get me back in favour. . .

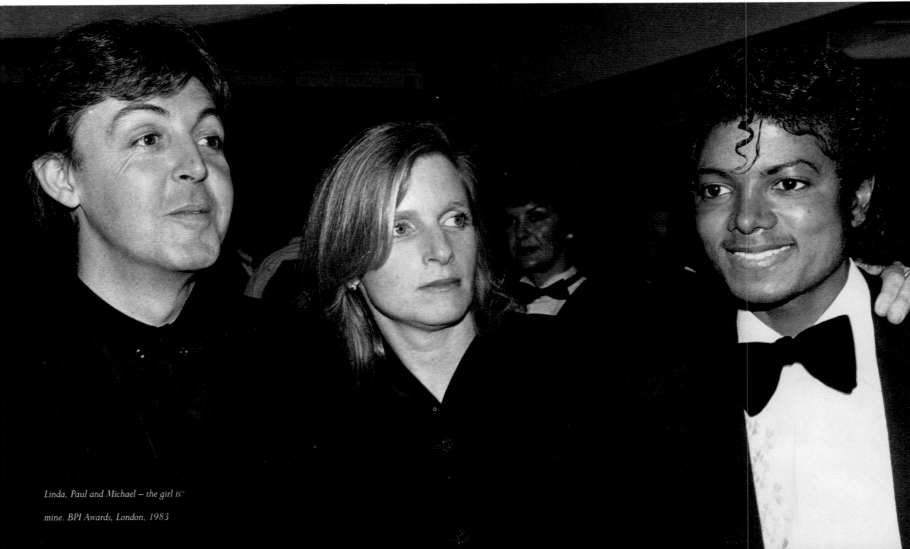

Linda, Paul and Michael – the girl is

mine. BPI Awards, London, 1983

Paul and Linda McCartney – still
bopping after their Buddy Holly party.
The Lyceum, 1984

You can't expect everyone to love you all the time. Mick Jagger and I go back about 10 years, and we have what I would call a love/hate relationship. On some occasions, if he sees me outside a restaurant alone, he'll ask me in for a beer. On others, he may just growl at me as he walks by. In general, the big rock stars who have been in the business for some time don't mind being caught by photographers. They see it as part of the business, and they are not about to spend their lives creeping about in fear of being spotted.

That's not to say that they make it easy for you. Mick Jagger once made me wait six days for a shot of him with Jerry and their first baby, Scarlett. On the first day, a Monday, he came out of his house in Kensington and looked a bit surprised to see me there. I told him I'd like a picture of him with the family, and he said not today, maybe tomorrow. The next day he said not today, I'm going to watch the cricket. Then Jerry wasn't ready, then the baby wasn't ready. Other photographers had congregated, and one day we were having a bite to eat, some burgers, chips and milkshakes. Just then, Mick and Jerry came out with the baby. We dropped everything and ran for our cameras. They got in their car, Mick waved and said: 'Not today, maybe tomorrow!' We were left on the pavement, trying to clear up the mess as they sped off. Finally, on the Saturday, they took pity on us. Jerry, looking fabulous, came out with Mick and the baby and posed on the pavement for us. They were the first, if unofficial, shots of the family together, and they sold around the world.

I've taken shots of Mick that haven't required so much legwork — not on my part anyway. One morning during the school holidays, my son Danny had been out playing football with his mates in Holland Park. He came home and told me he'd seen Mick jogging there. The next morning, I went down to the park with Danny and we kicked a football around a bit. Suddenly Jagger appeared and started jogging. I took some shots and he said: 'Oh no, how did you find out?' I told him, and he laughed.

That's one thing Bryan Ferry rarely does when faced with a camera. He genuinely dislikes being photographed. Not long ago, Lady Rothermere asked me to take photographs at her daughter's wedding party. They also hired a video-camera team. I was watching the team in action, and I saw them approach the table where Ferry

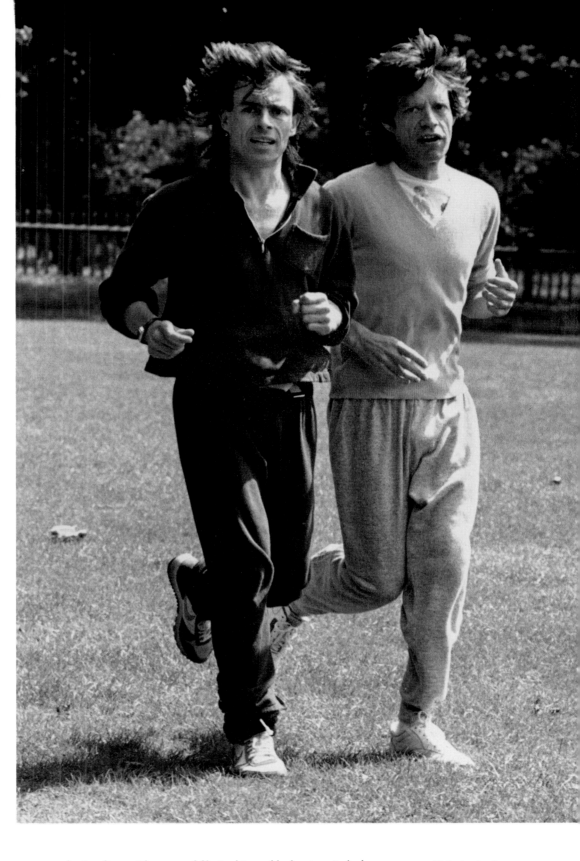

Mick – jogging Jagger.

Holland Park, 1987

was having dinner. They started filming him and he leapt up, jerked the camera out of the guy's hands and yelled: 'Don't you film me while I'm eating. No one takes pictures of people eating!' He was quite right. People make very strange expressions while they're chewing, and the camera can catch them. If you don't want to upset someone, don't take a shot of them having their dinner.

Mick, Jerry and baby Scarlett

– a lovely family photo, even though

I had to wait a week for it.

Kensington, 1984

Mick Jagger – I gatecrashed his 39th birthday party. Langan's, 1984

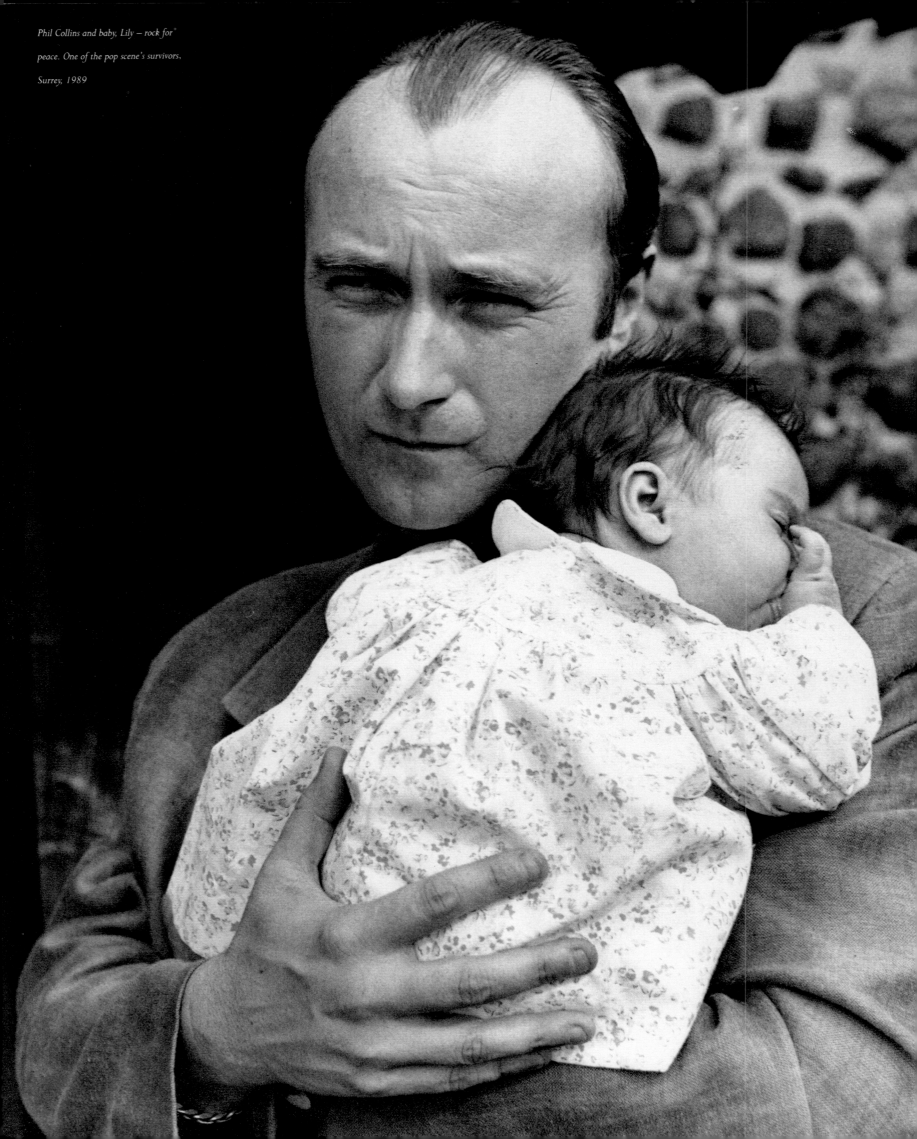

Phil Collins and baby, Lily – rock for
peace. One of the pop scene's survivors,
Surrey, 1989

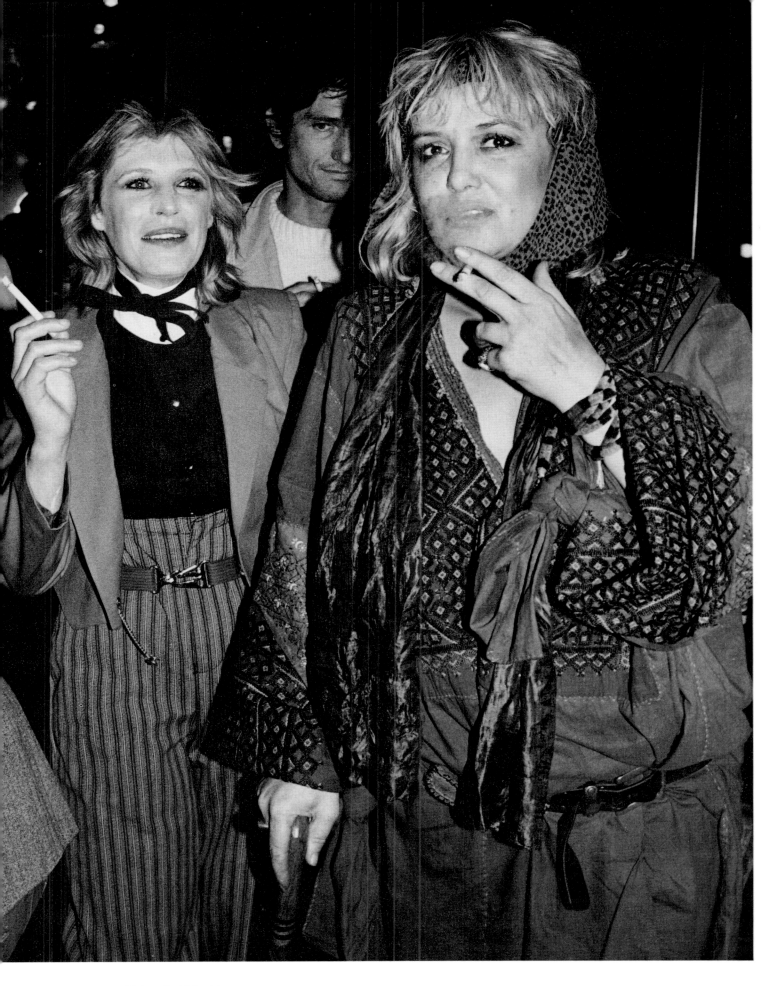

Marianne Faithfull and Anita

Pallenberg — it wasn't easy to shake

off the effects of the roller-coaster

years with the Stones, but these

two won through in the end.

The Embassy Club, 1979

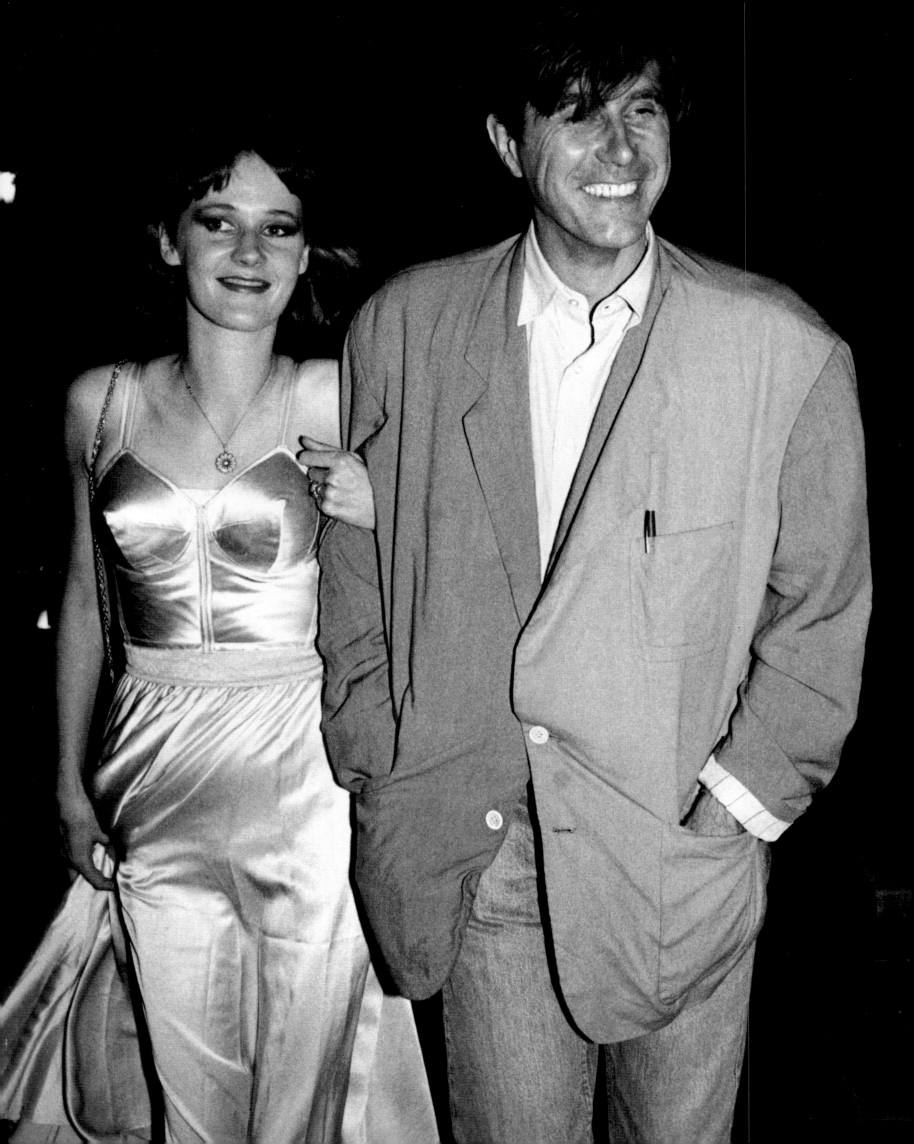

One of the few occasions that I have caught Ferry in a relaxed, cheerful mood was after one of Mick Jagger's parties. He must have had a great time in there, because he was quite happy to be pictured walking down the street with his wife, Lucy. Jagger's parties have always been good for me too, even when I haven't been invited! One year, he had a party upstairs at Langan's. I was out on the street below, and when I heard them singing 'Happy Birthday', I raced up the stairs and, using waiters for cover, got into the room just in time to pop up and snap Mick blowing out the candles on the cake.

Another year, there was a party I just couldn't get into. I knew Jagger and his mate David Bowie were there, and I wanted to get some shots of them together. So I asked one of the guests to take my camera in and take the photographs for me. The results were very good!

Jagger and Bowie, Elton and Rod Stewart, when some stars get together it's very much a boys' night out. Rod loves fooling around in front of the camera just as much as Elton. Once I was at a party and I got a call to go to Rod Stewart's hotel. He'd got all dressed up in his sea captain's outfit and he wanted me to take some pictures of him, for all the world like a little boy showing off his new school uniform!

I was like a little boy in a sweet shop, the day of the Live Aid concert. Everyone in the rock world that I've ever wanted to photograph was there – together! The atmosphere was fantastic, everyone was very much aware of the reason why they were there, and there was no room for the usual jostling of egos you get when stars are together. I spent most of the day backstage, taking informal shots of the stars waiting to go on stage or chatting to each other. The car park behind the stage was turned over to all the groups and their gear. Elton John set up home and invited all his friends to a barbecue. I've got some greats pics of Elton hard at it, grilling the steaks! Everywhere you turned there were famous faces. I've never worked so hard in my life! It really was a fabulous day for rock.

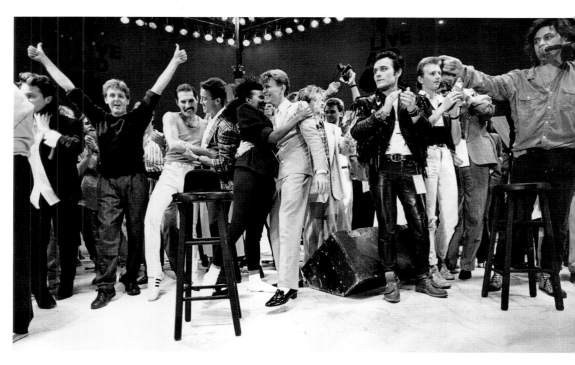

No egos, just music. Live Aid, 1985

Elton John – entertaining his friends in

the car park, before entertaining

millions on stage. Live Aid, 1985

Bryan and Lucy Ferry – a rare smile.

Leaving a Mick Jagger party.

Chelsea, 1986

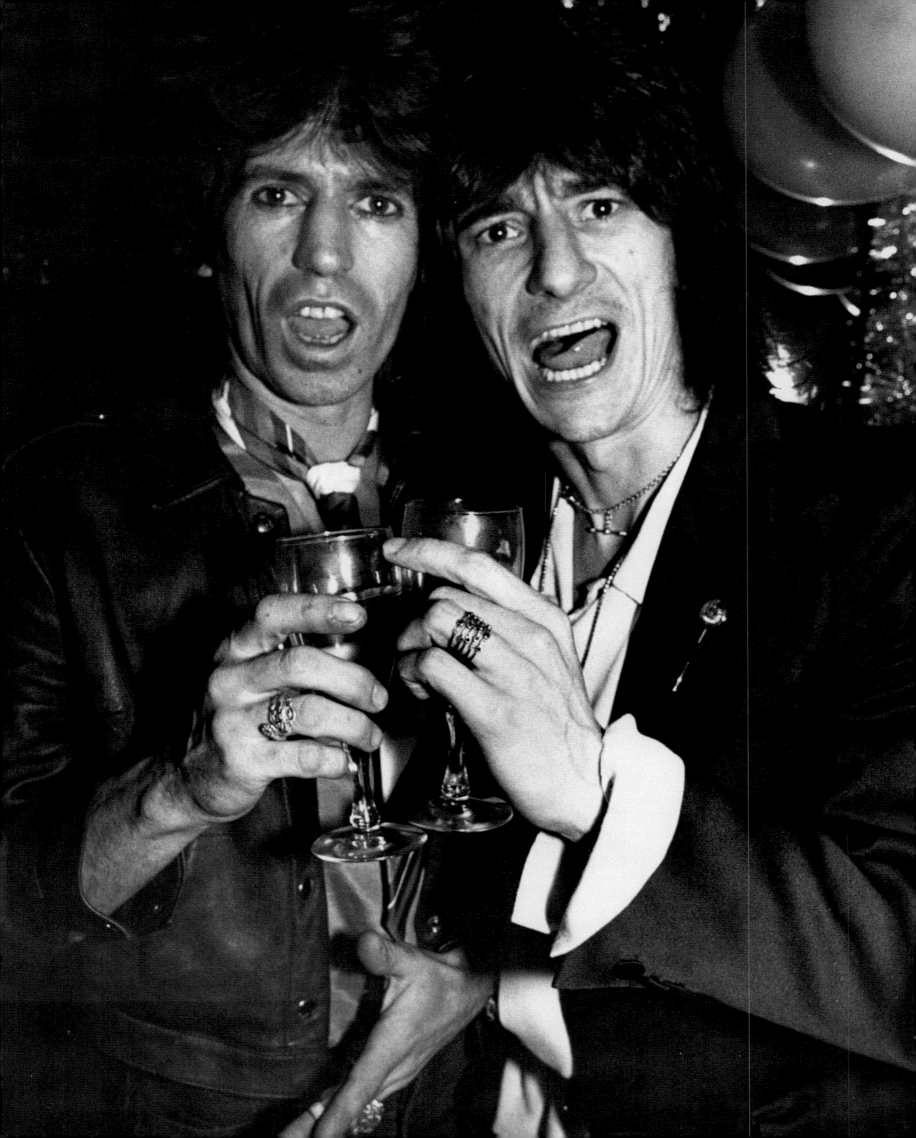

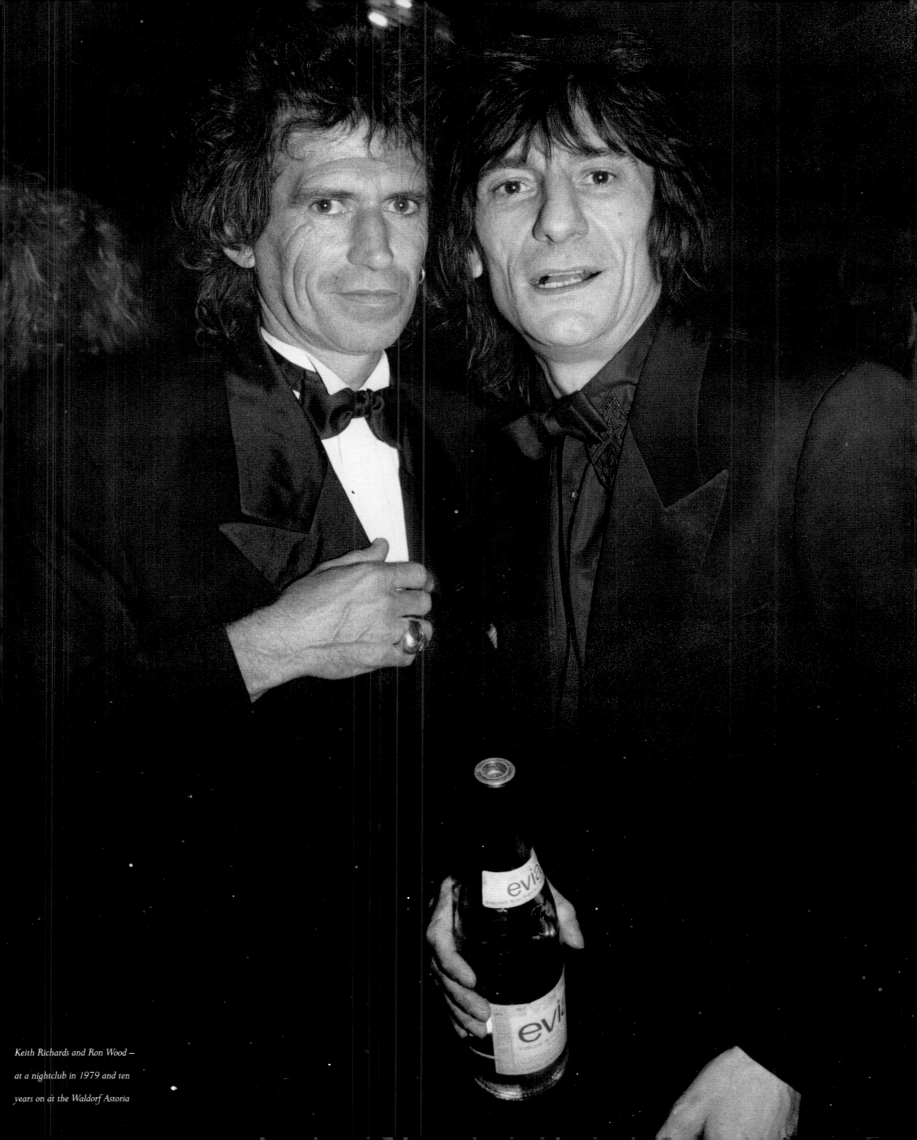

Keith Richards and Ron Wood –

at a nightclub in 1979 and ten

years on at the Waldorf Astoria

The Royal
Roundabout

Everyone wants photographs of the Royal Family. There's a constant, insatiable demand from newspapers and magazines at home and abroad for the latest shots of our royals, particularly the Princess of Wales. A shot of Diana on the front page sells the paper, and any picture I take of her will appear in publications around the world.

This means that she and the other royals are constantly followed by photographers. Buckingham Palace try to limit the numbers at public engagements by operating a rota system. Different newspapers and agencies are appointed to take the photographs at each function. On other occasions, a fixed rota will operate, which means that the photographers can only take pictures from previously designated viewpoints.

However, much as they'd like to, the people who work in the Buckingham Palace Press Office cannot control photographers – or the royals – all the time. I prefer to snatch pictures of the royals enjoying themselves rather than working. I photograph them at polo matches, art gallery openings and outside nightclubs and restaurants. It's unofficial: you never know in advance that they are going to be there, but suddenly I may turn round and see Diana or Fergie coming into a restaurant. I can get a much more interesting shot in those situations than taking a picture of one of them on an official engagement, when they're opening a town hall or visiting a factory.

Another, more predictable, way of gaining access to the royals and the high society in which they move when they are enjoying themselves is to be invited to cover charity balls. The royals are all patrons of hundreds of charities, and they will attend the relevant annual ball. The charity wants publicity, so I am invited along too.

Although I am not part of what is known as the Royal Ratpack – a group of photographers and journalists who follow the royals around the world – I have been taking pictures of the Royal Family for about 15 years. They all know who I am, and some of them are fairly friendly.

I have to say that Diana is my favourite royal, a preference I share with many people. I've been photographing her right from the beginning, when we used to chase this shy young Sloane from her flat in South Kensington, to the nursery school where she worked in Pimlico. She was incredibly young, only 19, and she looked very sweet, but quite ordinary. In those days, it was almost impossible to get a good shot of her, because she kept her head down all the time. Even in the official engagement shots, she had her head on one side – it was a natural reaction to the barrage of flash-guns she suddenly had to face.

Her first official function after her engagement to Prince Charles was a revelation, in more ways than one. Her car drew up outside Goldsmiths Hall, and when Diana got out, there was an audible gasp from the crowd. She was wearing an extremely low-cut, black silk taffeta dress and, as she bent to get out of the car, I think she revealed more than she had intended. Fortunately for me, I happened to be placed at exactly the right angle to capture the moment in all its magnificence! With that dress, Diana was showing the world just how good she could look. From that moment she threw off the Sloane look, with its floral prints and sensible tweeds, and was on her way to becoming one of the most beautiful, glamorous women in the world. She was transformed, from Lady Diana Spencer into Princess Diana. And she has never looked back.

Diana – in that dress.

Goldsmiths Hall, 1981

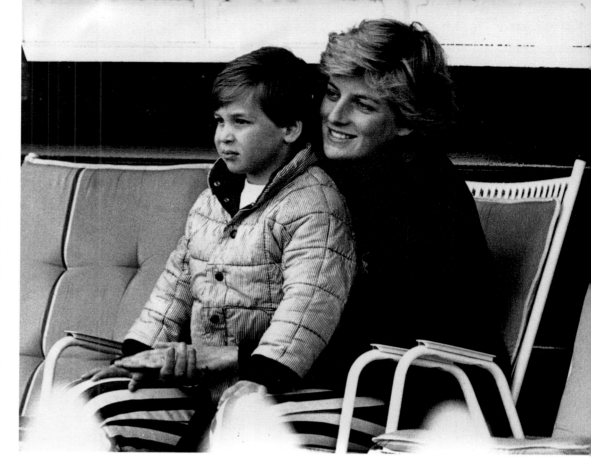

I understand that she got a bit of a ticking off from the Queen Mother, and, unfortunately, she has never worn anything quite so daring since. Not that she needs to. Diana is fabulously photogenic, dresses beautifully and I've never seen her looking less than fantastic. I think she enjoys the effect she has on people, and on some days she will play up to the camera by turning and looking straight at me with that gorgeous smile.

A good shot of Diana will always get into the papers and magazines, but anything slightly unusual will be used again and again to illustrate the hundreds of articles that are written about her. One of the best places to get good pictures is the polo ground, where she comes along with the children to watch Charles playing. I'm not sure that she's all that interested in the polo, but she spends time with her sons, meets her friends there, and turns it into a social occasion.

On one particular afternoon she went for a wander with William and got stuck behind a fence. She either had to go under or over it. She chose to go under the fence, and I have some lovely shots of the Princess of Wales crawling on the grass on her hands and knees! My favourite picture is a simple photograph of her cuddling William as she watches the game. Everyone loves to see her when she's just being an ordinary mum.

I have a lot of time to observe the royals during long afternoons at the polo ground, and Charles and Diana never seem that affectionate. I remember the occasion when he caught her sitting on the wing of his precious Aston Martin. He was really quite cross, and I don't think she took too kindly to being told off in public.

*Diana and William – mum's
the word she likes best.
Smith's Lawn, Windsor, 1987*

Earlier this year, Diana went to the Virgin Islands for a holiday with her mother, her sister and her children, but without Charles. On the day she flew out, I had been asked by the *Express* to photograph her coming out of San Lorenzo where they thought she was having lunch. While I was waiting outside in the car, I got a call from Rex, my agency, asking if I was free to follow Diana out to the Virgin Islands! I grabbed my Bermuda shorts and was on the next plane . . .

*Charles – the dent seems to be in
Diana's pride rather than his Aston
Martin. Smith's Lawn, Windsor, 1987*

there was a two-mile exclusion zone around Necker!

We went back to Virgin Gorda and waited. The days went by, and although I was enjoying a free winter holiday, I was slightly worried at the prospect of returning to the agency with no pictures. Every day the royal detectives would come over in their boat, and every day we would ask them if Diana would let us take some photographs. They would always say: 'Not today.' I might have given up, if it hadn't been for the Royal Ratpack. They told me that as the detectives hadn't refused them outright, it meant that the Princess would consent . . . eventually.

It was on the Sunday morning that our chance came. The detectives arrived at Gorda and told us that Diana would be on the beach with the children that morning. We were allowed to take photographs from a boat for 15 minutes. Now, what the world *really* wants to see is a shot of Diana in a swimsuit. Well, she *was* in a swimsuit – although she did have a sarong wrapped around her waist. The pictures still sold very well and, thanks to Diana, I had a prolonged winter holiday in the sun.

When you photograph someone a lot, some sort of relationship does naturally develop, and Diana has always been very friendly. I know it sounds soppy, but it does make me feel rather proud when the Princess of Wales, one of the most famous and beautiful women in the world, smiles at me and says: 'Hello, how are you, Mr Young?'

One lunchtime I was sitting at the bar of San Lorenzo, having a cup of coffee, when there was a tap on my shoulder. I turned round and there was Diana. It's not often the Princess of Wales suddenly turns up for a chat, so I was a bit flabbergasted. I managed to say something like: 'Have a lovely weekend and give my regards to the family!' On another occasion she introduced me to a friend as: 'One of the nicer photographers.' I think it was a compliment . . .

And then one night I was at a charity ball where the Princess was dancing with one of the organisers, while I was having a dance with a colleague. Diana moved over and said: 'I'm glad to see you taking some time off to enjoy yourself!' I didn't tell her I had my camera hidden under my jacket.

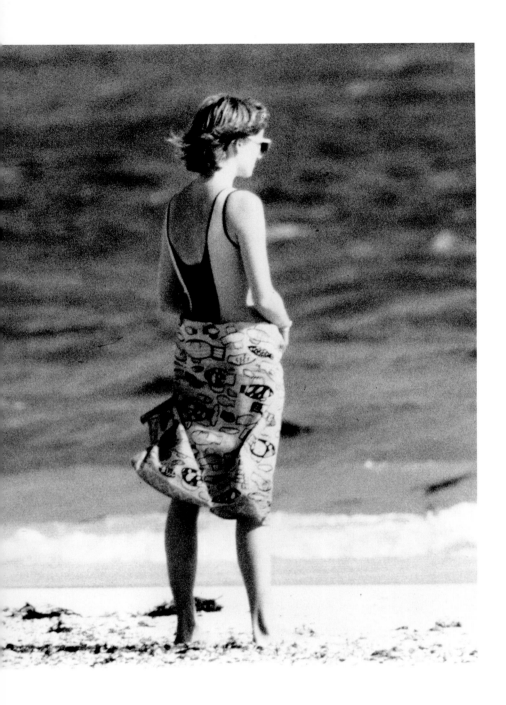

Diana – the world wants to see Diana in a swimsuit. She was prepared to compromise. Necker, Virgin Islands, 1989

Diana and her family were on Richard Branson's private island, Necker, so I booked in to the nearest hotel, which was on another island, Virgin Gorda, five miles away. A couple of royal photographers were heading there too, so we hired a helicopter to take us. On the way, we passed over Necker and, as luck would have it, Diana and the family were all on the beach directly below us, so we started taking shots from the helicopter. Suddenly, a police plane appeared and shooed us away. Over the radio, they told us that

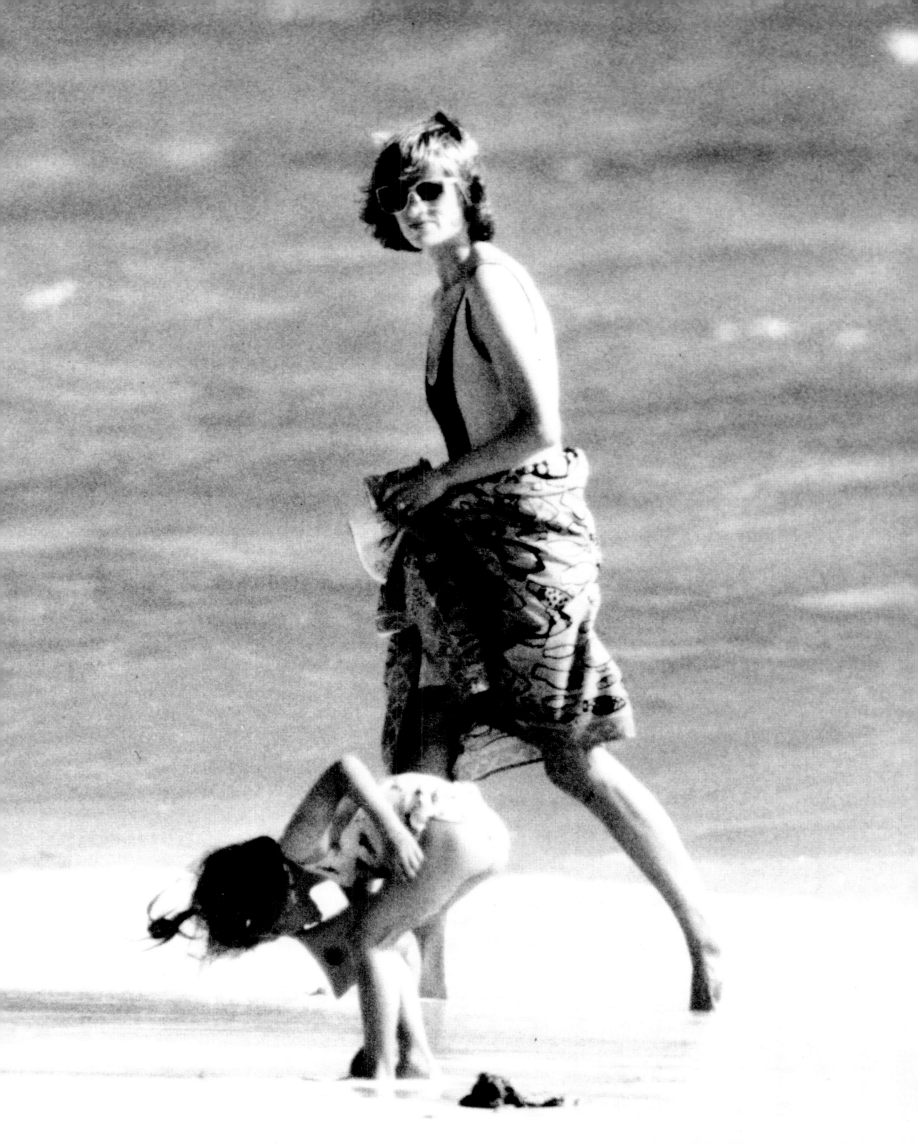

When Sarah Ferguson appeared on the scene she, naturally enough, got an enormous amount of attention. I think Diana was rather surprised when the spotlight shifted from her for a while, and I'm sure there was some kind of tension between the two women, even if it did not go beyond friendly competition.

However, when they are together in public, which isn't so often these days, they seem to have a lot of fun. I think it all got rather out of control at Ascot a couple of years ago; they were seen poking their umbrellas at some poor guy's bum, and I would imagine they were asked to tone it down a bit.

I spot Fergie out and about town in much the same way as Diana. I might catch her at polo, a rock concert, outside Harry's Bar. One night, Fergie was having dinner with some of her old flatmates in Harry's Bar. I had spotted the royal Rover outside, so I was waiting with a colleague to catch her coming out. Fergie emerged from the restaurant with her friends. She was obviously furious with her detective, and we heard her say: 'I don't believe you said that, I really don't!' She was looking extremely cross. Just as I raised my camera to my eye, her other detective jostled me in no uncertain manner. By the time I had recovered, Fergie had got away. My colleague got the shots, and they made the front pages of all the papers the next day.

Charles and Sarah Spencer —
a rare picture of them together.
Klosters, Switzerland, 1979

Fergie – looking . . . big.

Smith's Lawn, Windsor, 1988

Things have settled down a lot now that both Charles and Andrew are married. The photographers used to lead a pretty hectic life, chasing after every girl they were seen with. My first royal assignment abroad was to get shots of Charles with Sarah Spencer, Diana's sister, when they went skiing together.

I had been sent by *Bunte*, a German magazine, and they provided me with a car and a chauffeur. I was picked up at Zurich airport and I had no idea where to go. 'Take me to St Moritz,' I said. Well of course, Charles wasn't there, but a lot of photographers were. The next morning we were all milling around in the hotel lobby when calls started coming through from their papers, telling them to get to a place called Klosters, 60 miles away! We all jumped into our cars, shouted 'Klosters!' and zoomed off in convoy.

When we arrived, we spotted Harry Arnold, the royal reporter for the *Sun*, in a car travelling in the opposite direction. In a swirl of snow all the cars executed hairpin turns and followed him. We were led straight to the door of Charles' chalet, and just then Charles and Sarah arrived from their day's skiing. Everyone fell over themselves trying to get out of their cars and then extract cameras from their bags while running down the street.

Later in the week, I was in the car outside their chalet on my own – all the other photographers had got stuck somewhere. Charles and Sarah came back and I followed them down the street. They were carrying their skiing gear and they were quite close together. Those shots sold everywhere!

Charles has always had a fairly pleasant attitude towards photographers – it comes from years of experience. Besides, he can always get away. No one can follow him into Buckingham Palace! It's very different for the royal girlfriends: once the press have caught up with them, they are under incredible pressure, which is why Diana was moved into Kensington Palace with the Queen Mother as soon as the engagement was announced.

Before Diana came on the scene, every girl Charles went out with was also subjected to the paparazzo treatment. However, Charles had a high turnover of girlfriends, so fortunately no one girl was under pressure for too long.

Koo Stark's case was different. It seemed that Andrew was seriously in love with her, and the sky was the limit on the value of a shot of them together. Photographers shadowed her everywhere. I used to go down to her apartment and follow her into the West End on my motorbike. It was generally believed that she went to meet Andrew at Fortnum & Mason, in a room upstairs. On one occasion things got a little out of hand, and Koo was chased through the store by swarms of photographers. It can't have been very pleasant, but that's what can happen if you have a relationship with a member of the Royal Family.

I came very close to getting that elusive shot of the two of them together. One night I was standing around outside Tramp. I knew Andrew was inside, because I recognised his detectives' car parked by the front door. It was about 3am when suddenly these two policemen appeared, which was unusual. Stranger still, they stopped to talk to me. I was facing the front door and, behind me, I could hear the side door being opened up. I turned to look, and a policeman said: 'We'd rather you didn't look round, sir.' I said: 'You can't stop me looking wherever I want!' I just glimpsed Koo getting into a car, which then sped away, and at that moment Andrew came out of the front door and got into his car. That was the closest anyone got to catching them in the same place at the same time, and a very frustrating experience it was too . . .

Koo Stark and Bea Nash –
on the run from the paparazzi.
Fortnum & Mason, 1983

Exchanging confidences: Andrew and
Prince Philip – Badminton, 1982 –
Fergie and Diana – Smith's Lawn,
Windsor, 1987

As long as the magic word Princess appears somewhere, some newspapers seem to print anything that comes into their heads. There has been a lot of gossip about Princess Anne's marriage over the years. At one point there was speculation that she and actor Anthony Andrews were fond of one another. It's true that the royal couple and Andrews and his wife are good friends; they share a great interest in horses and so they frequently meet up.

One night I was working at a charity gala night at Simpson in Piccadilly. Princess Anne was sitting next to Anthony Andrews. I was watching them towards the end of the dinner, as they sat together in the glow of the candle-light. They looked very cosy and relaxed, and she had this half-smiling, dreamy expression on her face. Frankly, she looked like a woman in love. I took a shot of them, and it was used in the papers the next day, with a suitable caption. The picture seemed to confirm all the rumours – it didn't show, however, that Anthony Andrews' wife was sitting a few feet away!

Some photographers will go a lot further than that in the hope of a royal scoop. Certain newspapers are constantly trying to rake up some royal scandal, and they are always looking for shots of royals to hang their stories on. One photographer waited around in some dark alleyway until the small hours, in order to get anything which could be construed as a compromising shot of Diana leaving a private dinner party. I don't work like that. Firstly, the shot wouldn't be worth it because of the bad feeling that it would arouse. I'd find myself coming up against a lot of closed doors. Secondly, although it may sound strange, I think that sort of photography amounts to an invasion of privacy.

Unless it's for charity work, I think Anne feels that *any* photographs of her are an invasion of privacy. On one occasion last year, I caught her in a rare situation. Not only was she coming out of a nightclub in London – Harry's Bar – but she was also with her husband (and, I have to say, Anthony Andrews and his wife). For once I think Anne was quite pleased to be photographed. She wanted some pictures of herself and Mark to get into the papers in order to counteract the rumours about her marriage.

Princess Anne and Anthony Andrews –

people will say we're in love. Simpson,

Piccadilly, 1986

The Queen – a mac, a headscarf, dark
glasses. For most people, a disguise;
for the Queen, a trademark.
Badminton, 1980

When the Queen is not on an official engagement, I think she probably feels the same way, though she would never show it. She is not relaxed in front of the camera, and the best shots of her are taken when something has really caught her interest. Then her face relaxes and she looks charming. I don't know what Joan Collins said to her when they met at a concert at the Albert Hall, but she obviously appreciated it, because her smile is full-strength, warm and genuine.

The Queen's real passion is for horses, so usually I get good shots of her at the main horsey events – Badminton, the Royal Windsor Horse Show, the Derby and Ascot. She's often so absorbed in what's going on at these events that she lets her guard down, and I can capture much more animated, interesting photographs of her. I especially enjoy Badminton: the royals are walking about and taking part, rather than being placed behind barriers or in special enclosures. There's usually a pack of about 30 photographers, and we all tend to lose a lot of weight at Badminton. The royals travel around the course in Range Rovers, and we are left to run after them, carrying all our equipment!

I think the Queen enjoys watching her son playing polo too, although she doesn't get the chance to do so very often. I find it very touching, the way he kisses her hand when she awards him a prize. She tends to arouse that sort of feeling in people and I always enjoy photographing her for the simple reason that she's the Queen.

Obviously, it's not that often that you get a paparazzo shot of Her Majesty. She's not likely to be out on the town, in restaurants or nightclubs. One night, though, I was outside the Ritz Hotel, and the Queen came out after attending her sister's 50th birthday party. For a brief second, no one was close beside her, and I caught a shot of her alone, looking for all the world like a tired, middle-aged housewife after a night at the theatre.

One of the stiffest and most embarrassing photo-calls involving the Queen was when she went riding with former US President, Ronald Reagan, at Windsor. I think the whole event was too stage-managed and Americanised for the Queen's liking. That's not her style at all, and it showed. After they had set off for the ride, many

The Queen – a rare shot of the monarch

alone for a moment, leaving the

Ritz after Princess Margaret's

50th birthday party, 1980

of the photographers left. I hung around. I was trying to work out how Reagan was going to get back to Westminster in time to give a speech that afternoon. I decided that he must be using a helicopter and, on the off-chance, I went up to Smith's Lawn, which was an obvious area to use as a landing-pad. I got there and, sure enough, there was a helicopter hovering above. It landed in the far corner of the field, and some people got out, carrying shoes and a handbag, followed by the Queen Mother! They were all walking in my direction, and when the Queen Mother drew near to me, she stopped and asked what I was doing there. I explained and she said: 'Oh no, no, no. The only reason the helicopter is here is because the damn thing has a fault. I was supposed to be on my way to Margate.'

Everyone loves the Queen Mother, and photographers adore her. She enjoys life and doesn't mind who knows it. She is a very experienced subject for the camera. She knows exactly the angle and the type of shot that the photographers need, and she is always happy to provide it.

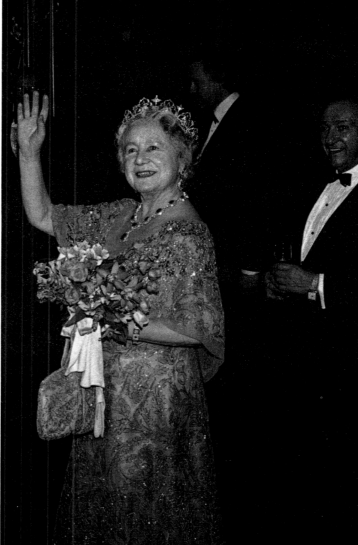

The Queen Mother – arriving in style.

Smith's Lawn, Windsor, 1984

The Queen Mother – everyone's

favourite royal. Her Majesty's Theatre,

Piccadilly, 1988

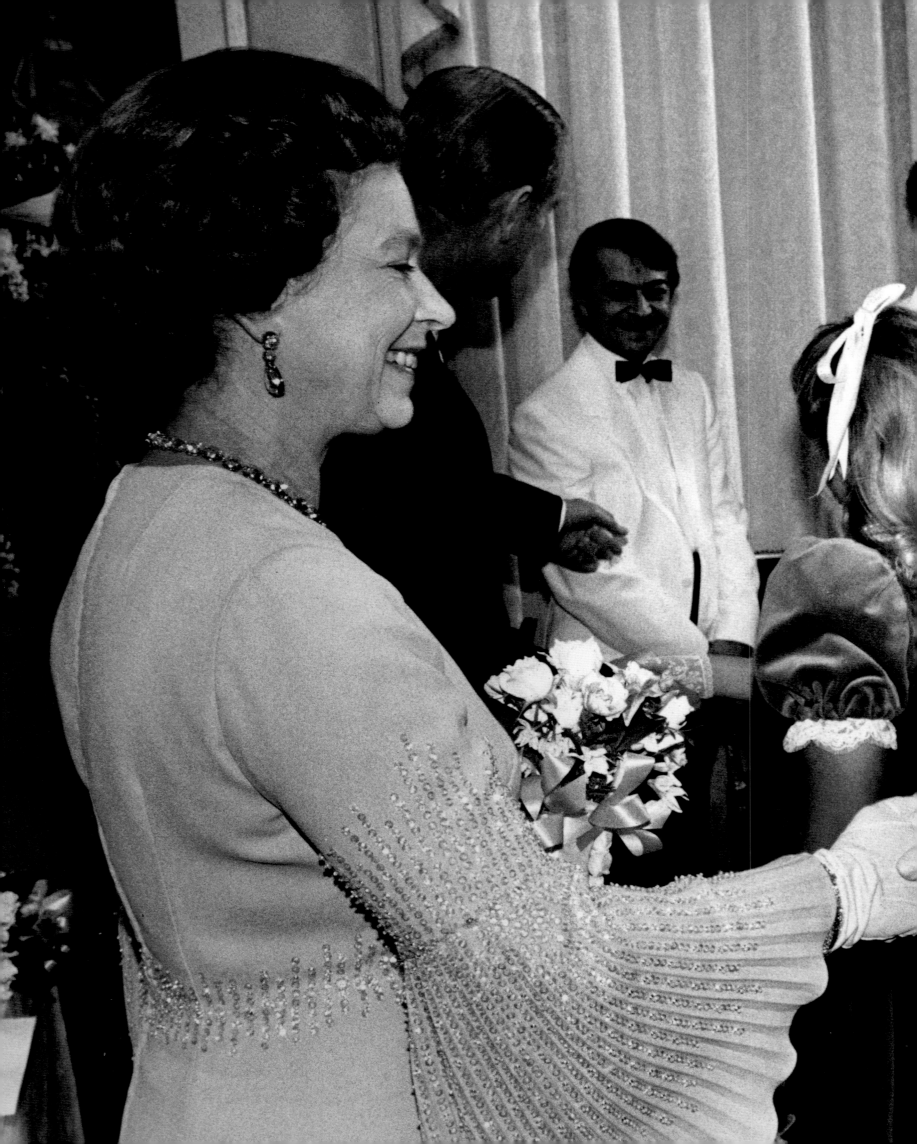

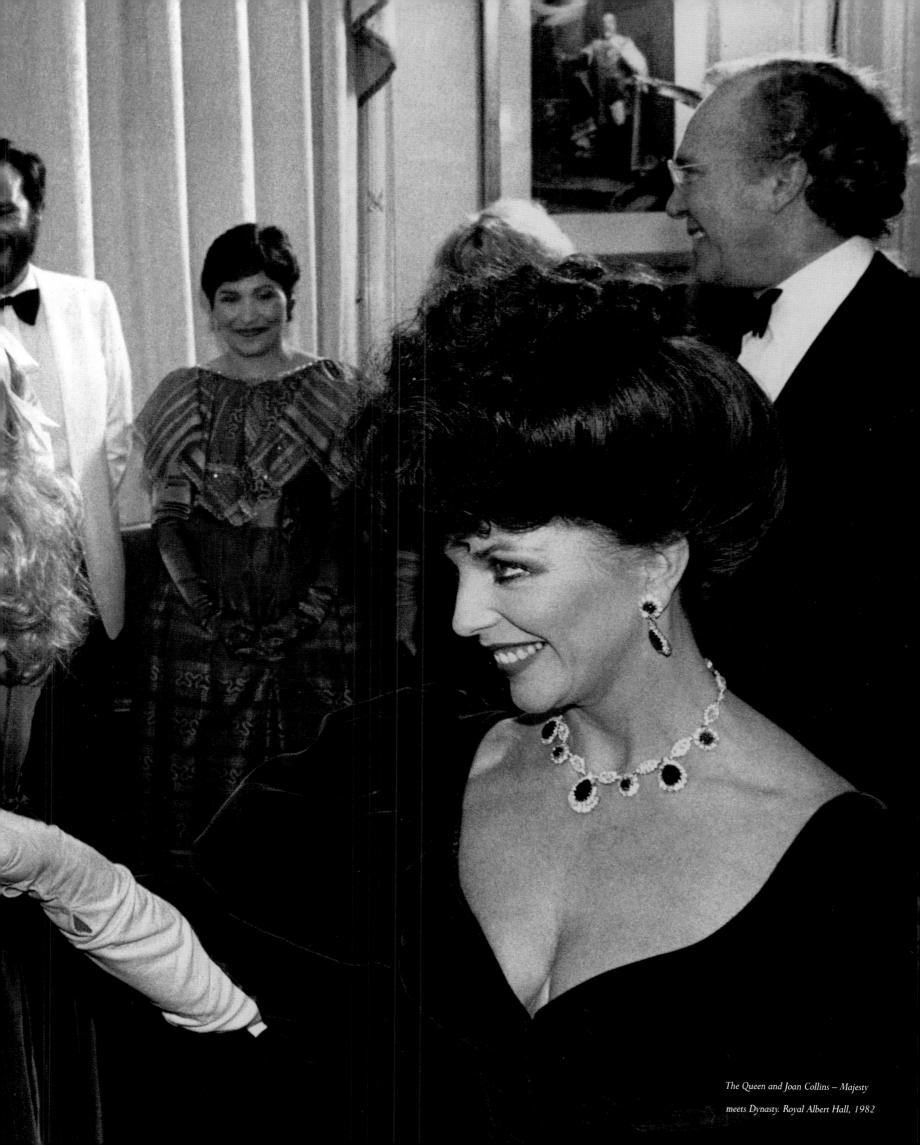

The Queen and Joan Collins – Majesty meets Dynasty. Royal Albert Hall, 1982

Princess Margaret, on the other hand, has a different attitude. She tends to be very protective of her royal position, and particularly dislikes any pictures being taken of her smoking or drinking. But she and the other royals do seem to have a sixth sense about cameras. One minute they have a glass in their hand, the next minute it has disappeared.

One night I was invited to Maidenhead, to cover the official opening of a nightclub by Princess Margaret. The royals are roped into doing the most extraordinary things in the name of charity. But worse was to come. After the dinner, the organisers started up a game of bingo! Everyone was supposed to join in, so Margaret could hardly refuse. There she sat, the Queen's sister, filling in this bingo card as the organiser shouted out the numbers! I couldn't resist the temptation to take some pictures. Margaret didn't look too pleased. The next minute I felt this hand on my shoulder, and her detective said: 'Come on, hand over the film.' I said, 'Don't be silly.' I wasn't going to hand over pictures like that without a fuss, so he just said: 'Don't take any more,' and walked off.

My favourite pictures of Margaret were taken one night at a big charity gala dinner at Maxim's in London. It was about midnight, and I'd taken some nice shots of her dancing. She was just leaving but, on her way out, she went past the piano where two guys were playing some honky-tonk music. She went over to them and asked if they knew certain tunes. They did, so Margaret started singing. She was really enjoying herself, waving her arms about and singing away. She stayed until three in the morning – and so did everyone else, because no one could leave before her. Everyone else got a bit tired, but I got some wonderful material!

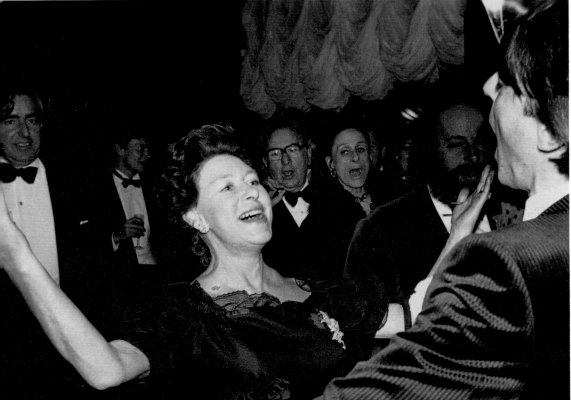

Margaret – the heart and soul of the party: playing bingo at Maidenhead in 1979; singing at Maxim's, 1983

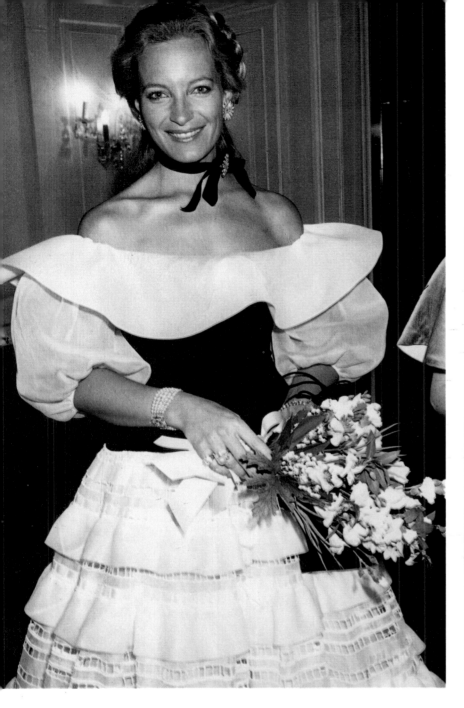

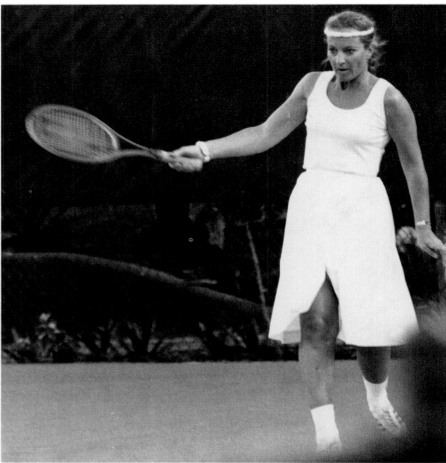

Princess Michael always used to give me good pictures – once she even said I was her favourite photographer. I remember her posing for me at some charity ball in a dress that I don't think did her justice. I sent her the pictures and she wrote back saying that they were the nicest photographs she'd ever had taken!

Unfortunately, my friendly relationship with her deteriorated a few years ago. Peter de Savary had invited me out to Antigua, to take photographs of the opening of a club he owned on the island. The Prince and Princess Michael were flying in for the official opening and were planning to stay for a few days. I was wandering around the club grounds one day, and I saw the Princess on the tennis court. I went up and took some pictures. I admit she didn't look glamorous; she had no make-up on, her hair was scraped back and her legs aren't fantastic, but then few women look great in sportswear. I thought it made a good picture – a royal looking like anyone else for once. Princess Michael didn't see it like that. When the picture was published she was furious, and when I next met her, she refused to let me photograph her and would barely speak to me.

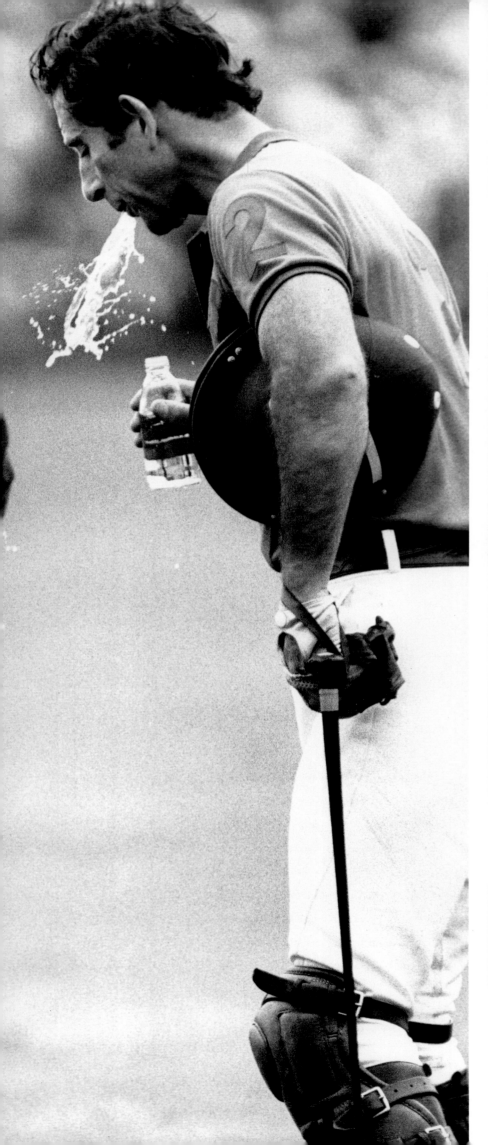

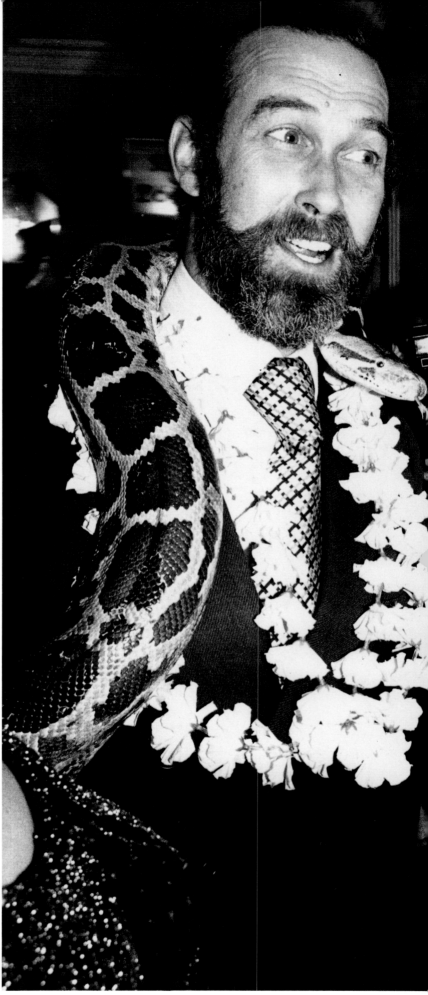

Charles – a spitting image.

Smith's Lawn, Windsor, 1986

Prince Michael – smiling in the face of

certain constrictions. St James Club,

London, 1985

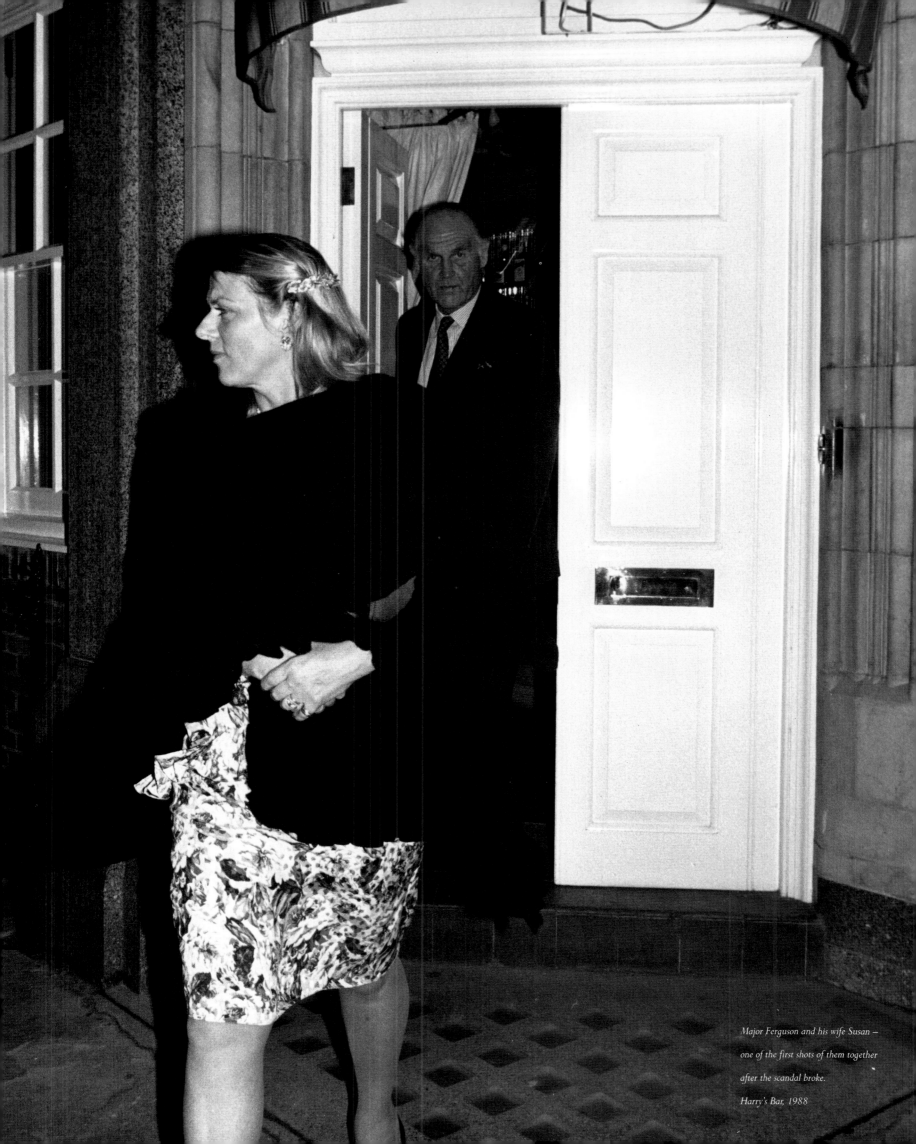

Major Ferguson and his wife Susan —

one of the first shots of them together

after the scandal broke.

Harry's Bar, 1988

Edward – showing his credentials at the opening night party for Aspects of Love, 1989

Viscount Linley – one of the few pictures of a royal being frisked. Hammersmith Palais, 1986

Susannah Constantine and Viscount Linley – back in the Sloane days. Private party, 1984

In general, the younger royals are more friendly. I find Andrew will chat quite readily, particularly since he's taken up photography. I offered to take him out on the town with the rest of the boys, so he could see what it's like at the sharp end of the business. I think the idea appealed, but he had to decline . . .

Prince Edward has a good sense of humour. I like the way he turned up for his first day at work clutching a box of teabags! It seems as though his work colleagues really do treat him like an ordinary employee. On the first night of *Aspects of Love*, Edward turned up for the after-show party and was asked for his invitation! It's not often a member of the Royal Family has to show his credentials . . .

That reminds me of a similar occasion at a charity do in Hammersmith. There had been some terrorist activity in London, and everyone, but everyone, was getting frisked at the door. It was slightly unusual for members of high society to be body-searched, and I was busy taking photographs of it all. It was when I got a shot of Viscount Linley with his hands up that the organisers decided they could do without my presence. The next minute I was flying through the air . . .

Linley himself is very pleasant. Like me, he's a motorbike enthusiast, and I have been trying to persuade him to buy a Harley Davidson for the last couple of years. He has been with the same girlfriend, Susannah Constantine, for a long time now, but recently she has undergone a dramatic transformation. I don't know if it's because she's now in the fashion business, working for Alistair Blair, but she has lost a lot of weight, thrown off the dowdy Sloane image, and emerged as a very glamorous young woman.

A while ago Linley's sister, Lady Sarah Armstrong-Jones, and her second cousin, Lady Helen Windsor, were constantly being followed around town by photographers. They are both very attractive young ladies and Helen, in particular, always seemed to have a different young man in tow, so a picture always made the diary pages of newspapers. Now the pressure seems to have died down a bit. I have a feeling that the young royals have been warned, for security reasons, not to be too predictable about the places they frequent, and to adopt a lower profile around town.

Lady Sarah Armstrong-Jones – out on the dance floor at a private party, 1983

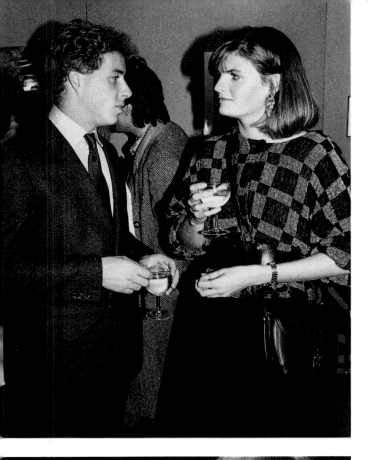

Susannah – stepping out,

streamlined and glamorous,

at The Camden Palace, 1988

It's not only the young royals who get chased about. The high society antics of the aristocratic and the super-rich at all these balls and functions also make very interesting material for the paparazzo photographer.

I like to keep up with what's going on in the lives of the glitterati. I take photographs of the aristocratic and powerful because you never know when they're going to become news-worthy. Embezzlement, fraud, adultery, marriage and divorce can all put them on the front pages and, if they've left the country or gone into hiding, the papers need whatever shots they can get, the more up-to-date the better.

So it's not only the royals I cover at places like Ascot and the Derby. First of all, I'll position myself by the gates and photograph everyone arriving. On Ladies' Day at Ascot all the women are dressed up to the nines and the photographs generally make a good fashion spread. After that I go over to Car Park One where all the aristocrats have parked their BMWs and Rolls-Royces. Some invite all their friends to lunch, and they sit around in the Car Park, all these lords, ladies and marquesses, eating smoked salmon and caviar and drinking champagne.

At the Derby I go to the Ever Ready Marquee which is hosted by Sir Gordon White; he invites all the big stars who happen to be in town, like Roger Moore and Joan Collins, to name but two. I wander around and take pictures until it's time for them to sit down to lunch. These events are an odd mixture of informality and glitzy glamour, but it suits me fine . . .

In general, the young royals and the high society with which they mingle are fairly easy to photograph. They are there in all their splendour, at charity balls, at Ascot, at the Derby, at Badminton and at Wimbledon. They are dancing, drinking and doing what they do best – enjoying themselves. And, for most of the time, they have no objection to being photographed doing just that.

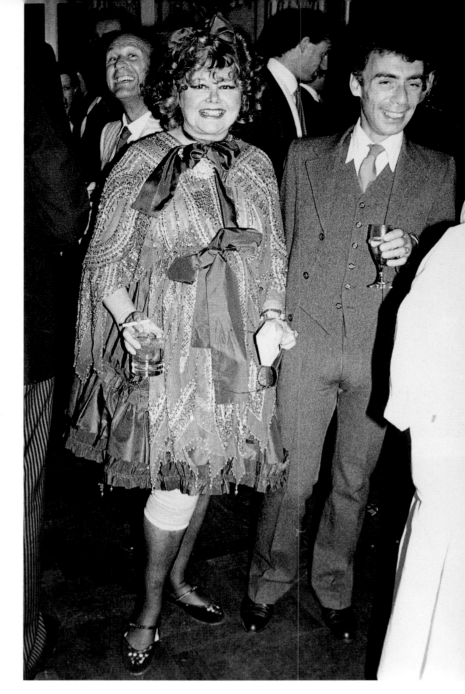

Bubbles Rothermere – one lady who really knows how to host a party. 1987

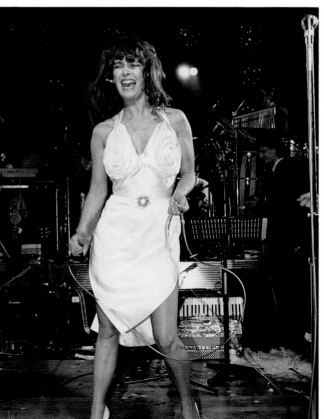

Teresa Manners – the aristo who took to the stage with The Business. The Hippodrome, 1987

Soraya Khashoggi – once the wife of one of the richest men in the world, to my surprise – and hers – I caught Soraya in her little-known role as a stallholder in Antiquarius, the antiques market in the King's Road, 1988

The Big Shots

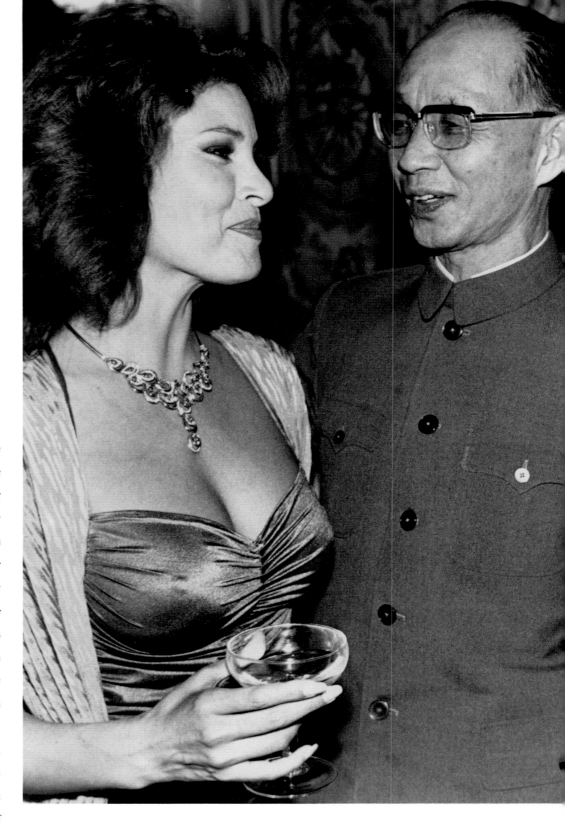

In the highest echelons of fame are the people who have been stars for a very, very long time. The reason for this is usually that they are talented, or beautiful, or both, but nine times out of ten it also means that they are very pleasant people, otherwise nobody would have put up with them for that long. These people are stars with a capital 'S' and their lifestyles are luxurious and glamorous. They belong to a very exclusive club. Wherever they go in the world, they have a *carte blanche* invitation to the best parties, restaurants and nightclubs where they meet their friends – who just happen to be other stars of the same calibre. They accept, and have come to expect, public recognition and adulation, and most of them react to it as real stars should – with charm and grace.

This means that they are some of the easiest, and most pleasant, people to photograph. They are used to living the life of a star 24 hours a day, and being photographed is a part of that existence. It happens wherever they go, and they recognise the value of publicity for keeping their chosen image in the public eye.

That is why you would never get people like Raquel Welch or Sophia Loren shying away from the camera. They know the game inside out, and they are not surprised or shocked to find photographers at the premières, the first-night parties or the restaurants that they frequent. They simply turn their dazzling smiles on you, get snapped and get on with the party . . .

Raquel Welch – fostering cultural exchange with the Chinese Ambassador to London. London Palladium, 1978

Sophia Loren – unperturbed by the camera. Claridge's, 1984

Diana Ross – she didn't mind who saw
her enjoying herself; her partner
obviously had nothing to hide either.
The Embassy Club, 1979

Responding to the camera with a relaxed attitude generally gives the stars more freedom than if they react with hostility. Trying to hide from the cameras makes some celebrities prisoners of their own success. I was once at the Embassy Club in the early eighties when Diana Ross arrived. She was on tour and she obviously felt like a bit of relaxation. She boogied the night away with some extraordinary partner she found – who was dressed only in underpants, waistcoat, suspenders and fishnet tights! Still, Diana seemed to enjoy herself and was perfectly happy to be photographed. . .

On another occasion I was at Stringfellows. Marvin Gaye was there and then Stevie Wonder, who was on tour at the time, arrived. They got together and played the piano until 3am. It was fabulous; there were about 50 people gathered round them having the time of their lives. Now, I don't suppose you'd get that happening with some pop stars I could mention . . .

Stevie Wonder and Marvin Gaye –
prior to their impromptu concert
at Stringfellows, 1983

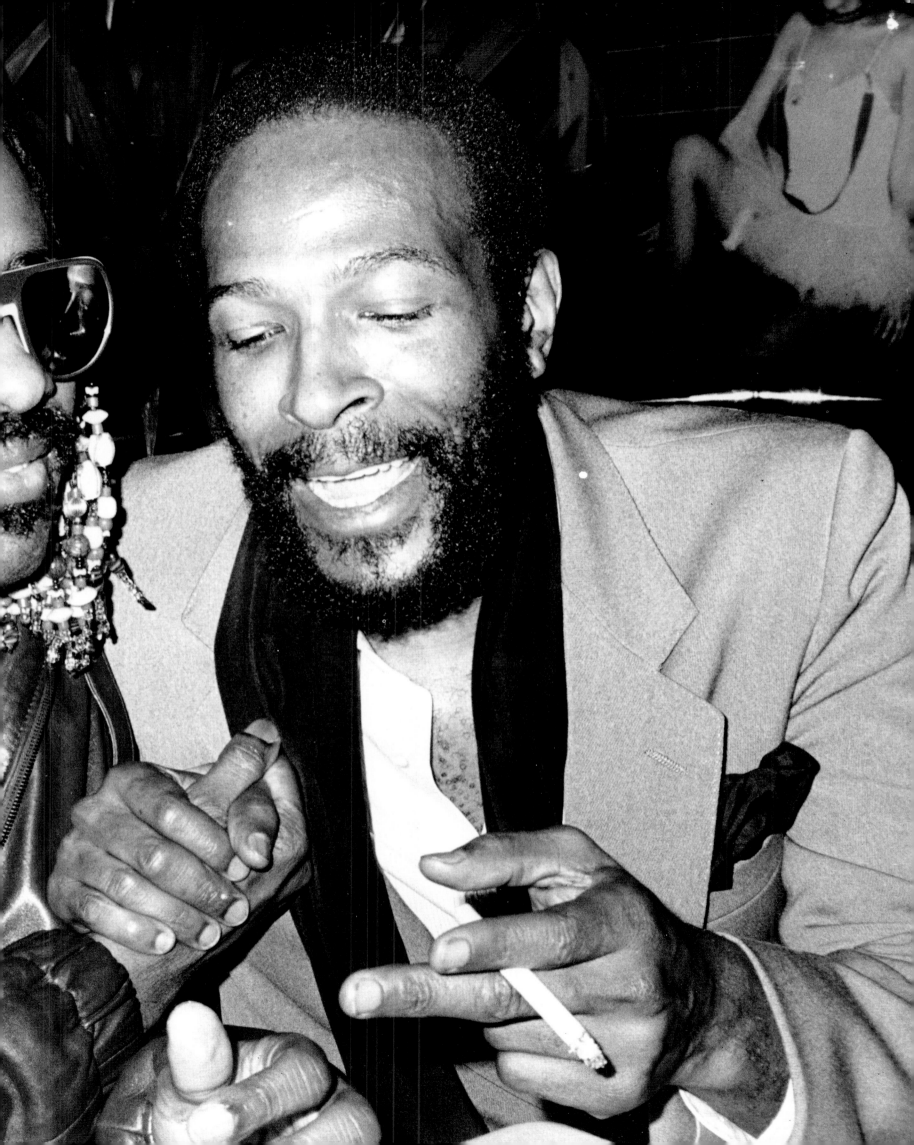

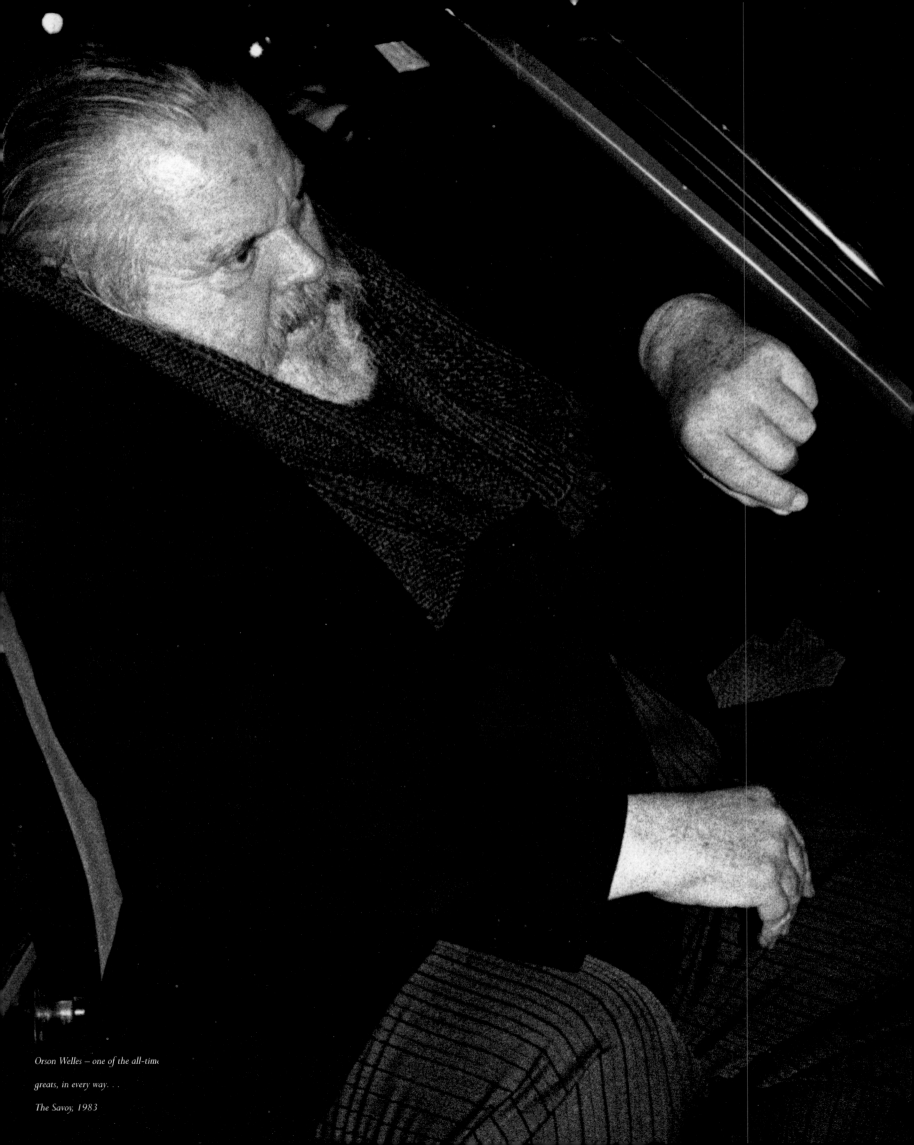

Orson Welles – one of the all-time

greats, in every way. . .

The Savoy, 1983

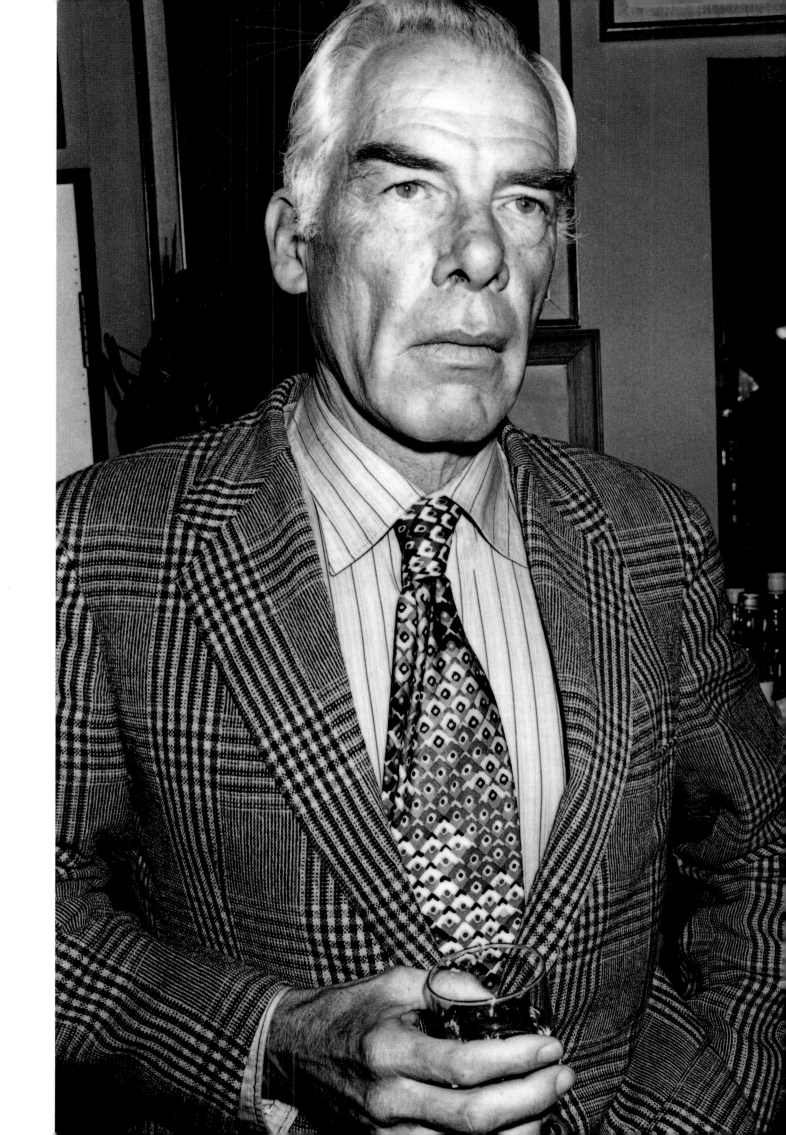

Lee Marvin – lean and mean.

Soho, 1976

Of course, with cameras following them around constantly, the stars can't enjoy themselves *and* pose and smile all at the same time. I'm not going to get Jack Nicholson putting down his cases at the airport in order to stand around and give me a big grin. He doesn't want loads of shots of him smiling into the camera in the newspapers. It doesn't suit his rather mean and macho image. He just gets on with whatever he's doing, and I get on with snapping him in the act.

You have to remember, though, that these people are all showmen and performers. Many of them can't resist hamming it up in front of the cameras. One day Nicholson was in town, and I seemed to meet up with him everywhere: I went to lunch at San Lorenzo and he was there; that evening I covered the Michael Jackson concert and he was there; later that night I was outside Tramp and there was Nicholson again! And this time he *was* in the mood for playing up to the camera.

Donald Sutherland, on the other hand, always seems to be in the mood for goofing around. On one occasion he was working in London, and I spotted him leaving Langan's with a hat on. He grinned cheekily at the camera and raised his hat. Underneath, he was bald! I found out later that he had had to shave his head for the role he was playing, but it gave me quite a shock at the time.

One evening I caught him having dinner with Sean Connery. I took a shot of them together, but I thought Sean Connery was looking rather odd. Sutherland came up to me afterwards and said: 'Do you want to know why Sean was looking so weird? Just as you took the photograph, I grabbed his balls under the table!' I think Donald in real life is fairly close to the character he played in *M * A * S * H . . .*

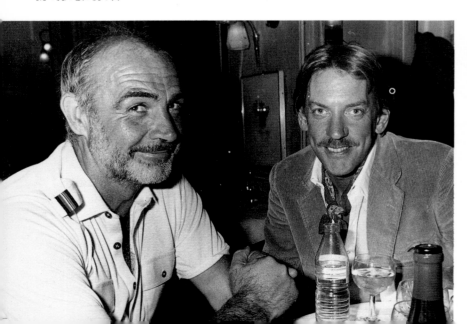

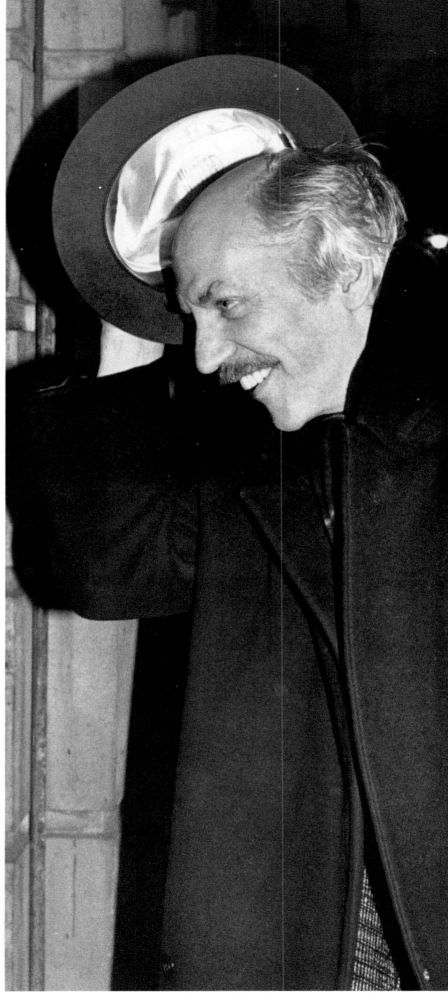

Sean Connery and Donald Sutherland —
a wry grin from Sean. Donald confessed
he had grabbed his balls under the table
as the camera clicked. Langan's, 1980

Donald Sutherland – greeting me

outside Langan's, 1988

Jack Nicholson – Jack the lad.

Mayfair, 1988

Jack Nicholson – still boogying as he leaves Tramp at 4am, 1988

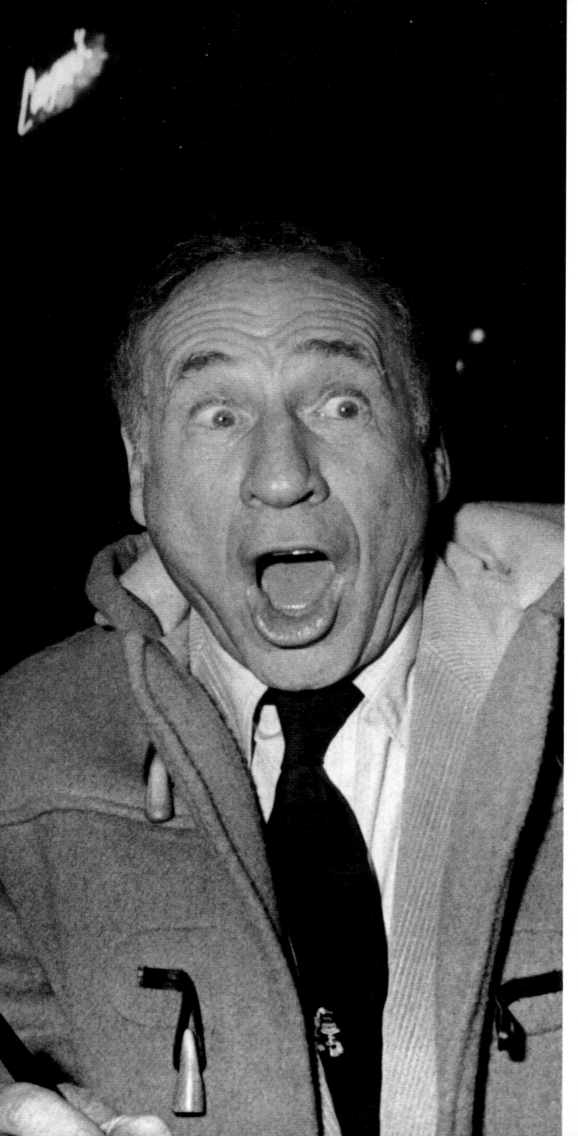

Whenever I have seen Mel Brooks, he is always exactly the same as he is in his films. He never stops being a comic, and as soon as a camera appears he seems to go into top gear. I think comedians of the old school, in particular, feel that they have to keep up their image whenever they are in public. They are, in any case, naturally very funny people, so it comes easy to them.

George Burns has it down to a fine art. *His* photo-call was one I did attend, because you don't often get the chance to see him over here. He was in London for a Royal Variety performance, so I went down to the Ritz to check things out. George Burns always looks as though he's in the middle of a wisecrack, which he usually is, and his photo-call was pretty lively I can tell you.

Of course, these people are well aware of the value of publicity. Steven Spielberg was only too happy to play around at the première party for *Raiders of the Lost Ark*. After all, publicity was what the whole party was about. This principle works just as well when I catch shots of stars unexpectedly.

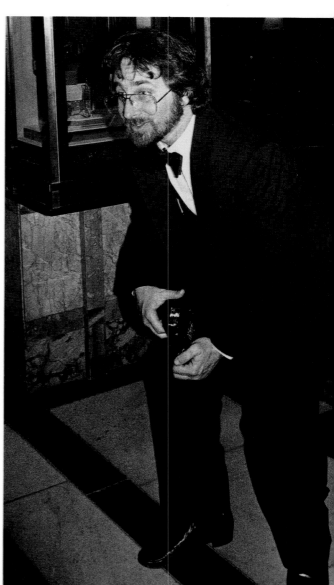

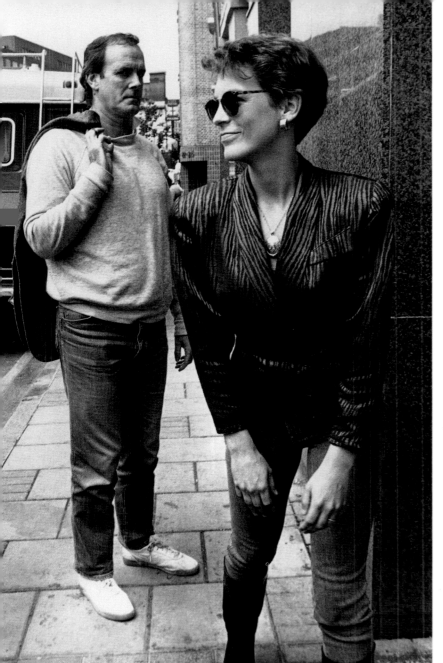

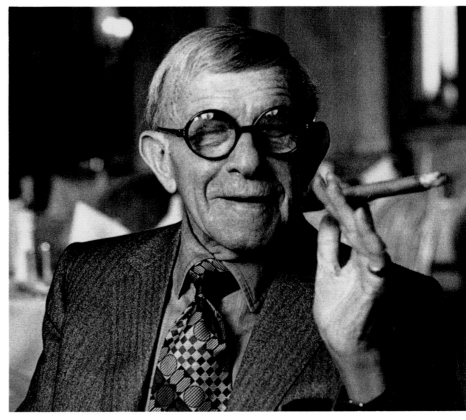

John Cleese and Jamie Lee Curtis –
hamming it up on the set of A Fish
Called Wanda. *Clerkenwell Green,*
1987

George Burns – wise-cracking
at the Ritz, 1985

I was on my motorbike on my way back to the newspaper office a couple of years ago. There was heavy traffic, so I took a detour through the City. I ended up near Clerkenwell Green and I saw some location trucks, so I stopped. It was the set for *A Fish Called Wanda* and John Cleese was standing outside his trailer, so I went up and said hello. I've known him for some time, so we had a chat, and then Jamie Lee Curtis came out of her caravan and asked if it was time to go to lunch. I suggested taking some shots of them going down the street. Jamie Lee wasn't too sure, but John said: 'Go on, he's alright.' Once she'd been persuaded to do it, Jamie Lee played up beautifully and I got some lovely shots of them together.

In general, I manage to get onto the film sets I am interested in.

I get tipped off as to the location and I am usually known to the PR people, so they don't mind me turning up to do some photographs. On one occasion I arrived on the set of *Revolution*. The film-makers had transformed Kings Lynn into New York Harbour in the 18th century – it was magnificent. Since they were using the main high street it was hardly a closed set, and I stayed up there for three days, getting some shots of Donald Sutherland, Nastassia Kinski and Al Pacino on and off set. I must say, being the official stills man on set must be the most boring job known to a photographer. They are stuck there for the duration of the filming, taking photographs of the same people in the same situation day in, day out. I far prefer the excitement and precariousness of being a freelance.

Steven Spielberg – fooling around
at the Savoy, 1985

127

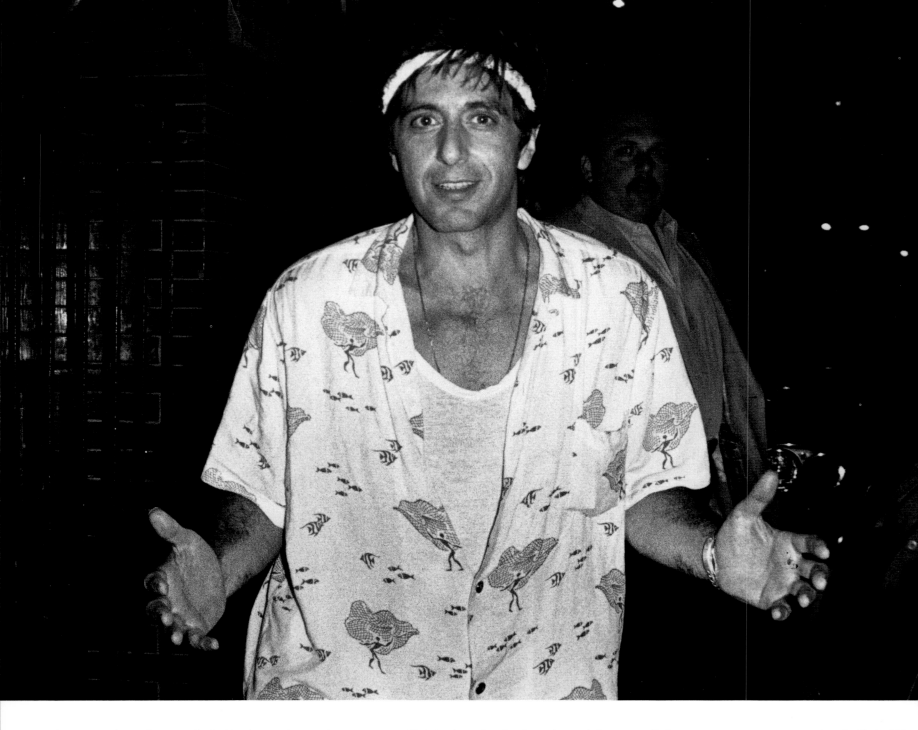

Al Pacino is a hero of mine, so I take his picture whenever I can. I caught a lovely shot of him in a typical Pacino pose after the first night of a play he'd brought over here from Broadway. He's always been very friendly and I wouldn't want any problems to arise between him and me. You should avoid upsetting your heroes; if you have a row with them about taking photographs, that special feeling will disappear.

Some stars go out of their way to attract attention by their unexpected antics for the camera. I remember seeing Billy Joel and Christie Brinkley coming out of a restaurant just before they got married. They decided to give us something different from the usual 'we are a couple' shots. So they started fooling around and

Christie threw her hands up in mock horror at all the cameras. They gave me some great pictures – which show just how the camera can lie!

Right at the beginning of my career, I chanced upon Princess Grace of Monaco with Prince Albert and Princess Stephanie, having a late dinner at Langan's. I waited and waited for them to finish, then I took shots of them leaving. They were very pleasant about it, and I kept on snapping as they got in their car. Then Stephanie suddenly started to play around, hiding her face but, at the same time, revealing a lot of thigh. I got some wonderful shots of those regal and unforgettable legs!

Al Pacino – my hero. Joe Allen's, 1985

Billy Joel and Christie Brinkley –
playing up to the camera in a taxi
outside Langan's, 1984

Princesses Grace and Stephanie – her
mother was all charm, Stephanie
all legs. In a limousine outside
Langan's, 1981

129

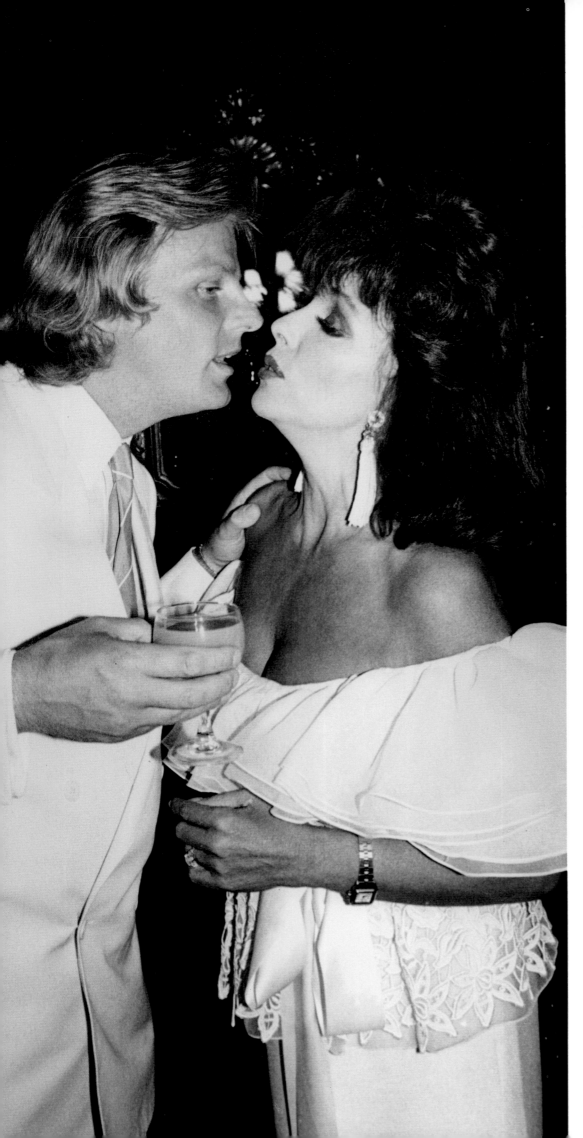

Big stars know the value of publicity, not only for the film or play they are starring in at the time, but also for their personal image. I have photographed Joan Collins for the last 15 years, at premières of films like *The Stud* and *The Bitch*, at nightclubs, and then throughout her 'exile' in Hollywood during the *Dynasty* period of her career. She has always been a big star, and behaves like one. She takes enormous care to look her best, and always does. Whatever newspapers might say about her, I have never seen her behave less than charmingly to her public.

When Joan fell in love with Peter Holm, everyone was pleased she had found someone who could make her happy. When their engagement was announced, though, something happened which made me wonder if he *was* the right man for her.

They were in Antigua for the opening of Peter de Savary's new club, and I was covering the event. I had taken lots of pictures of Peter and Joan together, showing off the engagement ring. The next morning, Peter came up to me and offered me an exclusive session of him and Joan together, for a certain fee. I told him that I had already taken pictures of them, the night before. He said that this session would be different, because they would be in their swimsuits. I said that I didn't think it would be very exclusive, as there were swarms of photographers all over the place! I'm sure Joan knew nothing about it as she's always been very happy for me to take photographs of her quite freely. However, I think Peter was furious at the thought of his nice little earner disappearing.

Dirk Bogarde – one of the greats.
The Dorchester, 1981

Joan Collins and Peter Holm – she
wants to kiss but all he wants to do is
tell. Private party, London, 1985

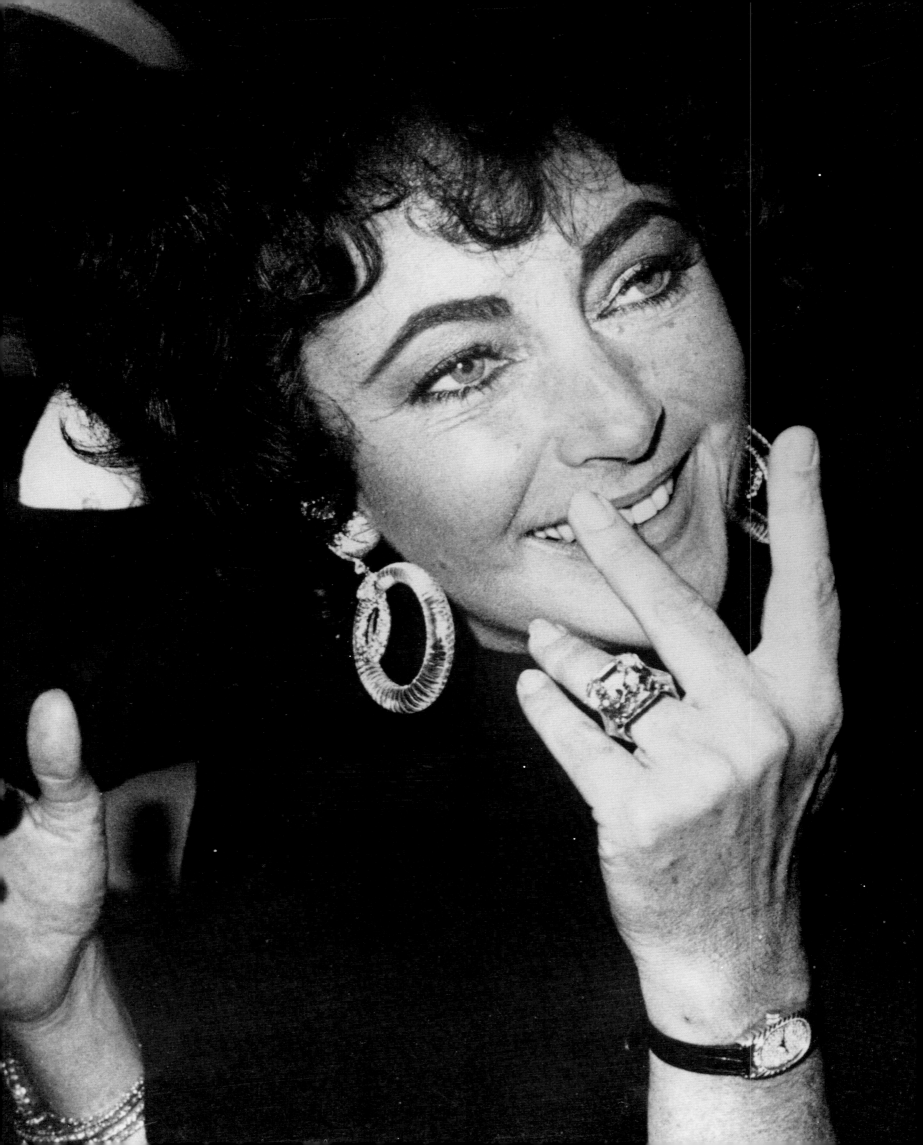

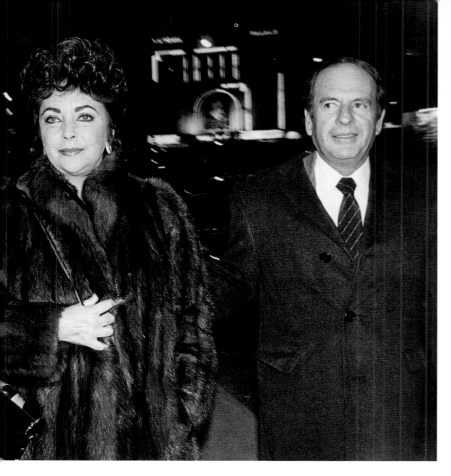

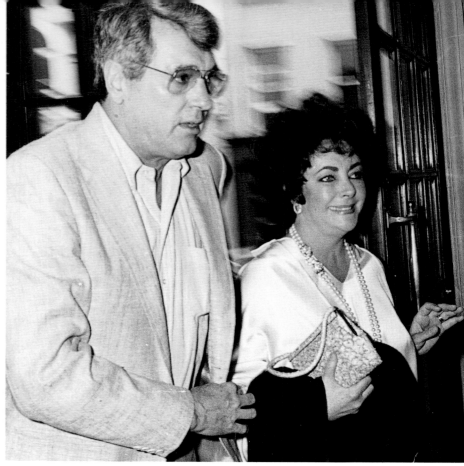

Joan is the sort of star whose picture gets into the papers, whatever she's doing. The same obviously goes for Liz Taylor. When I look at the pictures I've taken of Liz over the years, they tell a story about someone who lives life to the full. Everyone has their own little vices, smoking, eating, drinking, but Liz tends to do everything more extravagantly than anyone else, which I think some of the photographs reveal only too well.

Liz has always been very pleasant to me, and over the years she has supplied me with some of my biggest exclusives. One of these was during the period when she was involved with Senator John Warner. I had been flown over to New York by a record company to cover a concert at Radio City Hall. I was sitting at the bar of the Waldorf Astoria before the concert, when a friend of mine told me that Liz Taylor was there with John Warner. She was due to award prizes at a function for the Best-Dressed Male in America. I went upstairs and found Liz and the Senator coming out of an ante-room, on their way to the function. She said: 'What on earth are you doing here?' I told her and she let me take some pictures. The American photographers were furious. They had been held back and were behind Liz and John, so they ended up only getting pictures of their backs . . .

Liz Taylor — whatever her

measurements, she's every inch a star.

Here she is with Victor Luna,

Rock Hudson and John Warner

Liz Taylor — a regal wave.

Belgrave Square, 1975

With stars of this stature, it pays many times over to establish and maintain a good rapport with them. For instance, there was the night Liza Minnelli was having dinner with Shirley MacLaine and Richard Dreyfuss. Obviously, I wanted to get a shot of all three together, but there were about 15 photographers outside and I knew that the group would break apart and get into their limos when they emerged. So I went inside the restaurant and waited at the bar. When they had finished dinner, Liza spotted me. She came over, gave me a kiss and we had a chat. I told her that there was a pack of photographers outside and asked if she would pose inside with the other two. She said, 'Of course,' and I got some charming shots of the three of them. Then they put on their coats and dived

outside to their limos – so no one else got them together!

Sometimes it's the people between you and the stars, the management, who try to stop you getting a photograph, but I never let them put me off. Recently I heard that Diana Ross was throwing a surprise party for her husband at Mark's Club. I went down there, and her people practically threw a fit because they thought that my presence on the pavement outside would give the game away. I suggested that they invite me inside, but they wouldn't hear of it, so I stayed put. When Diana herself did arrive, she couldn't have been more charming, and I took lots of lovely shots.

Liza Minnelli, Richard Dreyfuss and
Shirley MacLaine – the inside job:
the other paps were on the pavement.
Langan's, 1989

Robert Mitchum – still as tough and
hard as ever. Filming in England, 1978

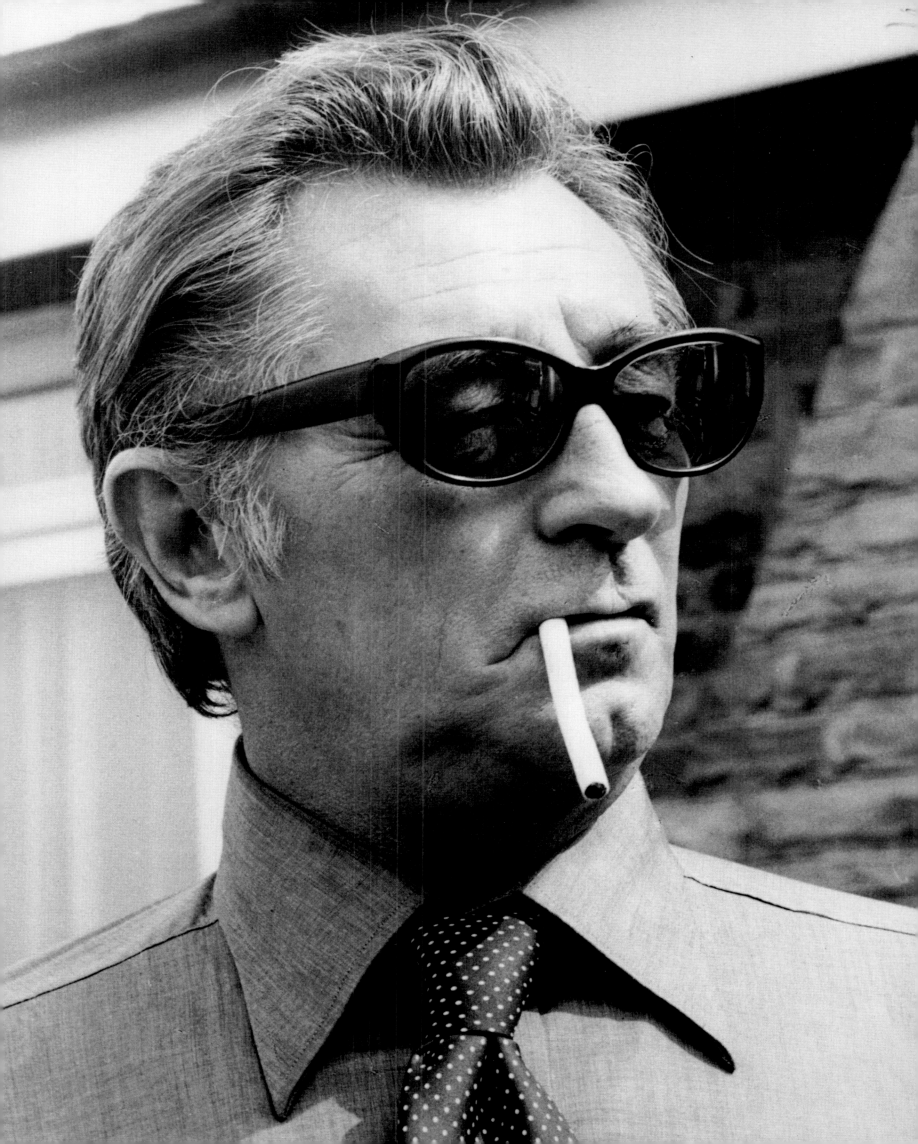

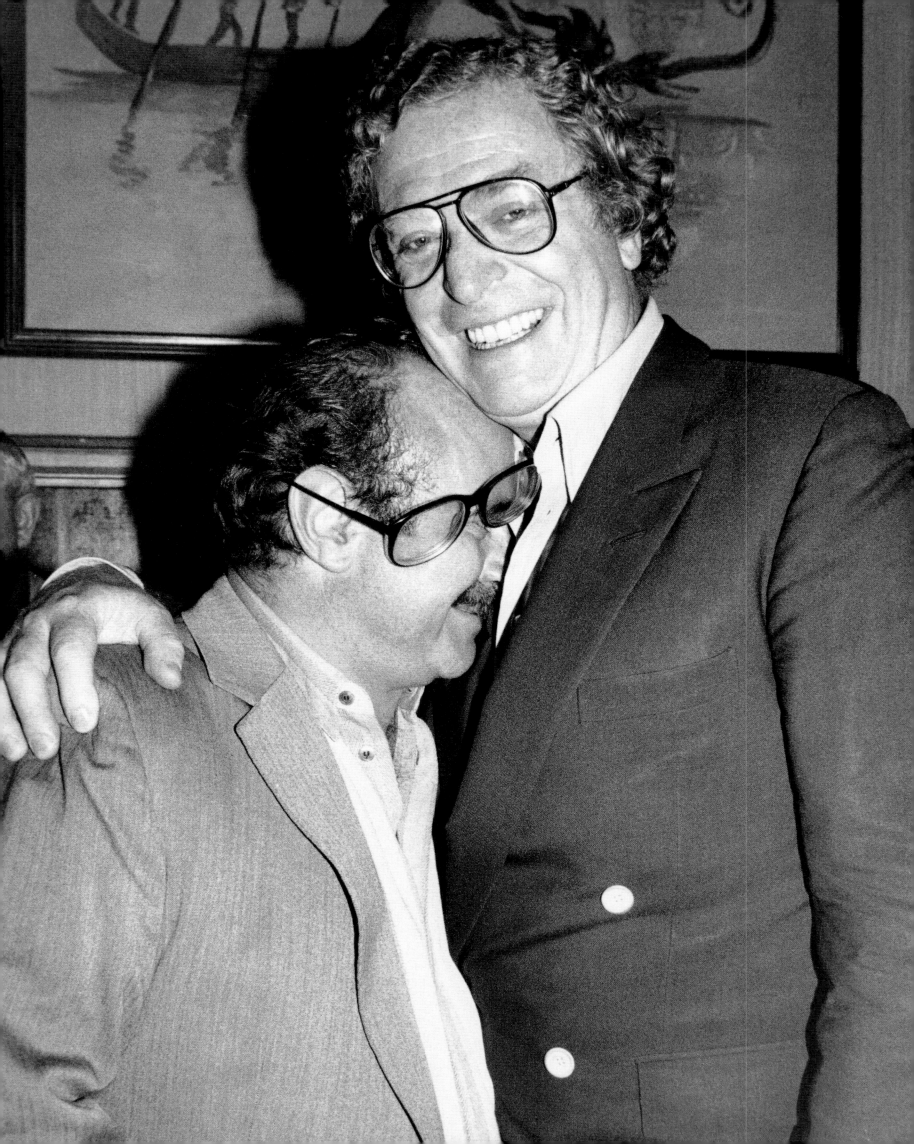

Robert Redford – tight lips, hard fist,
as my ear discovered on one occasion.
Heathrow Airport, 1979

Most big stars are professionals. They may or they may not like to luxuriate in the limelight, but they aren't going to be seen trying too hard. People like Michael Caine and Roger Moore are above it all – they never get agitated, at least not in public.

A while ago I wandered into one of Michael Caine's parties upstairs at Langan's. He said I could stay and take some pictures. Michael was talking to Bob Hoskins, and I asked them to move closer together. He then gave Hoskins such a bear hug that his glasses fell off! Michael Caine has always said that it's easier to stand still and smile into the camera – it's over then, and the newspapers haven't got anything to write about. If you get angry, or run away, or start a fight, then you're giving the papers a good picture and a good story to go with it. I must say there have been occasions when I haven't bothered to take a picture of Michael. He always comes out of Langan's and smiles. It's the same picture every time. What can you say? Here's Michael Caine leaving Langan's . . . again.

It's an example that some other stars would do well to follow, for their own sakes. Richard Gere seems to be getting the idea. He always used to resist having his photograph taken. I remember on one occasion when he was in London I was tipped off that he and his girlfriend had gone to the theatre. I waited outside. When they came out, they spotted me and started running down the street. That's the sort of shot I like. I chased after them, got the pictures and then watched the spectacle of her crashing into all these cars as she tried to get out of a tight parking space in a hurry!

Recently I met Richard again at the Nelson Mandela concert in 1988. I took a few shots and he was surprisingly nice about it. I asked him about his change of attitude and he said: 'Well, it's a special day, there's nowhere for me to run, and I thought that if I gave you a few shots now, you'd leave me alone.' And that's what I did.

Richard Gere – an officer, a gentleman,
and shy too. Soho, 1987

Michael Caine and Bob Hoskins –
I asked them to stand close together,
so they did. Private party, 1988

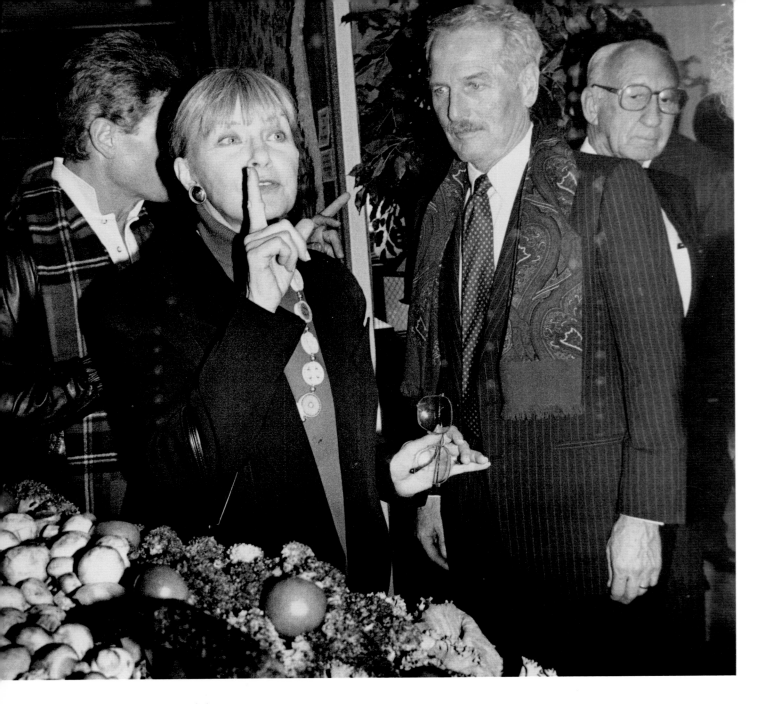

The big stars may have learnt to keep their feelings under control, but sometimes only just. When it comes to keeping cool, perhaps Paul Newman could take a leaf out of Roger Moore's book. I was in New York not so long ago, to cover the Antiques Fair. There were lots of socialites there and I photographed them, but I really needed a big name to appear. Just then, in walked Paul Newman with his wife, Joanne Woodward. 'Aha!' I thought, and started following them around. After about half an hour, Newman turned round and said: 'Haven't you got enough now?' 'Well, Mr Newman,' I said, 'I'm hoping to catch the definitive shot, the picture that shows what Paul Newman, the big star, is all about.' He looked flabbergasted. He simply didn't know what to say. I followed them for another hour, with Newman

growing more and more tight-lipped. When he decided to leave, he picked up his coat the wrong way round and all his money fell onto the floor. I offered to picked it up, but he growled: 'No, don't bother.' He picked it up and stalked out. A few moments later he returned, rather sheepishly. He had forgotten that he'd come with his wife . . .

Obviously, on some occasions, people have reasons for not wanting to be photographed that I don't know about. One lunchtime I was told that Robert Wagner, Natalie Wood and Laurence Olivier were having lunch together. I waited for them to come out of the restaurant, then I started taking photographs. Quite unexpectedly, Robert Wagner went crazy. He started screaming and shouting at me, and chased me down the street.

Paul Newman and Joanne Woodward –

at the Antiques Fair, New York, 1989

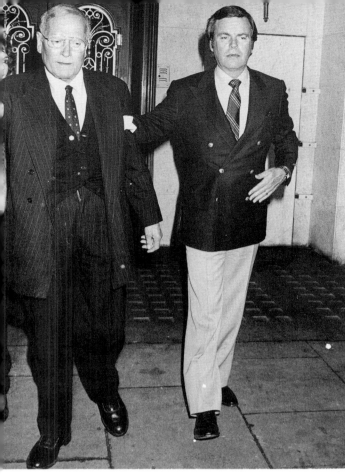

Later, he rang me and apologised for being so rude. He explained that the flash-guns hurt Lord Olivier's eyes, and he was trying to protect him. Well, I'm sure Laurence Olivier is photographed almost everywhere he goes, but it was decent of Robert Wagner to apologise. He's always been very pleasant since then.

Robert De Niro is a fairly unpredictable subject. I have done 20-minute photo-sessions with him when he has been charming; then on another occasion he has barged out of a restaurant and run to his car with his head down, so that no one could get a nice shot. Of course, behaviour like that always makes a good picture, because it looks as though the person has something to hide.

Marlon Brando, quite simply, just detests being photographed. I heard that he was having dinner with his son in an Italian restaurant in Notting Hill, so I went up there. When Brando came out and saw me, he closed his eyes. I don't know whether he thought the camera would steal his soul or if he believed that no one would use a picture of him with his eyes shut, but he walked all the way down the street and across Notting Hill Gate to his car with closed eyes! He refused to open them and it made a great picture – it was certainly different. Everyone could recognise Brando, even with his eyes shut, so he just looked rather foolish!

Jackie Onassis is someone else who dislikes having her photograph taken. She has had to put up with a lot of hassle from photographers in New York. At one point a photographer was forbidden, by court order, to go within a certain distance of her. She was in London a few years ago, with Teddy Kennedy, on her way to attend Lord Harlech's funeral in Wales. I knew she was staying at the Ritz while she was in London, so I decided to try my luck. When I reached the hotel, they told me she had left already for Euston. I zoomed over there on my motorbike and found her carriage. There were a few minutes before the train was due to leave, and I asked her if I could come into the carriage and take some pictures. To my surprise, she agreed. I took the shots and the train started moving! It was a fast train, its first stop was Crewe and so I spent the rest of the day getting back to London. But it was worth it.

Marlon Brando – pursed lips, buttoned

jacket and shut eyes. With son, Mico,

in Notting Hill Gate, 1988

Of course, stars can always avoid publicity if they want to. Usually Woody Allen wants to. He never goes to the showbiz parties, the openings, the first nights, the restaurants or the nightclubs that the showbiz set frequent. And he *never* poses for photographs. One night I was in New York for the opening of Peter Stringfellow's new club and, as no one very famous had arrived yet, I was at a loose end. Then an American photographer told me that Woody Allen and Mia Farrow were having dinner at Le Cirque, a lovely restaurant in uptown New York. He said it wouldn't be worth waiting for them as the weather was freezing and Woody never posed for photographs. I went up anyway, with a couple of other British photographers. When we got there I spoke to the *maître d'* and told him that we were British photographers, and would he please ask Woody Allen if we could photograph him when he left. To our surprise the answer came back that Mr Allen would be happy to pose for us. We waited around in the freezing cold, and finally Woody and Mia came out. They chatted and we took photographs. When they'd left we felt rather proud of ourselves, scooping the Americans on their own patch.

It wasn't until I got back to London that I realised why Woody had posed. It was the BAFTA awards that week and he had picked up two prizes. He had obviously thought that we had come out to New York specially to get photographs to tie in with the awards. . .

Ava Gardner is another star who likes to be seen as a recluse. She lives in Knightsbridge and, one summer, there was a party in her square to raise money for some new railings. Of course, she was there, holding court splendidly. I took some photographs and then, when she left, I followed, photographing her as she walked up the street. When she reached her home, she turned round and started throwing flowerpots at me! I said: 'Why are you doing that?' She replied: 'Because I don't want anyone to know where I live.' I said: 'But Ava, you're a star, everyone knows where you live!'

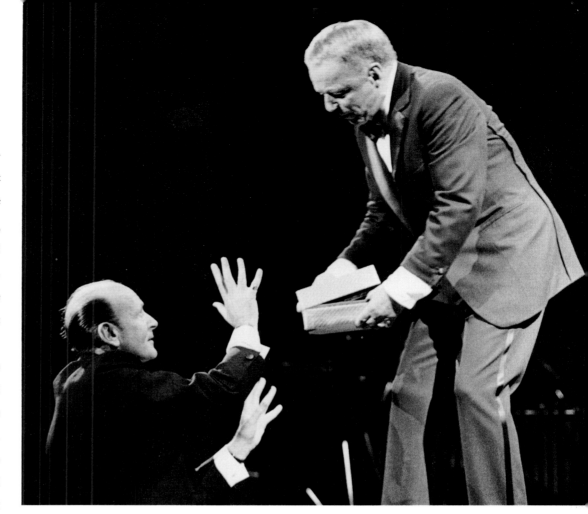

Frank Sinatra is the one who hides himself away most effectively. He has gone through the sound barriers of fame, he doesn't need publicity and he employs a number of people to see he doesn't get it. When he does have to set foot in some public place, such as an airport, he is surrounded by his own bodyguards. I reckon that Sinatra is better protected than even the Royal Family. Who else would do a dummy run into Heathrow just to test the security? His protection team is pretty tough, and I for one am not keen to tangle with it.

Almost the only time you can photograph Sinatra is when he is on stage. However, when he was over here a few years ago, I almost caught him on his own ground. I had heard that he was throwing a party one night, and I thought it would be at Annabel's. While I was waiting outside the club, I was tipped off that the party was being held at the Aspinall in Curzon Street. I was dressed smartly in a dinner jacket, so I went down there with a colleague. I had my camera carefully hidden under my jacket and we sailed through the front door. I knew there were private rooms further on, so we walked down the corridor and I saw Barbara Sinatra greeting guests at the door of a large room. I went in, announced my name and swept into the room. My colleague followed but, unfortunately, as well as his name he also announced his newspaper! I had spotted Sinatra in a corner with his cronies, and had just got him in my sights, when I was unceremoniously escorted from the room. It was very frustrating. The big one that got away . . .

When Sinatra was in town earlier this year he wowed them on stage, but once he was off it I was after him. His co-stars, Liza Minnelli and Sammy Davis Jnr, were out on the town every night, and I got some great shots of them. But I saw no sign of Sinatra, and my spy system could find no trace of his whereabouts. Either he stayed in his hotel a lot, or his system worked a lot better than mine! Still, when you tangle with the people at the top of this game you can't expect to win them all . . .

Ava Gardner – that star quality

keeps on shining. Garden party,

Knightsbridge, 1984

Liza Minnelli and Sammy Davis Jnr –

the stars who always smile for the

camera. London, 1989

Up in the Air, Down on the Ground

With Jack Nicholson – one of my all-time heroes . . .
Hamiltons Gallery, 1988

The job, and my lifestyle, have both changed enormously since I first started as a paparazzo photographer 15 years ago. Then I would walk the streets, keeping my ears and eyes open for any information that I could use. I spent many hours waiting for people to emerge through doors, only to discover that they had left hours before by the back entrance.

Over the years I have built up an information network of chauffeurs, doormen, waiters and minders who can let me know exactly where a person is, and where they are going. I have also established a reputation for getting my pictures in the papers. This makes me very useful to anyone who has a product to sell. Every morning I receive invitations to lunches, balls and parties; these are held to promote films, books, shows and charities. The organisers know that by inviting me in the hope of getting a picture in a national newspaper the next day, they could get, completely free, the sort of publicity that would cost them thousands of pounds in advertising.

These days, far from tramping the streets, I can find myself simply swanning from one social event to the next. Recently I was invited to a luncheon party to cover a Giorgio Armani fashion show at the Intercontinental Hotel, which was being held in aid of Birthright. The Princess of Wales is the patron of Birthright, and the charity is supported by a group of influential, high society women, including Lady Helen Windsor and Mrs Susan Ferguson. I sat with the organiser, Vivienne Parry, and chatted to her throughout the meal. The event was beautifully organised and very enjoyable. On my way to the *Express* to hand in the film, I saw Helen Windsor in the street trying to get a taxi, so I gave her a lift to the gallery in Charlotte Street where she works.

I go to a great number of art gallery openings and book launches, which tend to be in the late afternoon. One book launch that was slightly out of the ordinary was for Ronnie Wood's book of drawings and paintings at Hamiltons Gallery. Rod Stewart was there – so were Anita Pallenberg and Bill Wyman. In the evening there may be an exclusive function to cover, such as Sting's party in aid of the Rain Forest Foundation where I was the only photographer.

Later in the evening there will be the after-show and première parties. One very good first-night party was held at the Café Pelican when *The Vortex* opened, starring Maria Aitken and Rupert Everett. Everyone was there, from Jerry Hall and Marie Helvin to socialites such as Sabrina Guinness.

Life is rather pleasant these days. I am accepted at many places and people know me. And when they want publicity for their product, anywhere in the world, they call on me.

One year, Cartier were holding a party in Paris to launch a perfume. I was asked to take the photographs. I arrived at Gatwick to find that they had laid on a private Lear jet to fly their British guests over. As soon as I sat down on the plane, a glass of vintage Krug champagne was pressed into my hand. On the flight we were offered canapés of smoked salmon and caviar. When we arrived at the airport in Paris, we met up with celebrities who had been flown in from all over Europe – Ursula Andress, Omar Sharif, Alain Delon ... And a fleet of vintage Rolls-Royces were waiting to take us into Paris.

We travelled in style into the city, with police outriders paving our way. We swept into the Place Vendôme, where Cartier had put up a giant marquee. The inside was terribly glamorous, with decorated dinner tables, a dance floor and even chandeliers! I started work taking pictures, but I did take some time off for a fabulous dinner and a few dances! At two in the morning we were driven back to the airport, and by 5am I was back at home, standing in my dinner jacket, wondering what had hit me!

I love travelling and in my job I'm paid to enjoy it! Businessman Peter de Savary has asked me out to Antigua several times to promote his club there. I was invited to the gala opening, along with stars like Joan Collins and Liza Minnelli. Six weeks later I was asked back to cover the official opening by Prince and Princess Michael of Kent. Some time after that, Peter de Savary rang me up and asked if I would be the official photographer at his wedding. Naturally, I said yes, and he flew me out and put me up on the island. I relaxed for a couple of days, spent time on the beach, played in the casino. The wedding, with some 50 guests, was held on his yacht. It was very romantic, bobbing about on the Caribbean, with the palm trees on the distant shore waving in the breeze ... I took the wedding photographs and the pictures at the reception, which was held back on land at the club.

Ursula Andress with Harry Hamlin –
enjoying the high life at the Cartier
party in Paris, 1981

Last year I was invited to another extravaganza. A leading advertising agency asked me to go to Morocco and spend five days in La Mamounia, one of the world's most beautiful hotels. A casino was being opened there, and the hotel was flying in celebrities from all over the world to publicise the event. There were three gala nights, splendid lunches *and* Joan Collins' birthday party to boot. I was to be the only photographer there, and the ad agency wanted photo approval on everything. I was quite happy to let them have it. After all, if I am the only photographer, no one can scoop me.

On my arrival I was shown to a beautiful room in the hotel. The first night I relaxed with a drink and dinner. A lot of people were there – Elaine Paige, Fiona Fullerton, Bill Wiggins, George Hamilton and some socialites, such as Liz Brewer, from London. Early the next morning I had this frantic phone call from the *Express*. Apparently, the day before, Fiona Fullerton had broken the news about her affair with an MP and everyone wanted a picture of her. The next minute, there was a knock at my door. Two photographers, one from the *Daily Mail*, and one from the *Daily Star*, were standing there with wire machines and cameras. They hadn't been able to get into any hotel in Marrakesh. There was I, official photographer in a beautiful room with direct dial telephone lines to London. 'Come in, boys,' I said. They had been sent out to cover the Fiona Fullerton story, and they wanted to set up the wire machine in my room. The machine can transmit photographs straight to the newspaper offices, so it would save me a lot of time and hassle. I was also glad to see them because it took the pressure off me. Now that I had competition from two other newspapers, I couldn't be expected to stick to the agreement made when I was the only photographer, and I explained to the organisers that I had to look after the *Express* now that these boys were on the scene.

Everyone wanted shots of Fiona Fullerton – it was the hot story of the day – but I was the only photographer with access to all the grounds. So I wandered down to the pool area and found Fiona having lunch with some friends. I sat down with them, had a chat and then I said: 'Hey, Fiona, you're looking great today, how about

some pictures?' She said: 'Oh, do you think so?' Then she said: 'Come on, Richard, where are these shots going?' I said I was the official photographer for the whole event, so she took off her sunglasses and agreed to be photographed.

I went back to my room where the others were having some sandwiches, and told them I had the shots. The bathroom had been turned into a dark room, so one of them dived in there to process

Fiona Fullerton – sometimes the official photographer calls the shots. Morocco, 1988

With Mick Jagger – Mick is a star; the

Stones are the best rock and roll band in

the world. Fashion Aid, 1985

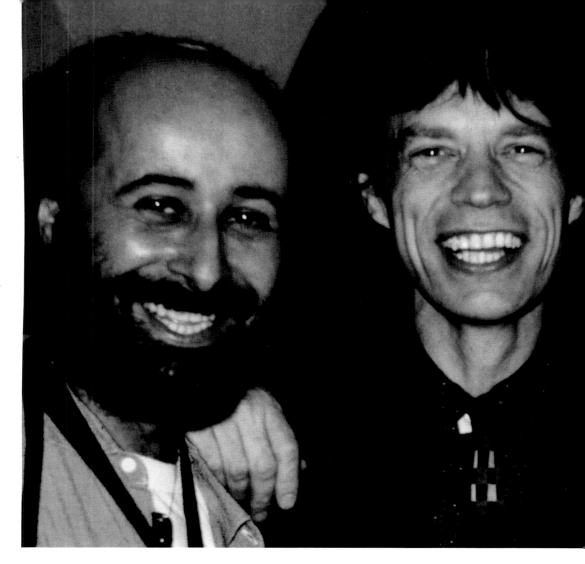

the film. I had enough shots for all three newspapers, so we each chose one and sent it back to our respective papers. We were all covered and everyone was happy!

Of course I enjoy the high life, the beautiful locations, the top hotels and the most glamorous parties, but mingling with the rich and famous has given me some very expensive tastes. I like to buy only Hermès ties and Giorgio Armani suits; for years I've been dressing just as I've always wanted to dress. The only thing now is that I would like to be slim again. Some people smoke, some people drink – my vice is eating. In this job, you get offered extremely good food, and I rarely say no . . .

One Christmas, good old Cartier threw another of their splendid parties. This time it was in London. They were inviting their customers to view the jewellery and on the invitation they called it a caviar evening. I thought there would be a few canapés with a smattering of caviar on them. I had some other jobs to do first, so by the time I turned up, the party was in full swing. I went upstairs and at the far end of the room were three great silver tureens. Each was full of caviar, one with Russian, one with Chinese and one with Iranian. I just stood and gawped, but not for long; I was told to help myself and I did just that. I went for the Iranian, my favourite caviar, and like everyone else I didn't stop at second helpings!

You can tell a lot about parties by their food. Some PR people will try to get you along to an event with the promise of some big names among the guests. However, big names or not, if you walk in and see quiche and chicken vol-au-vents, then my advice is to turn around and walk straight out again.

I go to parties practically every night of my life, and those that stand out are the ones where people have made an effort to ensure that their guests enjoy themselves. One of the best parties I've been to recently was Marty Wilde's 50th birthday party. The champagne was flowing, there was a mouth-watering spread of food and a wonderful atmosphere. It was a party for Marty's friends and family. The guests included The Shadows, Gary Glitter, Elaine Paige and, of course, Kim Wilde, and they all got up on stage and sang and danced their hearts out.

Kim Wilde with her dad and

Gary Glitter – whooping it up at

Marty's 50th birthday party. Private

party in Hertfordshire, 1989

Jobs like that are always special, because you have been asked to be there by the host rather than the record or film PR people. As I have become more widely known to celebrities, I have received more and more personal invitations to work for the stars.

One commission was from George Harrison. He rang me up and asked if I would like to do some family shots of him, his wife Olivia and their son Dhani at their home in Henley-on-Thames. They were to be private photographs and not for publication, as George Harrison is a very private man. A chance like that doesn't come by very often and I couldn't get there fast enough! When I arrived, George told me that I was the first photographer to set foot in the place for over 18 years.

I spent a most enjoyable day with the family. The house and gardens are beautiful, and I took pictures in the kitchen, the garden around the house and finally in the guitar room. Here was housed George's magnificent collection of guitars, and he explained the history behind some of them. There were guitars from the Beatles era, one of Lennon's instruments and a 12-string Rickenbacker which Roger McGuinn had played on 'Mr Tambourine Man'.

Then we went into Harrison's recording studio and he played me some tracks. The whole day was magical for me. I, like millions of others, count George Harrison as a living legend, and to spend a day with him in his own home was a thrilling experience. I felt that I'd got a lot more out of it than he did, so I refused payment for the photographs. That's the effect living legends have on me. Fortunately, there aren't too many of them around . . .

With Prince Andrew – at the launch party for his book of photographs. London, 1986 (I'd just like to say I thought his pictures were very good!)

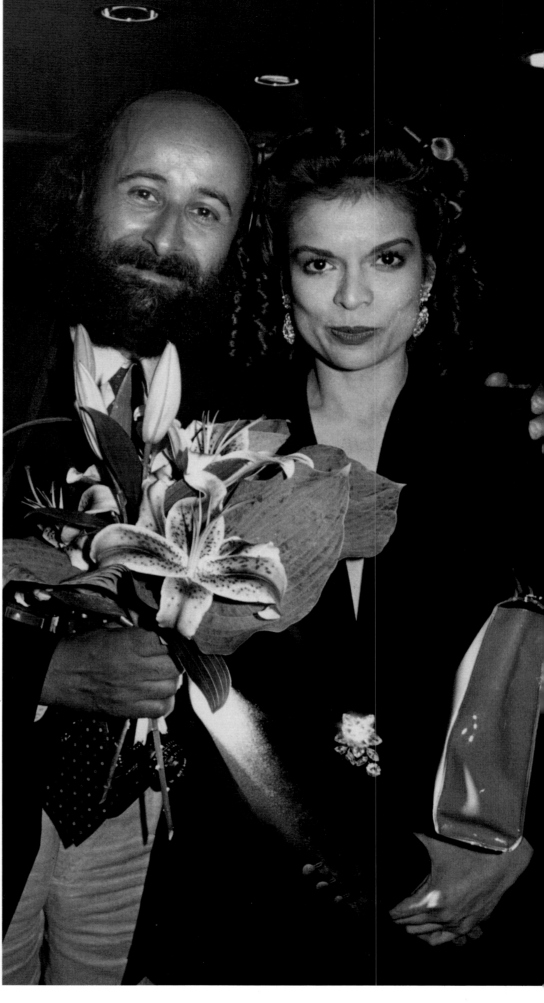

With Bianca Jagger – I asked if she'd have her picture taken with me and she agreed, on condition that I hold her flowers. London, 1986

My lifestyle may sound rather luxurious and cushy, but I'm still in at the sharp end of the business and I wouldn't have it any other way. These film stars and pop groups may be flying high when their film or record comes out but, at other times, their lives are extremely insecure. They have long periods when they are not doing anything, and they have to rely on someone else to ask them to make another film or record, or star in another musical. I don't rely on anyone. If the invitations dried up tomorrow and the phone never rang again, I would just get on with the job. I would be out there, turning up and taking pictures. When I've finished the assignments I've been invited to do, I drive around, checking out certain places and restaurants and finding out who is doing what. I never go home until I am satisfied that I know exactly what's happening in London that night.

In my job I lead a double existence. One minute I'm on the inside, drinking champagne, eating caviar and taking the shots the stars want – the next minute I'm on the outside, definitely unwanted and getting photographs that everyone is trying to stop me taking! I can be an official photographer in the morning and a paparazzo in the afternoon; the two roles co-exist relatively happily. However, after reclining on a sunbed in the Caribbean for a week, it does take a bit of getting used to crouching behind a car again in the freezing cold, waiting for someone to come out of a restaurant.

The hanging around is a vital part of the job if I am going to stay on top in this business. There are still times when, if I want the shot, I have to wait for it with the other photographers – it's very tedious. I stand around chatting to the paps that I get on with, and trying to avoid the ones I don't. The worst thing that can happen is rain. Not only do I get wet, but my cameras get wet. I can't use an umbrella, because it's impossible to take a picture with one hand. It's like trying to be a photographer at a party when you have a drink in one hand, a cigarette in the other and a canapé in your mouth. I just stand outside in all weathers and suffer, because the person I want could come out at any minute. Actually, even worse than the rain is wanting to go to the loo. I daren't go, because if I do, I know I'll miss the action. It's happened before so I just have to cross my legs . . .

With Pamela Stephenson and a snake – I should never have told her I'm scared of snakes. The Roof Gardens, Kensington, 1985

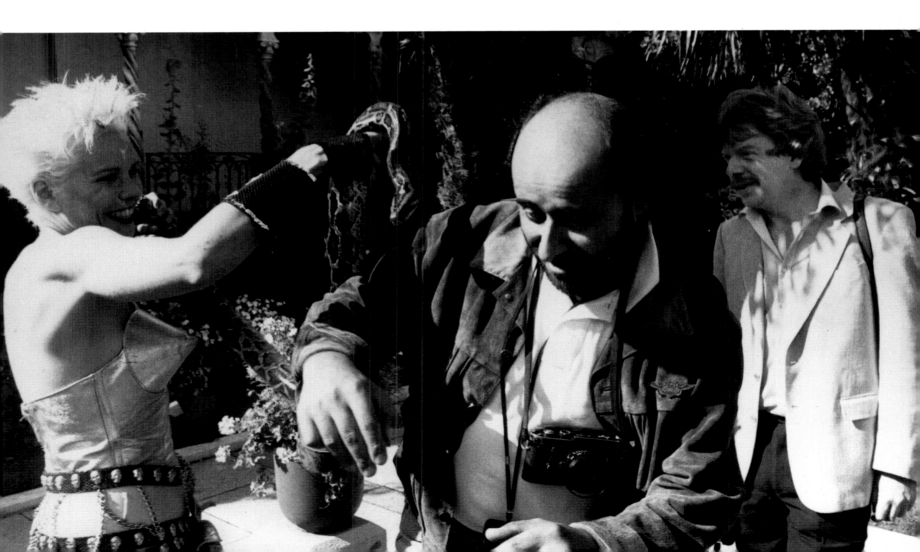

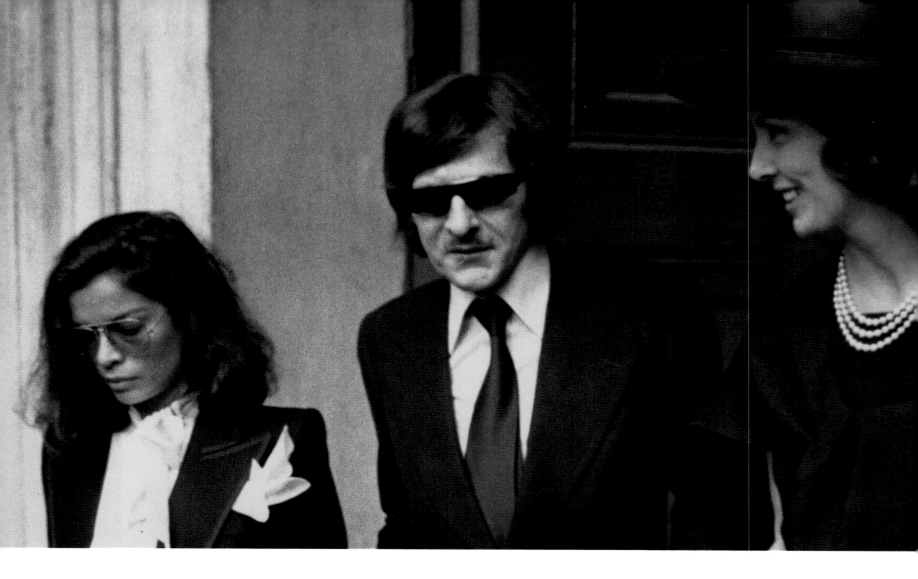

The paparazzo shots may be the most difficult to get, but they are the ones that have the potential to earn me the most money. When I look back over the years, the shots that have earned me the most have been the ones that I have taken because I was in the right place at the right time: Liz Taylor and Richard Burton at Burton's 50th birthday party; Paul Getty Jnr in London after his kidnapping; Prince Charles and Sarah Spencer at Klosters; Mick Jagger and Jerry with Scarlett; Madonna's car running over a photographer.

Another big earner was a pic I took of Jackie Onassis in New York, right at the start of my career. I was with my first wife, Riitta, and we were walking down the street when she nudged me and said: 'Look, there's Jackie O!' We followed her into a few shops, and I started taking pictures. Suddenly she realised what was happening, and she ran into a hairdresser's salon and hid behind some partitions until they called her a taxi. By then, of course, I had got the shots.

The Getty family have been very good for my career. My photographs of Paul Getty Jnr were the very first pictures I sold and, a year later, his father Paul Getty III made me a lot of money when I caught a rare shot of him out in public. At that point, Getty III was a complete recluse. One of the richest men in the world, no one ever saw him and nobody was even sure where he lived. One day I was in a taxi, going through Mayfair, when I saw that something was going on at the American Church. I stopped the taxi and asked someone what was happening. I was told it was a memorial service for Paul Getty III's father, so I stayed to see who would come out of the church. One of the first to emerge was Bianca Jagger, on the arm of a frail-looking man in dark glasses. I knew it had to be him, and I started taking pictures.

Those shots were the first photographs of Paul Getty III for 20 years, and they were used all over the world.

*Paul Getty III and Bianca Jagger
rare shot of the reclusive Getty, tak
after a memorial service for his fat
Mayfair, 1976*

Many things may have changed in the 15 years since I started the job, but one that hasn't is the amount of hard work involved. I am never off duty. When I am in London I always have a camera with me, and I even take one on holiday with me, just in case. Keeping tabs on what's going on is a never-ending job. Reading newspapers or magazines is never a relaxing pastime – it's work. I am constantly storing away information about people and places that may one day be useful to me. I keep a diary of people's birthdays and anniversaries so as to remind myself of forthcoming events. If that person is in town, I keep an eye on the likely restaurants to make sure I know where they are having the party.

Obviously I have to keep an eye on the changing scene in London, so that I know which restaurants and clubs a certain person is likely to frequent. My favourite restaurant, and that of Princess Diana too, is San Lorenzo. I have been a customer for 20 years, I met Susan there and we had our wedding party at the restaurant. I have a deep affection for the place.

Then there's Langan's Brasserie. The stars go there, particularly Americans, but since Peter Langan's death in 1988 the place has sadly lost much of its former appeal to the stars. Le Caprice is a lovely restaurant, much frequented by the younger royal set. Mr Kong is the favoured haunt of the music industry – Boy George goes there and George Michael has been known to patronise it. The Café de Paris is the place to go on Wednesday nights. It's one of the best music clubs in town and you get the trendy crowd there, from the fashion and art worlds. Joe's Café is owned by Joseph, the famous designer, and it's very much a fashion business restaurant. Joe Allen's is the natural habitat for Americans and theatre actors. They all go there for dinner after the performance. For lunch, the royals and top businessmen go to Green's Oyster Bar in Duke Street, and for breakfast, everyone goes to The Connaught.

As for nightclubs, well, there are still only two that the paparazzo photographer needs to know about in London, and they are Annabel's, owned by Mark Birley, and Tramp, owned by Johnny Gold. Birley also owns two members-only restaurants, Mark's Club and Harry's Bar. With his three establishments, he has cornered the entertainment market of royals, high finance and the highest echelons of rock and roll.

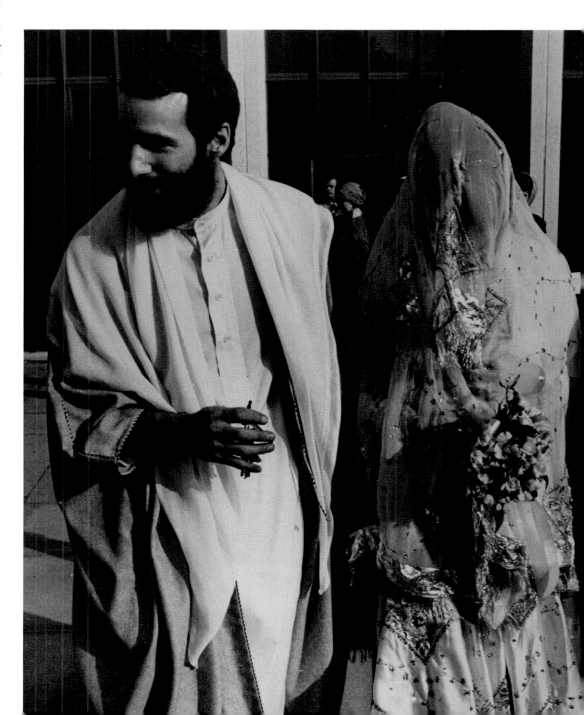

Cat Stevens and bride – I do quite
a bit of wedding photography now!
The Regent's Park Mosque, 1978

As well as keeping up with the London scene generally, I have to keep up with what's happening on a minute-to-minute basis. My life and work have been transformed by communications technology. Bleepers were around in the early days, but they weren't efficient. When I was somewhere I shouldn't be, I could always rely on this noisy bleeper to draw attention to me in a crowd! The message couldn't be stored – it was announced twice by the operator and if I missed it because I had turned off the bleeper, or the battery faded, or I was in a noisy place, that was too bad!

I used to spend hours trudging around looking for a telephone to contact the newspaper office. I would miss half the action because I was half a mile away on the phone. Recently at a Sting concert, I was able to ring up the impatient picture editor and tell him that I was in the photographers' pit, taking shots of Sting on stage. Then within half an hour a despatch rider had got the film to the editor's desk.

That sort of equipment might make my life easier, but what makes it more enjoyable is my Harley Davidson motorbike. I dreamed of owning one from my teenage days. I used to go into Fred Warr's off the King's Road and admire the bikes there; I loved the style, the design and the image of the Harleys. As soon as I had passed my test I bought a second-hand one, but I soon traded it in with Fred Warr, and since then I've bought seven brand-new models from him. It's difficult to convey my feelings for Harley Davidson bikes, but I know many people share them.

Although my bike is not absolutely essential for my work, and I ride it mainly for pure pleasure, it's amazing how often I have become friendly with people and taken their photograph because of their interest in my Harley. Eric Clapton, Viscount Linley, Mickey Rourke, Terence Trent D'Arby and top US businessman Malcolm Forbes are all motorbike fans, and whenever I see them we have long, interesting conversations about bikes. Even people who aren't bike fanatics stop and admire my machine, and I'm only too happy to answer their questions!

I'm also often asked about the cameras I use, and the technical side of photography. I suppose people think that as I must have taken about two million shots in my time, I might know what I'm talking about. Well, when I started I read a lot about photography, and I've always loved looking at pictures by other photographers but, to be honest, I still don't know that much about the technical side. I work with two Leica M6 cameras, one with a colour film, the other with a black and white. When I'm working in daylight, I use a Nikon.

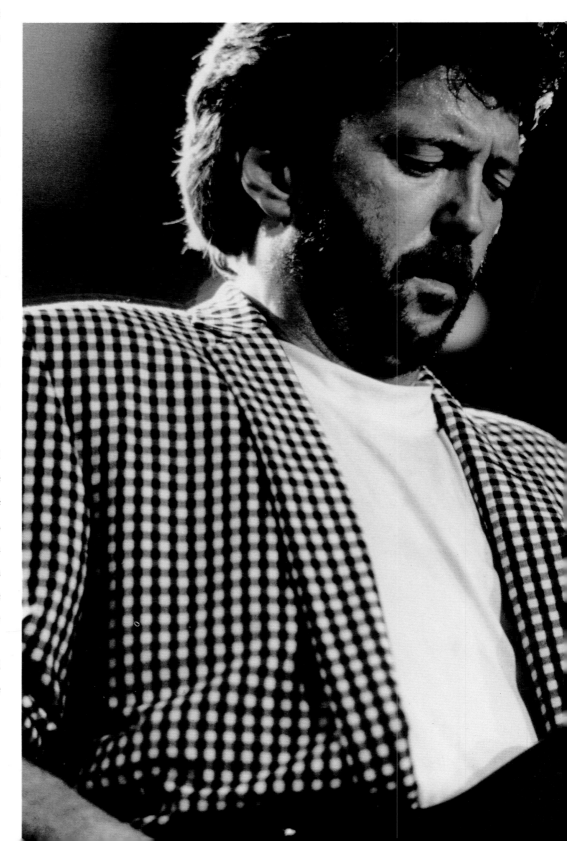

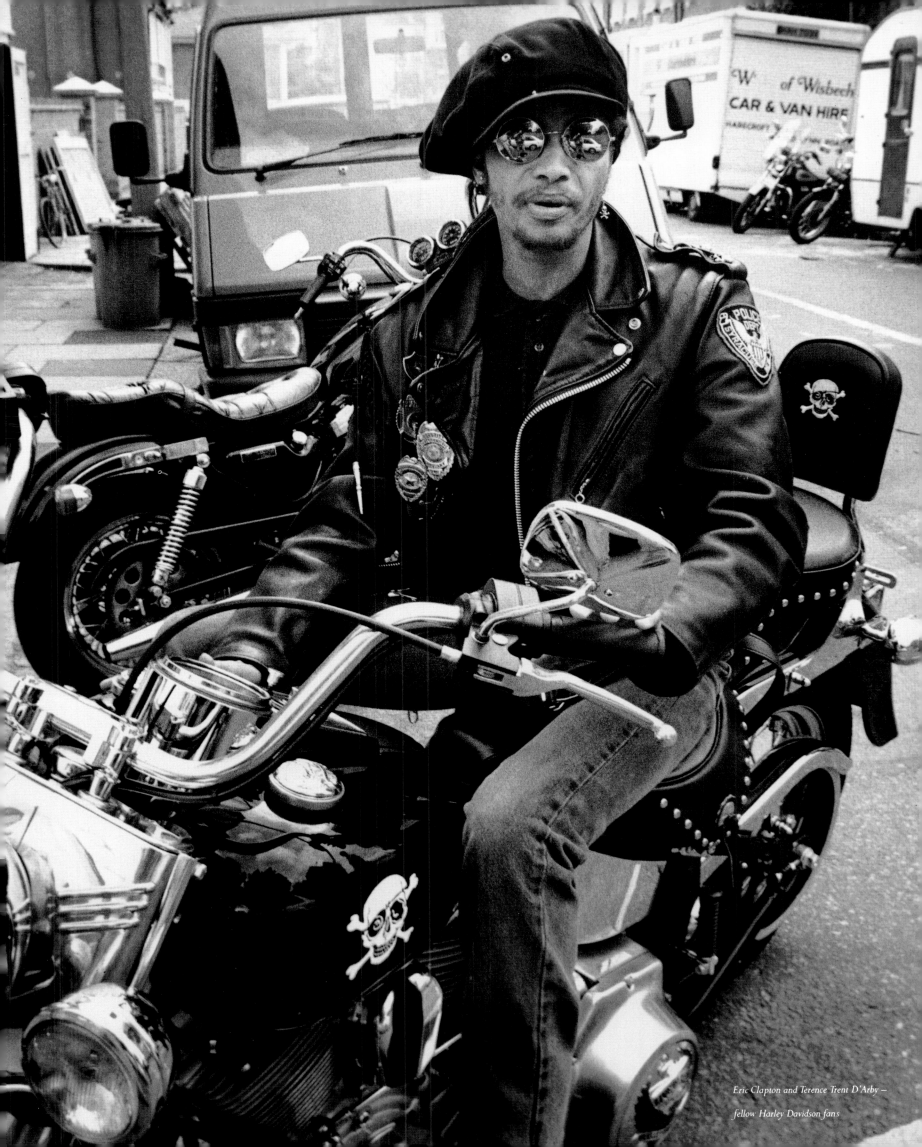

Eric Clapton and Terence Trent D'Arby –

fellow Harley Davidson fans

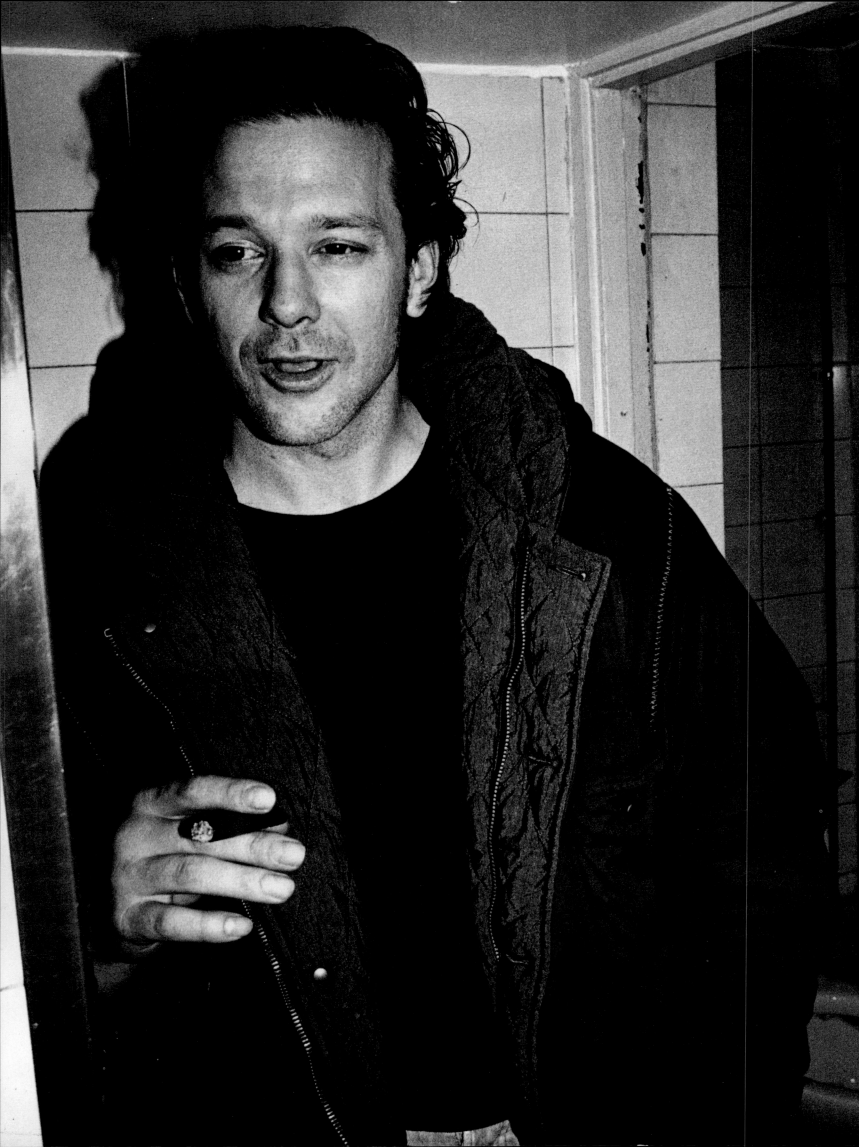

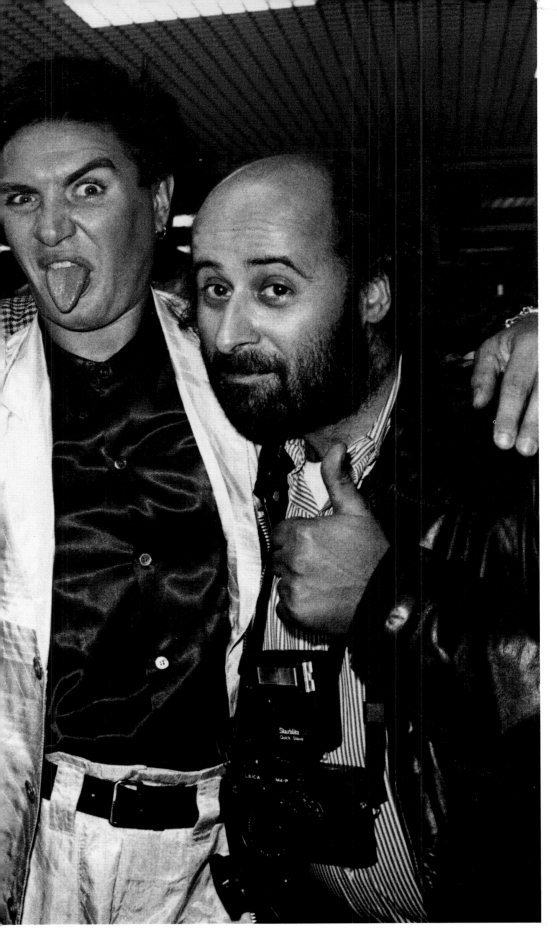

RY with Simon Le Bon – I get on very well with Simon, really . . . Piccadilly, 1986

Mickey Rourke – the only pic I've ever taken in the gents! Mickey was too shy to pose at the bar. Café de Paris, 1987

My rules of photography are fairly simple. For newspaper pictures it's important to be able to recognise a story, and so you must keep up to date with current affairs. Not too long ago, I attended the opening of a new Daks shop in Regent Street. Mark Phillips has a contract with Daks , so he was there. I was chatting to him when Anthony Andrews and his wife, Georgina, came in. With the current rumours about Mark's marriage and the past innuendos made about Princess Anne's friendship with Anthony Andrews, a shot of Mark and the Andrews together was an ideal photograph for the newspapers.

To get a picture of three people talking, I have to take a landscape rather than an upright picture. Generally I prefer to do uprights, because you can get more detail of what the person is wearing and, if you step back, you can get in some atmosphere and background as well. I try not to ask people to move together in order to fit them into the shot because, if you make them aware of the camera, you lose the magic of the picture. You get a shot of them posing for you, instead of talking to their friends. If they are talking, you get interesting facial expressions. If they are posing, then you just get a boring shot of them looking self-conscious and gormless.

What I do is stand a few feet away and keep an eye on the situation without being too obvious. I bide my time and let them get on with whatever they are doing. The right circumstances for the picture will usually come in the end. When I decide to make a move, I do it quickly – there's no time for fumbling around with the camera. I take most shots between three and six feet away, so the camera is focused already.

I have mucked it up on many occasions. Last Christmas at Anna Murdoch's book launch party, I had taken three or four frames before I realised that I had forgotten to put any film in the camera! I had to go into a corner and slip a film in, hoping that no one would spot me.

The photographer's nightmare is to run out of film just as things start happening. There's nothing you can do, it's a hazard of the job, but it's extremely nerve-racking trying to change a film while everyone else's cameras are flashing around you.

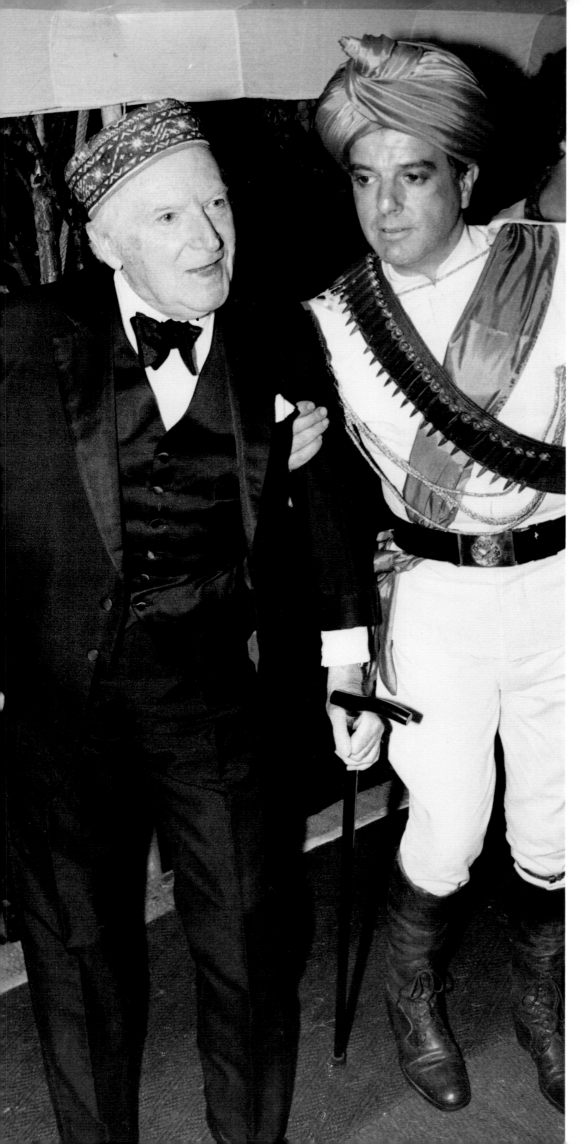

Two photographers in particular have influenced me from the very beginning. These are David Bailey and Cecil Beaton and, although their areas of photography and mine are worlds apart, I have been lucky enough to watch both of them at work.

Years ago, I was asked by French *Vogue* to photograph Sir Cecil Beaton while he took a portrait of Sir Ralph Richardson at the National Theatre. His methods of photography and mine could hardly have been more different! Ralph Richardson stood on stage in costume and Sir Cecil sat there chatting to him while his assistant set up the tripod, placed the camera, found out where Ralph Richardson was going to stand and focused the camera! After about two hours of this, Sir Cecil got up, went over to the camera, took about 10 frames, and said: 'That's it!' He must have seen the look on my face, because he said: 'Mr Young, if you can't get it on one roll of film, you haven't got it.' He's right. If you have a controlled situation like that, you do need only one film rather than 25! I'm trying to cut down.

David Bailey is a great photographer. His pictures are very distinctive; nobody else works like him. He photographed me once in his studio. He's very fast and efficient; he knows exactly what he wants and he will manoeuvre you into a situation so that he gets it. Bailey has been an inspiration to me since I was a teenager in Hackney, with his photographs on my bedroom wall.

Cecil Beaton – a man of great style.

Fancy dress party, Hampshire, 1980

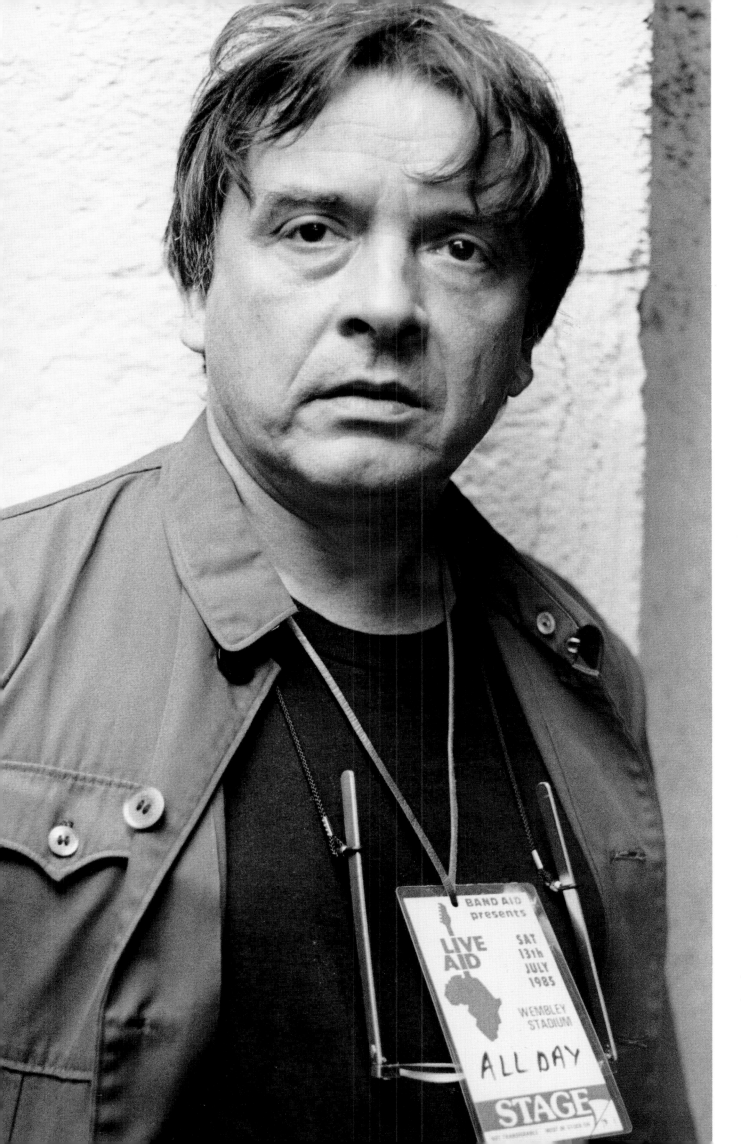

David Bailey – a brilliant photographer.

Live Aid, 1985

157

I feel that I have made my mark on the way photographs are taken, in my own fashion. When I first started, people posed for the camera. My approach was different. I want pictures of people doing something – talking, running, shopping, dancing. I try to capture something that exists only for a second, a moment that says something about that person and their life. Of course that's not always possible, but it's always my aim.

The idea of catching people as they are, rather than as frozen figures staring into the camera, has caught on widely. I get asked to photograph people's weddings, and they always say that they don't want those terrible posed group shots. They ask me to walk around and take pictures of them and their friends enjoying themselves, and I feel that I have played a leading role in pioneering this approach. Mind you, at weddings I always do one group shot, and that is of the two proud mothers with their children. There is a limit to my innovation!

This job has given me many opportunities: I have travelled the world; I have met an enormous number of talented and interesting people; I have been able to enjoy a very good lifestyle. I hope I have recognised and made the most of the opportunities that I have been given. Certainly I would be happy for a son of mine to follow in my footsteps. My eldest son, Danny, has already shown an interest in photography . . .

This job may not be as stable or respectable as accountancy, but, as I said, it sure as hell is a lot more fun.

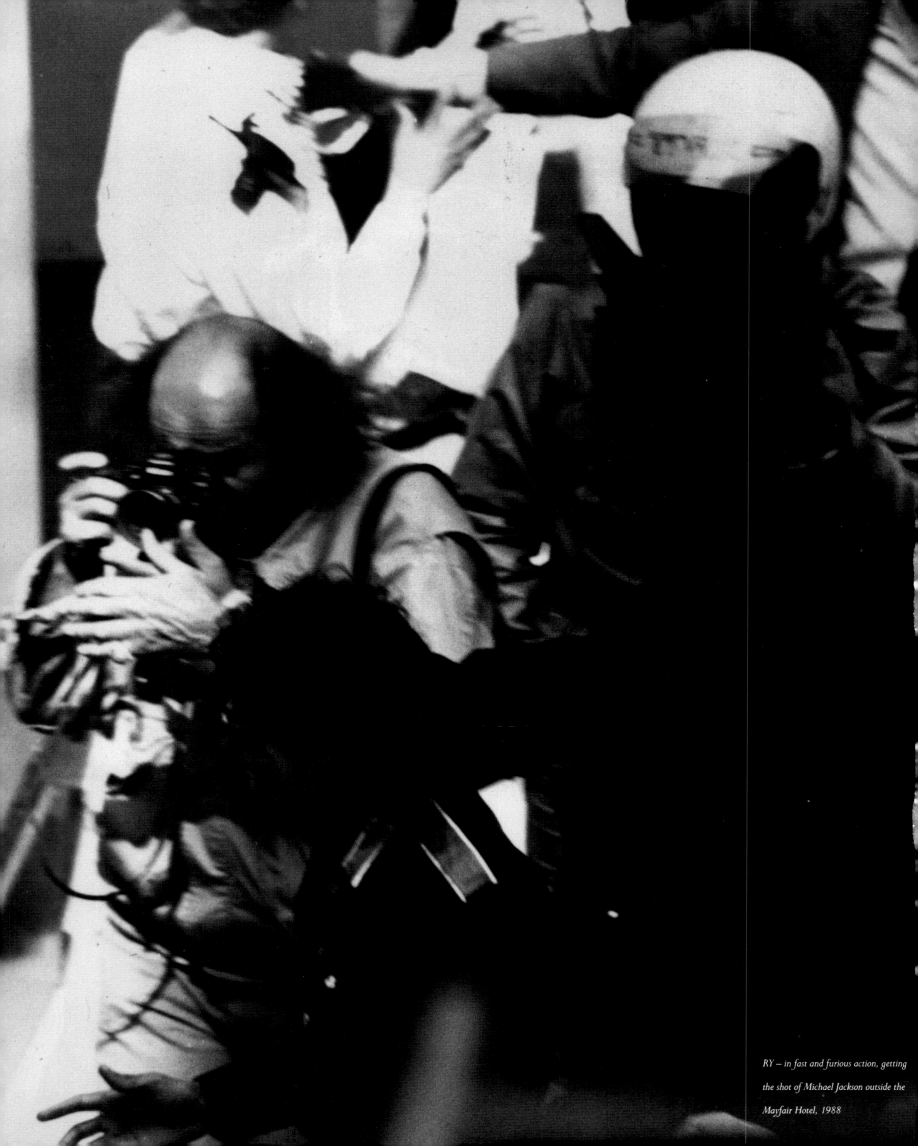

RY – in fast and furious action, getting the shot of Michael Jackson outside the Mayfair Hotel, 1988